VICTORIA AND ALBERT MUSEUM LONDON 1975

CATALOGUE
OF SCANDINAVIAN
AND BALTIC
SILVER

R. W. LIGHTBOWN

£4·15 net

© *Crown copyright 1975*

Printed in England for Her Majesty's Stationery Office by
William Clowes & Sons, Limited
London, Beccles and Colchester
Dd 133562 K20 12/75

ISBN 0 901486 65 5

CONTENTS

PREFACE

This catalogue has two purposes. One is to make the Museum's collection of Scandinavian and Baltic plate fully known to scholars. The other is to produce an introduction to the subject in the English language. Hitherto one has been wanting in spite of the large amount of Scandinavian plate that has found its way to the British Isles, a great deal of it brought back by the sporting and picturesque tourists of the nineteenth century.

In compiling the catalogue I have received much kind assistance. My first thanks must go to Mr B. W. Robinson and Mr C. Blair, successively Keepers of the Department of Metalwork, who encouraged me to undertake and to complete it. I also wish to express my gratitude to Mr H. Wakefield, Keeper of the Department of Circulation, who allowed me to include in it the Scandinavian plate belonging to his Department. This has now been transferred to the Department of Metalwork and is exhibited jointly with its collection. I thank Mr P. Thornton, Keeper of the Department of Woodwork, for placing his knowledge of Scandinavian art and languages freely at my disposal.

Mr Michael Snodin, Museum Assistant in the Department, helped in the revision of my first draft and to his enthusiastic interest, especially in the difficult problems posed by Scandinavian spoons, the text owes a number of improvements. He also undertook the measurement of the objects.

The difficulty of photographing silver so as to do it justice is well-known, and I must thank Miss Christine Smith for her skill and care in taking the photographs for the illustrations.

I also wish to thank Mrs N. Betts, who has patiently typed often difficult drafts, Miss L. Gill and her staff for other typing, and Mrs S. Bury, Mr A. North, Miss D. O'Day, Mr C. Truman, Mrs S. Webb and Mrs E. Friday for help in general.

Scandinavian scholars have given me generous assistance. Dr A. Polak, Deputy Curator of the Arts and Crafts Museums of Norway, not only provided valuable information about our Bergen silver, but read the introduction in draft and advised me to whom to turn for the solution of certain problems. Direktor Erik Lassen of the Kunstindustrimuseet, Copenhagen, gave up time on a visit to England to examine and comment on the collection, as did Dr Inge Mejer Antonsen of the Nationalmuseet, Copenhagen, who was also kind enough to read the introduction in draft. Dr Henning Alsvik of Drammens Museum, Dr Jorun Fossberg of the Norsk Folkemuseum, Oslo, Dr Inger-Marie Lie of the Kunstindustrimuseet, Oslo,

and Dr Fritze Lindahl of the Nationalmuseet, Copenhagen, have all responded to my letters with important information about certain pieces in the collection. Dr K. Holmquist of the Nordiska Museet, Stockholm, generously spared time on a brief visit to England to look over and give her opinion on our Swedish silver and on our Scandinavian spoons in general. The assistance given by these colleagues is acknowledged in the individual entries concerned, but responsibility for any errors is of course my own. For help in checking proofs I owe grateful thanks to Mr C. H. Gibbs-Smith.

I conclude by recording that as in many other branches of goldsmith's work so in that of the Museum's Scandinavian silver the first initiative of study was taken by Mr C. C. Oman.

R. W. L.

INTRODUCTION

HISTORY OF THE COLLECTION

The Museum's collection of Scandinavian silver was largely formed during the decade from 1901 to 1911. The few pieces acquired in the previous fifty years had almost all been obtained under the impression that they were something else, as in the case of the small group of spoons bought at the famous sale held in 1855 after the death of the great collector Ralph Bernal (c. 1785–26 August 1854). Bernal, a barrister and M.P. of Spanish Jewish extraction, had formed a typical Romantic collection of medieval and Renaissance art, and the survival in these and similar spoons of Late Gòthic forms encouraged the belief that they were late fifteenth or early sixteenth century Flemish or German work, a belief shattered when Scandinavians began publishing historical studies of their applied arts. The only important addition made during the next forty-five years was the fine parcel-gilt Swedish Late Baroque tankard (No. 84), traditionally said to have been presented by Queen Louisa Ulrica of Sweden to Lars Torbiörnsson, Speaker of the Peasant's House. It had been acquired in Sweden, probably in 1820, by Captain, later Sir Arthur de Capell Brooke, the Regency traveller.

In 1898 the gift of Colonel F. R. Waldo-Sibthorp, rich in fine German silver, also added some Scandinavian pieces. But the credit for making a systematic collection of Scandinavian goldsmith's work belongs to two men, one a Museum official, H. P. Mitchell of the Department of Metalwork, the other George Jorck, who was later to leave to his native Denmark a foundation one of whose purposes is to support the acquisition of works of art for museums. Jorck was then a dealer in Hatton Garden. He offered the Museum his first selections of pieces entirely on speculation, but was encouraged by his reception to bring in Scandinavian silver for purchase at regular intervals. From the first Jorck seems to have represented not only himself, but Scandinavian dealers anxious to dispose of pieces in their stock to the best advantage in wealthy, antique-loving Edwardian England. Mitchell was successful in pressing the acquisition of the best of what Jorck offered. The antiquarian and literary enthusiasm of the eighteenth century for Northern antiquity had rather waned in the Romantic age but from the middle of the nineteenth century interest in Scandinavia had been steadily increasing. It was of course greatly promoted by William Morris. Official late nineteenth century taste, probably influenced by the current enthusiasm for all that was thought to have been produced by the 'folk' and also by the Arts and Crafts Movement, had become sympathetic to folk art, and a

number of the Scandinavian pieces purchased were regarded as highly desirable merely because they were made for the Lapps or for peasant customers. During the 1850s and 1860s their purchase would not have been considered. Now many of the pieces submitted by Mitchell were seen and approved for acquisition by Walter Crane.

Jorck first approached the Museum on 5 November 1901, with a consignment of silver spoons from Copenhagen of which five were purchased (1591 to 1595–1901). On 22 November he brought four Scandinavian beakers, the vanguard of a whole army that were to march in during the next few years. Mitchell minuted: 'we have in the Museum only one example of a Scandinavian beaker somewhat similar to the four specimens offered; the patterns of the feet of all four are different from the one we have as well as from each other. There is very little Scandinavian work in the Museum and none decorated with the engraved foliage ornamenting two of these pieces'. Crane saw and recommended them and accordingly they were purchased. On 14 February in the following year a whole collection was offered through Jorck's agency. Mitchell wrote: 'A client of Mr Jorck's residing in Copenhagen, who has been collecting silversmith's work for many years, has brought over a considerable collection to sell in London. The objects now on approval are a small selection from the many dozens of similar pieces which he submitted, made with regard to the requirements of the Museum collection...With two exceptions the selection consists almost entirely of specimens of Scandinavian and Russian work, a class at present most meagrely represented in the Museum. In having had the choice of the best pieces from a considerable collection the present seems an unusually favourable opportunity of furnishing the Museum with a good representation; the price of the selection amounts to £234 1s 6d. Among the silver submitted on approval by Mr. George Jorck are two Swedish beakers, No. 650 (£16) and No. 406 (£10). They are two of the oldest and most interesting of those brought from Copenhagen by Mr. Jorck's client and of particularly fine form and solid workmanship. They vary in important respects from the specimens we have and would form a valuable addition to the very small collection of Scandinavian plate in the Museum. It would also be interesting if possible to add to the series one of the small round handleless cups ('tumling'). No. 116 (£1 6s 6d) is an old and good example with the characteristic Swedish wavy moulding round the lip.' Mr Jorck's client was probably the antique dealer Josef Nachemsohn, of 31 Østergade, Copenhagen, whose name appears in later papers. Not everything was bought, but a tankard and five beakers were selected; after purchase two of the beakers were sent to the Dublin Museum.

In March Jorck offered more, and this time quite a number of purchases were made, including a fine Swedish tankard (765–1904) and the 'Lapland wedding-cup

brought by Mr Jorck from Denmark'. Mitchell minuted: 'A few of the best of the fine old Swedish silver beakers are included, picked out from something like two hundred specimens. Mr Jorck tells me large numbers are being sold to the American museums; it is pretty clear that the country districts of Sweden are being denuded rapidly and it might be well to make our gaps complete while there is this opportunity...The Swedish tankard No. 2 (765–1904) is beautifully made and engraved and in excellent condition; the price is not extravagant for such a specimen and it would provide the Museum with what it has not got at present, a really first-rate example of the kind. The Lapland wedding-cup seems to me a good and simple piece...' W. W. Watts, Keeper of the Department, supported this plea for purchase. 'Until comparatively recently our collection of Swedish silversmiths' work was very poor and although we now possess several beakers of similar form to those now offered, I think we should do well to take advantage of this collection; the beakers are extremely valuable for Circulation purposes and are sought after by such places as Birmingham and Sheffield.' This policy of purchase for circulation to provincial museums must be remembered if the Museum now seems to have rather an oddly large collection of Scandinavian beakers.

During the following years Jorck continued to offer, though in much diminished quantity, and the Museum to buy, except that Watts now began to lay a restraining hand on Mitchell's enthusiasm for beakers—indeed it was not until 1909 that another was purchased from Jorck.

That interesting character Marius Hammer (1847–1927) of Bergen first enters the Museum records in November 1898, when he sent in his card with a note 'I have brought over something which I think the Museum would buy....' The something was a sample of his enamelled wares, mostly spoons (see No. 76). Hammer had begun life as an antiquary and dealer, and, having formed a large collection of Scandinavian silver, was inspired to turn goldsmith in 1871. So at least the *rapporteurs* of the International Jury at the Paris Exhibition of 1900, but the truth must be that Hammer conducted his business as a goldsmith and as a dealer simultaneously, for he became a master goldsmith in Bergen in 1871. Certainly some of his goldsmith's work was inspired by the traditional Norwegian silver in which he dealt. His silver in both Art Nouveau style and the Nordic styles of the past was very popular with visitors to Norway. Over the years he mechanized his workshop and his firm was the most important of its day in Western Norway. Hammer next crossed the Museum's path in 1910, as a dealer. During a late summer visit to Bergen in 1910 the Director of the Museum, Sir Cecil Harcourt Smith, saw Hammer's stock of old silver. 'I arranged with him that he was to send us *photographs* of a selection of his more important things with a view to our advising him whether

any would be worth submitting on approval. Instead of this he has taken the inconvenient course of sending some objects and is bringing others.' But to Hammer's enterprise in making trips abroad—in October that year he was staying in Berlin 'selling my enamelled things to the high class jewellers here'—the collection owes its most beautiful piece of Norwegian silver (No. 35). In all the Museum spent nearly £400 on the pieces he brought, the Director urging that 'considering the increasing rarity of objects of this character and their high artistic interest, the prices asked appear to be extremely reasonable'. In 1913 Hammer offered the Museum a tankard of 1632 by Hinrich Meyer (now in the National Museum of Wales, Cardiff) with a note that it came from 'the Osteraf (Island) near Bergen' for £100; but when it was declined—the Museum's grant being already heavily committed—he offered no more.

The Museum's very different attitude towards eighteenth and early nineteenth century Scandinavian plate in international styles was plainly expressed in a minute by Watts of 29 August 1910, rejecting a Copenhagen fruit-stand of c. 1820. He remarked that it was 'probably imitated from the fine work of an earlier period produced in England and France. It lacks the finish of this work, especially as regards the piercing, and being of the nature of an imitation it loses much interest to our Museum'. By contrast some pieces of contemporary Norwegian enamel work and a group of four fine Danish silver bowls and beakers designed by the famous designer Thorvald Bindesbøll were acquired from 1893 to 1900, as part of the Museum's policy of keeping English art-students and craftsmen abreast of what was most novel and interesting in contemporary design and technique. Its scarcity accounts for the absence of any Scandinavian church plate in the Museum's collections. The one exception, an early thirteenth century chalice from Grundt church, Iceland, is catalogued, not here, but in my forthcoming catalogue of medieval church plate, because of the problems of attribution it raises.

Not very many pieces have since been added to this Edwardian foundation and so the strengths and weaknesses of the collection are very much those to be expected of the enthusiasms and prejudices of the early years of this century in the matter of foreign silver. For the period up to c. 1750 the collection is a remarkable and important one. To cite some exceptional pieces, from Denmark come the earliest dated small Danish beaker of the Renaissance (No. 1), made by one of Christian IV's goldsmiths, and a magnificent display dish of c. 1680 (No. 5), among the finest surviving pieces of Danish Baroque silver. From Norway, the most sparsely populated of all the Scandinavian countries from the Renaissance until comparatively recent times, we have a fifteenth century drinking horn (No. 29) mounted in copper-gilt, but included in this catalogue because of its interest as a type, a fine Bergen peg-

tankard of 1652, the beautiful late seventeenth century Baroque tankard from Drammen, made for an important Norwegian ironmaster (No. 35) and a very rare Bergen brandy-bowl from the second half of the seventeenth century (No. 33). The Swedish collection contains no Renaissance vessels – though it does include two fine Late Renaissance spoons – but a serpentine tankard mounted in silver gilt of 1643 (No. 77) has fascinating historical associations with Caroline England and there is a splendid series of tankards from the Baroque period. The interest of the later pieces from all three countries is more unequal. The sole good piece of silver in one of the international styles of the eighteenth century is the handsome neo-classical Karlstad sugar-basin (No. 99), though this is not surprising when Watts' views on Scandinavian silver of this kind are considered. Of typically Scandinavian pieces there is a large array of Swedish beakers – the reasons for their presence have already been explained – some finer than others, but all certainly illustrating fairly fully both the influence of international styles on the design and ornament of such objects and the various decorative techniques used on them. The Norwegian pieces range from burgher plate like the stately if rather stiff Bergen welcome cup of c. 1745 (No. 38), which in spite of its inertness is important as an example of a rare type, and the delightful Bergen wager-cup of 1794 (No. 41), to beakers which belong to folk art, and are none the less charming for that. There is also a small but interesting collection of silver made for the Lapps (see the section on Lapland and the references there to other pieces of Lapp silver made in Sweden and Norway catalogued under those countries). From Finland come only four pieces, which extend the Museum's representation of the goldsmith's art round the northern and eastern shores of the Baltic. Also included in the catalogue are six pieces, four of notable quality, made in Riga – all that the Museum holds from a region so closely linked with Sweden during the seventeenth and eighteenth centuries.

SOME NOTES ON TYPES OF PLATE

As with other Western European countries, not a great deal of secular plate survives from the Scandinavian Middle Ages. The most characteristic type known in any numbers is the drinking-horn. Once universal in Western Europe during the Dark Ages, after the eleventh century it survived purely as a traditional ceremonial vessel elsewhere than in Scandinavia. A number of fine silver-mounted or copper-mounted drinking-horns from Denmark, Iceland and Norway can be seen in the National Museum, Copenhagen, and in other Scandinavian collections.

DENMARK

Most of the plate that does survive in Denmark from the sixteenth and even from the seventeenth century consists of drinking vessels, mostly beakers and tankards, testifying to that Nordic passion for deep potations at long banquets which terrified foreign visitors and infuriated the great dramatist Holberg at the beginning of the eighteenth century. In contrast with Germany and England, only a few standing cups survive. As in other countries plate was made partly for display and partly for use: an engraving of the banquet given by King Frederik III at Frederiksborg Castle in 1658 to King Charles Gustavus of Sweden shows cups, vases and basins of plate arranged on a royal five-decker sideboard. We have some information about quantities of plate in the Renaissance. An inventory of 1523 lists the plate belonging to King Christian II: it consists of rather more than fifty pieces – about the same amount that a great French nobleman of the same period would have possessed. By the end of the century many Danish noblemen and merchants owned plate – some fine jugs and flasks have survived because they were presented to churches for use in the Reformed service – and even a Danish peasant generally owned one silver cup. Like many princes of the late mannerist period, especially in Germany, the Danish kings nursed the ambition to create a Schatzkammer (Danish, *Skattekammer*) or treasure-chamber of costly works in precious metals and hard-stones, executed or decorated with the aid of rare and virtuoso techniques. Christian IV (c. 1577, ruled 1588–1648), the most remarkable of seventeenth century Danish kings, gave the lead to his successors, and a number of rich and elaborate pieces made for him by his court goldsmith Corvinianus Sauer still survive.

This taste for magnificence was shared by the subjects of the Danish kings, so

far as their corporate or individual means allowed. As in Germany guilds owned ceremonial plate, often of some elaborateness; indeed, in Scandinavia as in Germany the great covered cup became typical of guild ceremonial plate. According to Lord Molesworth, writing in 1692 of Denmark before the introduction of absolute rule in 1660 (Molesworth was a violent Whig!): 'Within Man's Memory the Peasants lived very happily; there was scarce any Family of them that was not Owner of a large Piece of Plate or two, besides Silver Spoons, Gold Rings, and other odd knacks, which they are fond of to this Day (and whenever they have any Money, will lay it out in such like things, because they dare not trust themselves with the Keeping of Money, the Inclination to spend it presently is so general): but now it is a great Rarity to find in a Boor's house any thing made of Silver, or indeed any other Utensil of Value, unless it be Feather-beds...' The treasures buried before the advance of Swedish armies in the devastating wars of the first half of the seventeenth century and since rediscovered bear out what Molesworth says.

The custom of passing round great tankards of beer or sometimes wine for all the guests to drink a toast led to the introduction in the seventeenth century of the peg-tankard, in which the pegs mark the draught to be taken by each guest. Even more popular than the tankard was the beaker. Lord Molesworth records in 1692 of the table of King Christian V that his 'particular Diet, every Day, is a Loin of roasted Veal, and his Drink *Rhenish*-Wine; whereof a Silver Beaker-full stands at every one's Plate, which generally serves for the whole Meal.'[1] Goblets (beakers on feet) were used in the Renaissance, but later went out of use, except in the form of small goblets for drinking brandy or snaps (*schnapps*). The Museum's collection of beakers does not contain any of the hexagonal or octagonal forms typical of seventeenth century Denmark. The two examples of the small beakers on feet whose form was borrowed from Germany during the second half of the seventeenth century are Norwegian, and our only example of the larger type with a cover was made in Riga. But the collection does include a fine Danish two-handled bowl of 1641; Boesen & Bøje[2] suggest that these were used for both eating and drinking. The small shallow oval silver drinking bowls rather loosely known as *skaal* were popular, and also the special boat-shaped sub-type derived from Russia, known as a *krusken* (see the entries for Lapland silver). Popular in Scandinavia were the cups of German derivation often described as *Rømer* (Danish–Norwegian) cups: copied from glass prototypes, they consist of a bowl standing on a tall bossed foot. Unfortunately there are no Scandinavian examples in the Museum collections. The small cups known as *tumling* (English, tumbler cups), which right themselves when placed on their sides, first appear in the Baroque age.

The taste for refined luxury which affected the style of Scandinavian life from

the beginning of the eighteenth century as it had earlier affected the style of life in France, the Netherlands and England led to the creation of new types of silversmith's work such as sugar casters and toilet-boxes. And the introduction of coffee and tea naturally introduced the vessels in which they were served. These were of the same general type as those used in the rest of Europe. Horace Marryat, brother of the novelist Captain Marryat, whose *Residence in Jutland, the Danish Isles and Copenhagen,* published in 1860, is the classic English nineteenth century account of Denmark, seems to have approved of Danish eighteenth and nineteenth century goldsmith's work: 'The silversmiths, though not equal in richness to those of England, are far superior in the solidity and design of their wares to those of France and Germany. In the private houses you meet with much plate of antique design, and to this style of old silver they keep; I have seen candelabras and other articles exposed in their windows, which would not disgrace the silversmiths of our own country.'[3] But it should be said that his praise was exceptional: Danish porcelain alone interested nineteenth century English collectors. Since there are no examples in the collection of Danish silver in metropolitan styles the reader is referred for an account of it to the books listed in the bibliography at the end of this introduction. Tankards and beakers continued to be made at the same time, but more perhaps for traditionally-minded or humbler customers than for the fashionable.

NORWAY

From 1397 until 1814 Norway was joined to Denmark in a political union under the rule of the Danish crown. The most important centres of goldsmithing in the country were the ancient cities of Bergen and Trondheim, on the west coast, and Kristiania (modern Oslo) in the south; in all three there were well established guilds of goldsmiths. The last Norwegian guild to be instituted was that of Kristiansand, in 1785. In Denmark, with its King and small but powerful aristocracy, there was a great range of patronage for goldsmiths: in Norway, which had no king and no great noblemen the patronage of the merchants and wealthy farmers was all-important. Until the eighteenth century Norwegian goldsmiths produced the same types of drinking vessels as those of Denmark, mostly tankards, beakers, *roemer*, two-handled bowls and many spoons. In the eighteenth century there occurred the same extension of types of goldsmith's work as in Denmark, but throughout it Norwegian goldsmiths were quite accustomed to producing silver in international styles for their sophisticated clients and at the same time beakers and spoons of traditional 'Hanseatic' design, patterned on German Late Gothic models, for the rural market. Others specialized in making such silver for the rural market.

Partly this was because goldsmithing was forbidden in the country, and partly be-
cause rural taste was conservative. The form in such traditional pieces is basically
Gothic, but certain elements and the chased and engraved ornament are modern-
ized. The beaker by E. P. M. Rømer of Oslo (No. 40) and that by A. Lude of Bergen
(No. 43) are examples of 'Hanseatic' beakers produced in the shops of goldsmiths
who also made silver in international styles. The same situation prevailed in
Sweden. Towards the end of the century the Lapps favoured silver in traditional
taste, and the trade with them no doubt contributed to the survival of early forms
into the nineteenth century. The co-existence of such disparate styles seems strange
to English eyes, but was not without its parallels in eighteenth century Germany.
On the whole, compared with Denmark, there was a smaller range of designs, and
a certain provincial simplification or elaborateness of decoration. Most surviving
Renaissance silver is from Western Norway and Bergen retained a pre-eminence,
though not an exclusive pre-eminence, into the nineteenth century. Much silver
was produced for the wealthier peasantry in the late eighteenth and early nine-
teenth century. In 1834 the Scottish economist Samuel Laing noted of Levanger
on the Trondheim fjord 'In so remote a small town, I was surprised to find two
working silversmiths. The small proprietors are fond of possessing plate, as silver
spoons and tankards, or jugs, for ale, having the heads or covers, and often the
whole, of silver'.[4]

SWEDEN

In Sweden the political and economic conditions of the sixteenth and early seven-
teenth centuries were not very favourable to goldsmith's work, though there is
evidence from 1568 that peasants were already collecting silver spoons as a form of
capital. It was the country's dramatic rise under Gustavus Adolphus to the position
of great European power which she held until the death of King Charles XII (1718)
that produced a blossoming of the craft in the middle and second half of the seven-
teenth century. In the 'fair brick house' which Queen Christina provided in Upsala
for the entertainment of the English ambassador Bulstrode Whitelocke in Decem-
ber 1653, the dining-hall had 'a cupboard of the Queen's plate richly gilt, with
other large silver vessels'. At a dinner given to Whitelocke by Count Eric Oxen-
stierna, second son of the great Chancellor, on 10 April 1654, 'a huge massy basin
and ewer of silver gilt was brought for them to wash—Some of the good booties
met with in Germany...The dishes were all silver, not great, but many, set one
upon another, and filled with the best meat and most variety that the country did
afford; and indeed the entertainment was very noble.'[5] Not all plate in Sweden was

booty: large numbers of German goldsmiths flocked to Sweden in the 1650s and for many years the minutes of the Stockholm guild were actually kept in German. During the early decades of Sweden's greatness in particular, Swedish tankards reproduce a number of German designs which are not found elsewhere in Scandinavia, and so have something of the same variety as the plate made in Germany itself. And certain other German types of plate were copied only in Sweden. But in Sweden as in her two sister countries plate was also made to designs which had become Scandinavianized, and vessels of the simpler patterns current in Denmark and Norway were also made there. At the end of the seventeenth century the Swedish court began the first of that succession of attempts to import French styles direct from Paris which became characteristic of Swedish royal patronage during the eighteenth century. Through the agency of the architect Nicodemus Tessin the Younger, drawings of French goldsmith's work were obtained and a French goldsmith, Jean François Cousinet, taken into the employment of the Court. Some elaborate pieces survive from the seventeenth century: quite a number of basins for display on the sideboard as well as richly decorated tankards, beakers and bowls. Richness is in fact a striking characteristic of earlier Swedish silver in comparison with Danish and Norwegian. That most remarkable and enchanting of seventeenth century travellers in Scandinavia, the 'Italo-Gothic' priest Francesco Negri (1623–98) of Ravenna has left in his *Viaggio Settentrionale* some incidental observations on the silver he saw during his residence in Sweden from 1663 to 1666. Of the wealthier Swedish peasants he writes that they were rather well-off for possessions compared with the Emilian and Romagnole peasantry he knew. 'In their houses especially they have silver plate, small spoons, little bowls (*scudellini*) for brandy, or else beakers of the same metal of ordinary size for the same liquid, and for beer some large beakers, and also vases of silver containing one or two *boccali* of measure. They do not give knives and forks to their guests, because there it is the custom for everyone to carry them with him in a sheath in his bag.' Except for the silver jugs, the types of vessel Negri describes can easily be recognized on looking through the Swedish section of this catalogue. Of the plate of the great he says little or nothing, probably because he saw nothing exceptional in their possessing it, but he does incidentally mention that, for preaching the funeral sermon of a great man, a Lutheran bishop might receive a present of spoons and forks of solid gold.

The pieces in the collection from the later period are all of traditional form; with the exception of the Karlstad sugar-basin already mentioned, metropolitan styles and such fashionable articles as candlesticks, toilet-boxes, vessels for tea or coffee and the like are not represented in the Museum. For these the reader should

consult the books listed in the bibliography. But the eighteenth century pieces in traditional style are far from being all peasant or country pieces: only those decorated predominantly in the wrigglework technique were produced for such customers.

[1] Molesworth, *An Account of Denmark, As it was in the Year 1692*, 4th ed., 1738, pp. 56, 99.
[2] *Old Danish Silver*, p. 18.
[3] i, p. 206.
[4] S. Laing, *Journal of a Residence in Norway during the years 1834, 1835, & 1836*, ed. of 1851, p. 61.
[5] B. Whitelocke, *A Journal of the Swedish Embassy in the Years 1653 and 1654*, ed. H. Reeve, London, 1855, i, pp. 219–24, ii, pp. 114–15.

SOME NOTES ON STYLE

The styles of Scandinavian silver cannot be studied in isolation from those of the rest of the Baltic and North Sea region of which Scandinavia is a part. The types of vessels and decoration used in the three Nordic lands were largely copies or variants from types of vessels and decoration which were invented in Germany and spread from there to all the Baltic lands. Their diffusion was promoted by the guild system with its insistence on the *Wanderjahr* as well as by the migration of German goldsmiths—and in some cases of German clients. The long German pre-dominance was certainly owing to the strength of design and high quality of craftsmanship for which German goldsmith's work has always been remarkable; originally, too, no doubt it was fostered by the commercial domination of the Hanseatic League over all the lands of the Baltic, a domination that lasted from the later Middle Ages into the Renaissance. In the mid sixteenth century Bergen, for example, before the expulsion of the Hanse in the 1550s, the goldsmiths were still divided into German craftsmen, protected by the Hanse and living on one side of the harbour under their own guild organization, while Norwegian craftsmen lived scattered about the town and had no guild. The tall tankards, with tapering cylindrical body, which are the most magnificent and richly decorated vessels to survive from Renaissance Scandinavia, originated in North Germany—where they are still sometimes called *Hansekanne*—and were copied in all the Baltic lands. So too were the small beakers decorated with an ornamental band, sometimes hung with rings and sometimes standing on feet, which became very popular in Scandin-avia and were still being produced there in the late eighteenth century.

As might be expected, the ornament of sixteenth and early seventeenth century Scandinavian plate was derived from Germany, with some admixture of Nether-landish influence, explained by the great circulation from the middle of the six-teenth century onwards of engraved designs. Moresques, strapwork, grotesques, the international vocabulary in fact of Renaissance art, appear on Scandinavian plate, mostly in a fairly simple guise. One feature that is sometimes as misleading to modern collectors as it was to the early authorities of the Museum is the late sur-vival of Late Gothic shapes and decorative motifs. These persisted in Scandinavia long after they had gone out in Germany: beakers of tapering form, decorative bands of dry branches, spoon-knops composed of stylized Gothic leaves. It is the accident of this time-lag which gives individuality to certain kinds of Scandinavian silver. During the late sixteenth and the first half of the seventeenth century the

smaller tankards which had come into vogue in Germany during the late Renaissance largely ousted the tall *Hansekanne*. In form they were a reduced or truncated version of the tall tankard, with a broader, though still comparatively narrow body resting either on a domed foot or on a domed foot raised on three supporting feet of inventive design, lions, for example, or lion heads. In the middle of the century the elements from which the Baroque tankard developed make their appearance: broad bodies, lids treated as a continuous form with the body, pomegranate feet with matching pomegranate thumb-piece. In tankards raised on feet there was now no domed foot: the body is conceived as a single cylindrical form. Aesthetically the second half of the seventeenth and the early years of the eighteenth century were the most original and brilliant period of Scandinavian silver. For tankards a design was evolved which is perhaps the most perfectly satisfactory of all designs ever produced for this vessel, which presents such difficult problems of composition with its requirements of great volume, separate lid, projecting thumb-piece and protruding handle. The diameter of the broad body was now made to correspond nearly or wholly to its height. The rounded and domed lid was marked off by the slightest of mouldings or by an elegant Baroque bulge. Three ball or lion feet raised the tankard majestically from the wood beneath and contribute rich sculptural motifs. If ball-shaped, the feet were usually given the form of bursting pomegranates or bunches of fruit, cast in two-piece moulds. To maintain congruity the thumb-piece was given the same form as the feet, and the handle, a bold and sturdy Baroque scroll, was skilfully harmonized with the body by being made to curve out between the thumb-piece directly above and one of the three ball-feet immediately below. Tankards were also sometimes decorated in the German manner with rich pictorial or decorative embossing. In those with plain bodies additional sculptural relief was introduced by the device of embossing a motif or applying cast plaques on the body above the feet; gilt and richly ornamented, the plaques provided a most effective contrast of relief and surface, while the embossed motifs initiated the first impulse of movement from the plain cylindrical form into the protruding sculptural forms of the feet. Swedish Baroque tankards of this design were not only more solid in form, but more lavish in weight than their predecessors. But it must be emphasized that tankards of the old late Mannerist proportions, with relatively narrow bodies, continued to be made, especially in Denmark and Norway, right up to the end of the Baroque period. The low broad tankards with plain body of abstract cylindrical shape have exceptionally pure lines for baroque objects produced outside the orbit of French classicism: their severity of form, elegantly relieved by the richness and gilding of the feet and thumb-piece, appeals strongly to modern taste.

Parcel-gilding, usually of the feet and plaques and of a band round the rim provided a most effective means of decorating tankards. But the ornamental repertoire of the Scandinavian goldsmiths had also been greatly enriched in the middle of the seventeenth century by a new Baroque style which they exploited with incomparable vividness and vigour. This was the Floral Baroque, one of the most beautiful of decorative styles, typical of the Baroque passion for flowers, for naturalism and for movement. It was invented in Germany in the 1640s, such designers as Johannes Thünkel and Johannes Reuthman playing an important part in its development. It consists of leafy sprays set with heavy flowers, carnations, lilies, tulips, roses. The stem is a motif that lends itself to plastic freedom—it can be bent into a formal wreath, or can scroll and wave and burst across a surface. The style is equally decorative in embossing—some Scandinavian tankards have bodies and lids embossed all over with Floral Baroque ornament—or engraving. At the end of the century it lost something of its picturesque variety, and the scrolling stem became a classical acanthus, again under the influence of German designers, themselves influenced by French Baroque classicism. And the attempt to replace the Floral Baroque with the new Bérainesque scroll-work was aesthetically a misfortune. For at the beginning of the eighteenth century the influence of French design made itself felt in the shapes of sophisticated silver and even more universally in decoration. The ornamental style of Bérain, with its light, crisp, flying scroll-work, was especially influential, for his style was mediated through Augsburg goldsmith's work and Dutch designers like Daniel Marot. One of the characteristic features of late Louis XIV goldsmith's work, the setting of ornament on a slightly sunk matted ground, was extensively copied in Scandinavia, but after German imitations of Parisian originals. Again the custom of spending the *Wanderjahr* in Germany or the Netherlands explains in part the transmission of influences from these countries.

This version of Louis XIV ornament persisted until 1740–50, when Rococo began to irrupt into its monopoly. Except for the feet of one or two beakers, the collection includes no example of the characteristic and very individual Scandinavian fluted forms devised in this style, but it does include a number of objects with fluted bases or decorated with simplified Rococo motifs—usually straightforward *rocaille*. Many beakers until the end of the eighteenth century are decorated with folk versions of both Louis XIV and rocaille or even earlier motifs, such as the two entwined sprays enclosing initials that first came into vogue in Europe in the 1630s. These are often executed in wrigglework. Also nearer to folk than to metropolitan art are the beakers chased with floral designs. Neo-Classicism was introduced from France, England and Germany in the 1770s and 1780s; the transformation of its motifs, notably the medallion and swag, into folk or near-folk ornament can be

seen on some of the objects from the 1790s and 1800s in the Museum collection.

The Museum has a good representation of Scandinavian spoons from 1500 to 1750. Indications of the date-range of each type have been included where this was felt to be useful. As a general rule short-stemmed spoons were replaced by long stems in the early seventeenth century, and the pear-shaped bowl by the oval bowl in the early eighteenth century. But the same conservatism that preserved the dragon-head junction of bowl and stem for more than two centuries after it had disappeared elsewhere in Europe kept old patterns in vogue in rural districts and small towns and in the goldsmiths' shops of larger places when working for the country market.

The attribution of unmarked Scandinavian spoons to precise areas or dates is fraught with difficulties. Spoons of the same or similar type were current in Denmark, Norway and Sweden—the three southern or Scanian provinces of modern Sweden belonged to Denmark until 1660—and only a few patterns or motifs seem to have been truly regional. Moreover, a number of widely differing designs were current simultaneously, traditional forms, as we have just noted, though becoming more and more stylized and in the eighteenth century thin and degenerate, flourishing alongside spoons made in European metropolitan styles and alongside others, perhaps the most frequent of all, which combined elements from the old and the new. Many designs seem to have had a long life, since they often tended to remain in favour with country customers when more modern patterns had come into vogue with the townsfolk of larger and more sophisticated places. But, if the variety and longevity of their designs makes Scandinavian spoons hard to date and to place, they are also two of their greatest attractions. In the case of the Museum's collection there is the additional difficulty that although so many spoons were obtained directly from Scandinavian sources, the attributions with which they were sold have not proved to be reliable—Nos. 112 and 113, for example, acquired as Danish, proved on investigation to be Swedish. Except in one or two cases, therefore, original attributions have been recorded but not taken as a guide.

SELECTED BIBLIOGRAPHY OF SCANDINAVIAN AND BALTIC SILVER
under countries, in order of publication

DENMARK

General

J. Olrik	*Drikkehorn og Sølvtøj fra Middelalder og Renais-sance...af Nationalmuseets anden afdeling*, Copen-hagen, 1909. An important catalogue of the collec-tions of the Nationalmuseet, Copenhagen. With very brief and inadequate summary in French.
J. Olrik	*Danske Sølvarbejder fra Renaissancen til Vore Dage. Katalog over den Historiske Afdeling af Københavns Guldsmedelavs Jubilaeumsudstilling MCMX*, Copenhagen, 1915. An important catalogue of an exhibition of Danish silver held in 1910.
A. Sølver	*Danske Guldsmede og deres Arbejder gennem 500 Aar (1429–1929)*, Copenhagen, 1929.
G. Boesen and Chr. A. Bøje	*Old Danish Silver*, Copenhagen, 1949. An excellent and very well illustrated survey of Danish secular silver in English. Published in Danish as *Gammelt Dansk Sølv*, Copenhagen, 1948. Concentrates mostly on silver from the beginning of the seventeenth century, but gives much the fullest and best repre-sentation of Danish spoons.
E. Lassen	*Dansk Sølv*, Copenhagen, 1964. Another excellent and well illustrated survey, including church plate, and with more reproductions of early pieces.

Special studies

H. C. Bering Liisberg	*Christian den Fjerde og Guldsmedene*, Copenhagen, 1929. A study of King Christian IV, his goldsmiths, and the goldsmith's works he owned.
A. Fabritius	*Fabritius Sølv og Guld: Mestre og svende, Recepter og arbejder*, Copenhagen, 1958. A study of a famous family of goldsmiths and assay masters of eighteenth and early nineteenth century Copenhagen. On pp. 29–33 their marks are reproduced.

Marks

Chr. A. Bøje	The standard work on Danish marks is *Danske Guld og Sølv Smedemaerker før 1870*, Copenhagen, 1946. As its title indicates, it ends in 1870.

A supplement to Bøje's book was published in 1949. The marks listed in this are included in their correct places in B. Bramsen's new edition of Bøje published by Politikens Forlag, Copenhagen, in 1954 (3rd ed., 1969). This new edition is handy for the English student and collector because it includes summaries in English and contains a series of drawings after dated pieces of standard types of Danish silver.

L. Grün	Marks after 1870 are included in *Danske Guld–og Sølvsmedes Stempler og Maerker indtil 1943*, Copenhagen, 1943.

See also A. Fabritius, under special studies above.

NORWAY

General

Th. Kielland	*Norsk Guldsmedkunst i middelalderen*, Oslo, 1927. A comprehensive survey of Norwegian mediaeval gold-smith's work up to the early sixteenth century.
A. Polak	*Gullsmedkunsten i Norge før og nå*, Oslo, 1970. The only complete survey of the subject, with full bibliography and English summary. It has now appeared in English as *Norwegian Silver*, Dreyers Forlag, Oslo, 1972.

Special studies including marks

Unlike Denmark and Sweden, Norway has no large comprehensive work on its goldsmith's marks. For Norwegian marks in general the only work is still
Kristiania (Oslo), Kunstindustrimuseum, *Gammel Guldsmedekunst i Arbeider fra 15. til 19. Aarhundrede*, Kristiania, 1909.
This is an exhibition catalogue, followed by what is still the fullest general list of Norwegian marks, though now superseded for certain towns and districts (see below).
See also STAVANGER below.

BERGEN

Thv. Krohn-Hansen and R. Kloster

Bergens Gullsmedkunst fra Laugstiden, 2 vols., Bergen, 1957. A complete survey of goldsmith's work in Bergen, the most important centre of the craft in Norway, from 1568 until the early nineteenth century. Contains a full history of styles, of the guild and of makers, with marks and an excellent English summary.

The exhibition catalogue Bergen, Vestlandske Kunstindustrimuseum, *Bergens Gullsmedlaug i 400 år 1568–1968* contains among other things illustrations and information about makers and their works of the later nineteenth century and modern period.

KRISTIANIA (OSLO)

H. Grevenor and Th. B. Kielland

Guldsmedhaandverket i Oslo og Kristiania, Kristiania, 1924. A long and well illustrated account of goldsmith's work in Oslo, with a list of marks on pp. 387–91.

KRISTIANSAND and the region of SØRLANDET

(Arendal, Mandal, Kvinesdal, Øyestad, Tvedestrand)

'*Gammelt Sølv i Privat Eie på Sørlandet*'. Catalogue of an exhibition held in Kristiansand 14–23 June 1963. With an appendix of marks.

OSLO see KRISTIANIA

STAVANGER

Th. Kielland and H. Gjessing

Gammelt Sølv i Stavanger Amt: Katalog over Stavanger Museums Sølvutstilling 1916 og de Stavangerske Guldsmeders Historie, Stavanger, 1918. A commemorative volume of an exhibition held at Stavanger in 1916 of Norwegian goldsmith's work, with a history of the goldsmiths of Stavanger and an illustrated catalogue of the exhibition. Contains a long list of Stavanger marks, and also reproduces the marks of goldsmiths from Arendal, Bergen, Brevig, Drammen, Flekkefjord, Fredrikshald, Kristiania, Kristiansand, Larvik, Mandal, Skien, Trondheim and of unidentified makers. The list also includes one or two town marks.

TRONDHEIM

Thv. Krohn-Hansen

Trondhjems Gullsmedkunst 1550–1850, Oslo-Bergen, 1963. A full study with a full list of marks.

SWEDEN

General

O. Kallström and C. Hernmarck	*Svenskt Silversmide 1520–1850*, 3 vols., Stockholm, 1941–46. A monumental work which is a full survey of the history of Swedish silver during the period covered. With English summary.

An impression of Swedish silver in metropolitan styles can be formed by the English reader from the exhibition catalogue, London, Victoria and Albert Museum, *Swedish Silver 1650–1800*, 1963.

E. Andrén	*Swedish Silver*, New York, 1950. A short history in English of Swedish silver by a recognized authority.

Special studies

E. Fischer	*Västsvenskt Silver och Västsvenska Guldsmeder*, Gothenburg, 1923. Silver in Gothenburg and its district. See also under marks.

Marks

E. Andrén, B. Hellner, C. Hernmarck and K. Holmquist	*Svenskt Silversmide 1520–1850*, Stockholm, 1963. The standard work on Swedish marks, of extraordinary comprehensiveness.

GOTHENBURG

Röhsska Konstslödmuseet	Exhibition catalogue *Gammalt Göteborgssilver*, June–September 1971. Marks and silver are reproduced: the objects reproduced are in metropolitan styles.

LAPP SILVER

P. Fjellström	*Lapskt Silver: Studier över en föremålsgrupp och dess ställning inom lapskt Kulturliv*, 2 vols. in 1 (text vol., followed by volume of catalogue & plates, Stockholm, Gothenburg and Upsala, 1962. With English summary. Includes a list of marks found on silver made for the Lapps not recorded elsewhere (p. 63 of vol. 2).

FINLAND

T. Borg	*Guld-och Silversmeder i Finland. Deras Stämplar och Arbeten 1373–1873*, Helsingfors, 1935. The standard work on Finnish silver and marks.

For Narva and Nyen see over.

L. Bäcksbacka *Narvas och Nyens Guldsmeder*, Helsingfors, 1946
 (with reproductions of marks).

BALTIC LANDS (Esthonia, Latvia, Courland)
Th. Buchholtz *Goldschmiedearbeiten in Livland, Estland und
 Kurland*, Lübeck, 1892. An old work, but still of
 value.

Marks

 The only survey of Baltic marks is still
W. Neumann *Verzeichnis baltischer Goldschmiede, ihrer Merk-
 zeichen und Werke*, Riga, 1905.

NOTE ON THE CATALOGUE AND PLATES

Scandinavian silver frequently bears ownership inscriptions, often of husband and wife, which are dated. In the case of unmarked pieces, or of pieces bearing a maker's mark used during a wide span of years these sometimes provide a means of dating a piece more precisely. But, as inscriptions were often added some years after the making of a piece, and as they were also on occasion erased not very much later to make room for another inscription, it is necessary to be cautious in using them to date a piece. Whenever it seemed that the date of the inscriptions on certain pieces corresponds more or less nearly to the date when they were made or provides a more precise dating than the maker's mark, the piece has been described at the beginning of the catalogue entry as 'dated such and such a year', e.g. TANKARD. Bergen, dated 1652. Whenever the precise year can be established, or is known, the year is given by itself. *Circa* (abbreviated to c.) indicates as usual that the date chosen is an estimate or conjecture within a certain margin.

Because of the difficulty of placing certain Scandinavian pieces, notably spoons, especially those which are not marked, some have had to be entered under a specific country with a caveat. In these cases the choice of country expresses an opinion slightly in favour of its being the object's place of origin, qualified either by a suggested alternative in the heading, e.g. *Danish or Norwegian*, or by a query. Entries are divided by countries, and under countries into plate and spoons. Since the collection includes a large range of spoons of very varied types, this arrangement seemed clearer, simpler and more advantageous to the reader. The entries for spoons made by Scandinavian silversmiths for the Lapp market are included under their respective countries, but the plates which reproduce them have been grouped with the reproductions of Lapp silver in the collection. This has not been done with one or two pieces in the round which may possibly have been made for the Lapps, since it is much less certain that they were made exclusively for the Lapp market. But in the catalogue entry for No. 122 a note has been inserted listing all pieces in the collection certainly or possibly made for the Lapps.

MARKS
Where marks are identified and reproduced in published works, the mark is described, the goldsmith named, and the authority from which the information has been obtained is cited either in the description of the mark or in the catalogue entry. The five or six marks which are unidentified are reproduced. In all cases the position of the marks on the objects has been stated.

ABBREVIATIONS

Bergens Gullsmed	Thv. Krohn-Hansen and R. Kloster, *Bergens Gullsmedkunst fra Laugstiden*, 2 vols., Bergen, 1957. The first volume contains the text, the second the plates.
Bøje	Chr. A. Bøje. *Danske Guld og Sølv Smedemaerker før 1870*, Copenhagen, 1946.
Fjellström, *Lapskt silver*	P. Fjellström, *Lapskt Silver. Studier över en föremålsgrupp och dess ställning inom lapskt Kulturliv*, 2 vols. in 1. 1; Text (with English summary). 2; Catalogue and plates (including some marks). Stockholm, Gothenburg and Upsala, 1962.
Oman, *Scandinavian silver*	C. C. Oman, *Scandinavian Silver*, Victoria and Albert Museum Small Picture Book No. 47, London, 1959.
Sven. Silv.	E. Andrén, B. Hellner, C. Hernmarck and K. Holmquist, *Svenskt Silversmide 1520–1850*, Stockholm, 1963.

Denmark

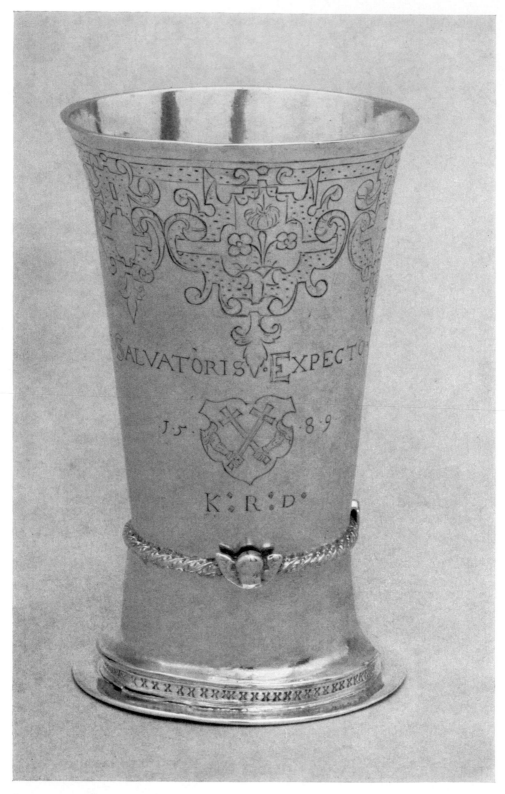

1 BEAKER

Hillerød, dated 1589. The trumpet-shaped body has an everted rim. The rim is left plain: beneath runs a band of six engraved Renaissance cartouches, alternately large and small, the small cartouches enclosing plain shields, the large two sprays of flowers, a bunch of fruit, and a crowned lion (for Norway). The hollow foot has a flanged base with a lozengy moulding (stamped from a repeating die): around the junction of foot and base runs a corded band set with three cherub's heads. Beneath the cartouche-work runs the inscription: EX-PECTO . LAETAM . VICTORIAM . SVB . VEXILLO . SALVATORIS . (*Under the Saviour's standard I await a happy victory*.) Under this is engraved a shaped shield containing *two crosses arranged in saltire and held by two arms issuing from clouds*. On either side of the shield is the date 1589: beneath are the initials K:R:D.

MARKS On the base.
MAKER'S MARK: GB in monogram for Gabriel Brockmüller (Bøje, p. 242, no. 1708). The mark is struck twice.
DIMENSIONS H. 12·4 cm. Diam. (max.) 7·8 cm.
CONDITION Some light scratching and denting.

M.236–1924

PROVENANCE Purchased (£2) from Mrs A. V. Bridge.

This beaker was acquired as Norwegian. Gabriel Brockmüller (for whom see H. C. Bering Liisberg, *Christian den Fjerde og Guldsmedene*, Copenhagen, 1929, pp. 116–18, pl. 2, and Bøje, *loc. cit.*) is mentioned as royal goldsmith for the palace of Frederiksborg in 1585, 1592–1605 and again in 1618–19. The design on the shield may be a coat of arms or alternatively a device. According to G. Boesen and Chr. A. Bøje (*Old Danish Silver*, Copenhagen, 1949, fig. 35) the present beaker is the oldest dated example of its type. The shape is that favoured for beakers in Renaissance Denmark and Norway. (Oman, *Scandinavian Silver*, pl. 3.)

2 BEAKER

Danish, c. 1600. Parcel-gilt. Trumpet-shaped body with flaring gilt rim. The upper part is engraved with a band decorated with hit-and-miss work. Beneath this runs a band of scroll-work forming cartouches enclosing a foliated motif in alternation with pendant stylized plant-motifs. On the front of the body are engraved the initials L.O.S.✳ D.P.D. To the right of this last trio of initials are the letters IS surmounting a cross. On the back are engraved the initials H.J.S./K.N.D. The junction of the base and foot is marked by a corded band, to which are applied three winged cherub heads cast in relief: beneath these is an engraved band decorated with zig-zag ornament. Above this is another band of scroll-work ornament, consisting of triangles alternating with fleur-de-lys and decorated with hit-and-miss ornament. The richly moulded foot begins with a concave moulding, followed by a gilt band of diaper ornament in relief cast from a repeating die. The plain flange is also gilt.

MARKS In the base.

MAKER'S MARK: a device in a shaped shield (Bøje, p. 448, no. 3065). Struck twice.

DIMENSIONS H. 12·9 cm. Diam. (max.) 8·1 cm.

CONDITION Dented, and worn. Gilding worn from round the rim.

Circ.322–1927

PROVENANCE Purchased (£10) from J. Harris, 6 Rumford Street, Liverpool.

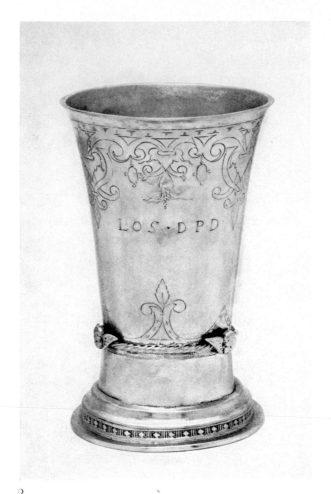

2

Acquired as Norwegian. Bøje (*loc. cit.*) records this mark as struck on a beaker of the beginning of the seventeenth century in a Danish collection. The goldsmith is unidentified. Compare the three beakers of this date in private collections reproduced by G. Boesen and Chr. A. Bøje (*Old Danish Silver*, Copenhagen, 1949) particularly fig. 40.

3 TWO-HANDLED BOWL

Danish, dated 1641. Parcel gilt. The bowl has a sunk everted rim, on the front of which are inscribed the initials H.I.S. M.A.D. . E.I.W., and on the back the initials I.M.S. Beneath the rim runs a plain engraved band within a double border. The bulge of the body below this is decorated with Late Renaissance strap-work. The initials HIS are crudely engraved below this at the back of the bowl. The plain moulded and domed foot is attached by a plate soldered to the base of the bowl, which has a serrated rim bent over inside. The two loop handles are attached to the body by cartouche-shaped plates: one of these is inscribed: ARNE/OLSEN/16*41; the other: MARTE/CHRISTENS/DAATER. The inside of the bowl is gilt.

MARKS None.
DIMENSIONS H. 7·5 cm. Diam. of bowl 11·8 cm. Diam. with handles: 18·6 cm.

CONDITION Body repaired below right handle. Gilding much worn and rubbed.

<div align="right">395–1907</div>

PROVENANCE Purchased (£15 13s 6d) from Messrs S. J. Phillips.

The bowl was acquired as Danish. The original owners were evidently the two persons whose names are inscribed on the cartouche-plates: the other initials are later, more crudely engraved additions. For the general form compare a two-handled bowl dated 1654 by Hermond Jensen of Aalborg reproduced by G. Boesen and Chr. A. Bøje (*Old Danish Silver*, Copenhagen, 1949, fig. 317). Oman (*Scandinavian Silver*, pl. 5).

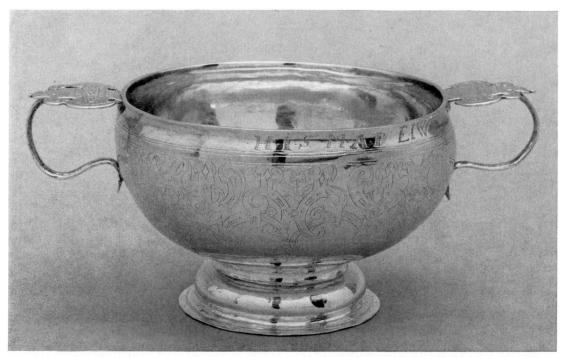

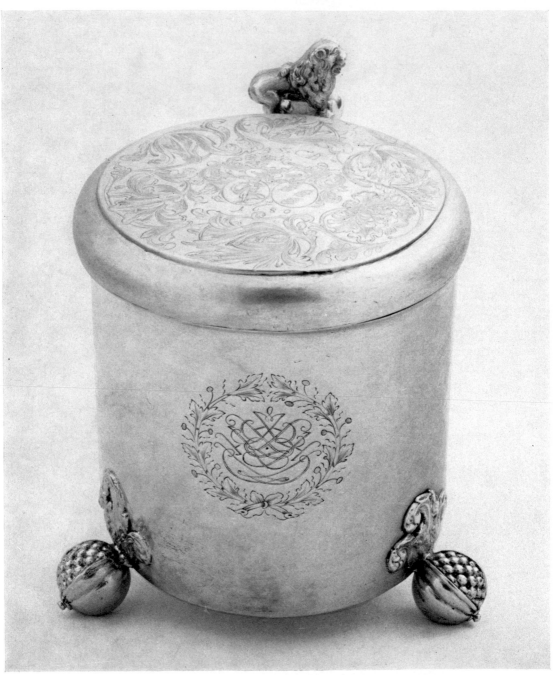

4

4 PEG-TANKARD

Elsinore, c. 1670. The plain cylindrical body is engraved on the front with two sprays of flowers and foliage forming a wreath which encloses the double monogram HBHD(?). The lid is engraved with scrolling sprays of foliage, tulips and roses in the Floral Baroque style encircling two coats of arms (dexter, *Fortune* with a crest of two sprays of flowers; sinister, *3 bees volant*, with a crest of a bird holding a twig). These are surmounted by the initials NBS*CB; beneath is the date 1680. The three feet are cast in two hemispherical sections in the form of bursting pomegranates: above each is a plaque cast in the form of a scrolling plant, applied to the body. The thumb-piece is cast in the form of a lion sejant with its tail curled round its waist. The scroll-handle has a ridge spine down the centre and is decorated at the top with an engraved stylized leaf. To its bottom end is applied a circular medallion with a gentleman and lady in 17th century costume seated in courtship on the left and Cupid on the right aiming his bow at the pair. There is a row of pegs down the inside.

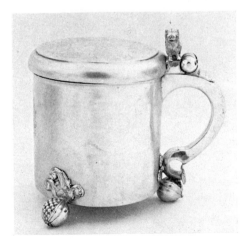

4a

MARK On the base.

MAKER'S MARK: JA in monogram for Joen (Jochum) Andersen of Elsinore (Bøje, p. 236, no. 1663).

DIMENSIONS H. 21 cm. W. 21·8 cm.

CONDITION Base scratched and a crack in it repaired: some light scratching and denting on body. One of the feet reattached by the insertion of a small semicircle in the base. Lid cracked. See also below.

M.479–1910

PROVENANCE Purchased (£60) from Madame Melanie Moller-Le Champion, of Gibbstown, Co. Meath, Ireland (see below).

Andersen, who is first mentioned in 1649, died in 1679. The arms and mantling on the lid are substituted for earlier ones which are still partly visible underneath. The date 1680 has also been substituted for an earlier date, and the initials above are squeezed in asymmetrically to fit the decoration. The tankard must therefore antedate 1680. The general form and the pomegranate feet surmounted by a scrolling plant are found in Denmark at least as early as 1648 (cf. Boesen and Bøje, *Old Danish Silver*, Copenhagen, 1949, fig. 15a) but the rich and freely swirling style of the engraved Floral Baroque decoration suggests a date in the late 1660s or 1670s for this tankard. The arms of 1680 have not been identified. According to the vendor, in a letter of 7 February 1910, the tankard was given in 1680 to a member of her family: in a later note, she stated that it had been 'for many generations in the Von Moller family, Barons von Latendorf'. The arms are not those of von Moller, and the tankard must have come to this family at a later date. Reproduced by Boesen and Bøje (*op. cit.*, fig. 20), who note that thumb-pieces of lion-sejant form are not common in Denmark.

5 DISH

Copenhagen, c. 1680. Silver-gilt. The dish, which is oval, has a broad frame with scalloped outer border and an inner border of egg and tongue. The frame is ornamented with a rich band of flowers and foliage, cast in relief and chased like the rest of the decoration. The centre, made separately, is cast in relief with a pastoral scene in a wooded glade. A shepherdess, holding a crook, listens to the plea of a shepherd, who presses his right hand against his breast and holds an elaborate plumed hat against his side. Two shepherd boys are seen on either side of the couple; the one on the right is hallooing, while the other sits by a tree trunk, piping. Sheep graze in the foreground. In the left background the view opens on to a river or sea-bay, with fantastic towering rocks and a castle on the other side of the water.

MARKS In the centre of the lower inner rim of the frame at the back.

TOWN MARK Copenhagen mark of c. 1680 (Bøje, p. 21).

OTHER MARKS Two illegible marks.

DIMENSIONS 55 cm. × 46 cm.

CONDITION Regilt, probably in the early nineteenth century.

M.49–1963

PROVENANCE Purchased (Messrs S. J. Phillips, £290). On acquisition, before the discovery of the marks, the dish was attributed to Hamburg, an attribution which Dr Manfred Mainz later informed the compiler (verbally) cannot be correct.

Engraved on the upper back frame is the inscription: 'The Bequest of the Right Honorable Sir Henry Watkin Williams Wynn, G.C.H. & K.C.B. to Sir Watkin Williams Wynn, 28th March, 1856'. Sir Henry Watkin Williams Wynn (1783–1856), for whom see the *Dictionary of National Biography*, s.v., was Envoy Extraordinary and Minister Plenipotentiary to Denmark from 1824 to 1853.

The marks are struck on the bend of the rim, and so are now partially indecipherable. However, the visible part of the Copenhagen mark corresponds most nearly to the mark given for 1680 in Bøje (*loc. cit.*). Unfortunately Bøje was not able to collect a complete series of seventeenth century Copenhagen marks, and as the lower part of the mark on the dish, which would have contained the year, is illegible, it is impossible to be certain of its exact date. Yet since there are three marks, it must date from between 1679, when the assay-master's mark was introduced in Copenhagen, and 1685, when a month mark was introduced and added to the other three marks.

It is unfortunate that the maker of this weighty and magnificent dish, one of the finest surviving examples of seventeenth century Danish silver, cannot be identified. He must certainly have been one of the foremost goldsmiths of his day. Clearly too the dish was made for an important aristocratic client. The pastoral scene is presumably derived from a Netherlandish engraving: the border is in the Floral Baroque style.

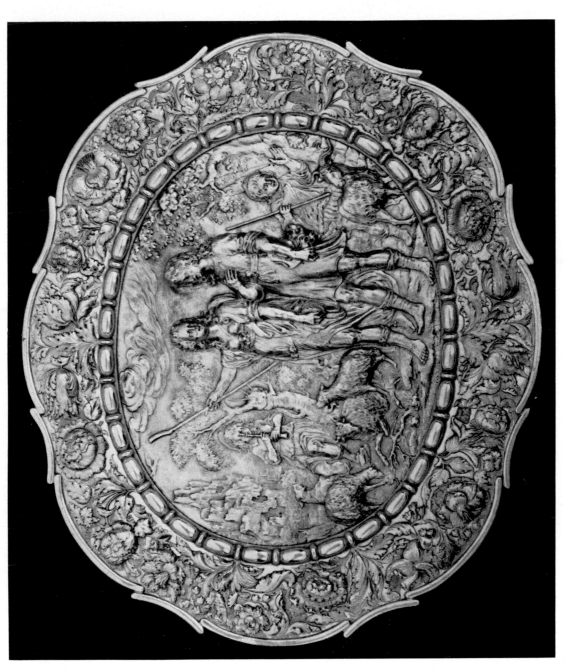

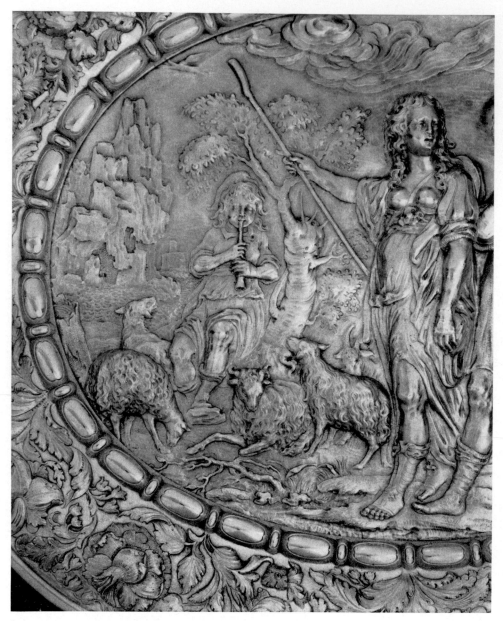

5a

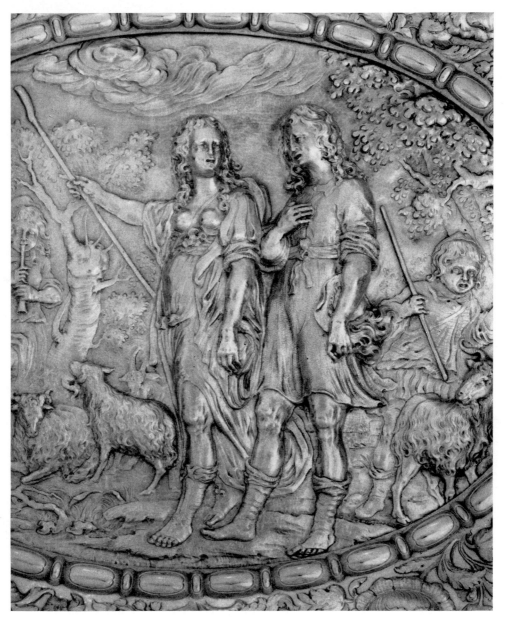

5b

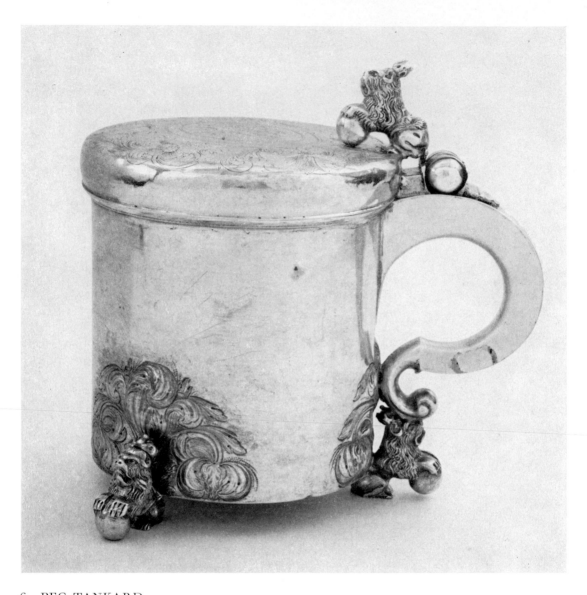

6 PEG-TANKARD

Horsens, dated 1696. The cylindrical body is plain except above the three feet, where it is embossed with a flowering plant motif in the Floral Baroque style. The feet and thumb-piece are in the form of a crowned lion with its fore-paws grasping a ball: they are all cast in two sections and joined vertically down the middle. The slightly domed lid, which is hinged to the handle, is engraved with a plain central medallion containing the initials: H.S.S./M.P.D./ 1696. Around this runs a scrolling band of engraved flowers and foliage also in the Floral Baroque style. The scroll-shaped handle is decorated with a row of bosses. Down the inside of the body runs a vertical row of pegs.

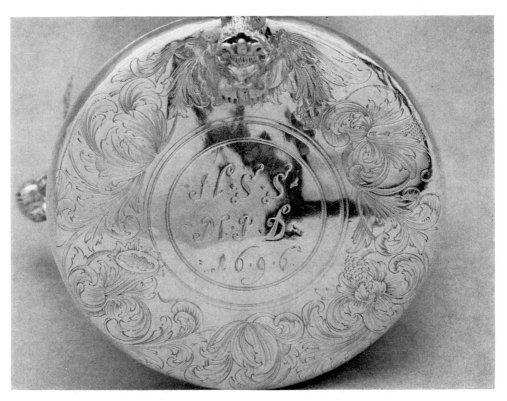

6a

MARKS On the base.

MAKER'S MARK: BC in a circle, for Berent Christoffersen of Horsens (see below). Struck twice.

DIMENSIONS H. (including thumb-piece) 19·2 cm. Diam. of body 12·9 cm.

CONDITION Some scratches on body. A split on the inner edge of the handle. Small patch let in on the handle, which is also repaired at the base.

286–1902

PROVENANCE Purchased (£40) from G. Jorck (probably acting as agent for Josef Nachemsohn of 31 Østergade, Copenhagen).

On acquisition this fine tankard was said to have come from Aarhuus. There is no record of the mark in Bøje, but Erik Lassen kindly informs me that it has been identified as the mark of Berent Christoffersen of Horsens, a town about twenty-five miles south of Aarhuus, formerly an important centre of silversmith's work in Jutland. Christoffersen began working in the 1690s and died in 1747. He is recorded as Berent Christophersen der Weyde in Bøje (p. 257) with a different maker's mark, apparently of 1707. According to Bøje, he was made a borger of Horsens on 13 April 1697. If this information is correct, presumably he used his mark before being registered as a borger, a practice not unknown elsewhere (see the case of Hinrich Meyer in *Bergens Gullsmed*, vol. i, p. 74). Otherwise it has to be assumed that the date on the tankard is retrospective and refers to an event in the life of the couple whose initials appear on it, e.g. there marriage. Alternatively, since the last 6 is of slightly different form from the first, the engraver may have misliterated a figure, e.g. 8.

7 DRINKING BOWL (mazer)

Danish or Norwegian, dated 1725. Birch-wood mounted in silver. The plain round bowl, with bevelled edge, has a slightly concave base, and is painted inside with a design of floral sprays in white, with some touches of black, on an ochre-grey ground. The silver rim, which is nailed to the bowl, has a strawberry leaf border; round it runs the inscription: *Drick Juule Aften Saa, du morgenen ei Glemer, Al du i Herrenshuus, Dit Offer ei Forsömmer C.L.S.1725*. ('So drink on Christmas Eve, that thou forget not in the morning, to make thy offering in the Lord's House.')

MARKS None.
DIMENSIONS W. 11 cm. H. 6 cm.

CONDITION Painted decoration worn away in base: vertical crack in wooden bowl (below H of inscription). Mount dented: slight cracks.

1566–1903

PROVENANCE Purchased (£4) from Fru S. Verdier, Østergade 4, Copenhagen.

The bowl was acquired as Danish: 'The Danish wooden drinking bowl with silver mount is a good and simple piece of work' (report by H. P. Mitchell, 25 November 1903). Although the attribution to Denmark has been maintained in this catalogue, a Norwegian origin is equally likely and is favoured by Erik Lassen.

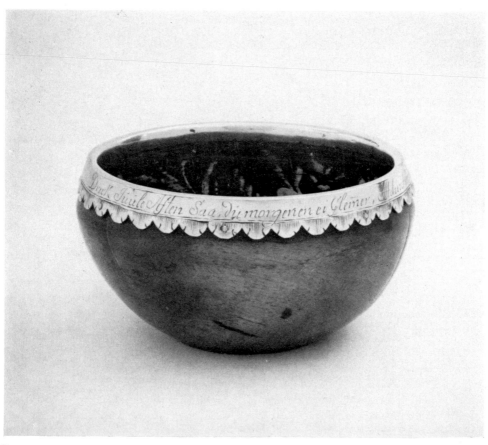

8 CUP

Copenhagen, third quarter of the nineteenth century. Silver, parcel-gilt. The bowl, which is gilt inside, has an everted rim, and is decorated with a band of gilding, below which runs a band of bright-cut ornament, with a zig-zag border above and below. The stem begins with a ball with cut-off top, gilt and decorated in filigree with bosses and rings below a corded edge. Beneath is a button-shaped member decorated on the underside with rosette-studs; under this is a globular knop whose upper half is decorated in filigree with corded rings set with bosses (see condition). The foot, which is entirely gilt, begins with a domed boss, is then decorated with a band of filigree open-work set with small domed bosses alternating with flowers and terminates in a scalloped edging embossed with egg ornament. On the rim of the bowl are engraved the initials P.L.P.

MARK Inside the base.

MAKER'S MARK: CGF for Christopher Glerup Jacobsen, b. 1803, working in Copenhagen from November 1847 until his death in 1880 (Bøje, p. 148, no. 1095).

DIMENSIONS H. 13 cm. Diam. 7·6 cm.

CONDITION Bowl dented; the ornaments, probably of glass, which originally were set in the filigree work decorating the knop, have been removed; holes are pierced in the edging of the foot for attachment to a support. See also below.

1907–1898

PROVENANCE Presented by Col. F. R. Waldo-Sibthorp.

On acquisition the cup was described as a chalice and as Scandinavian, eighteenth or nineteenth century. The foot was then loaded with plaster, and the mark was invisible. In December 1920 Dr H. Dedekam of the Kunstindustrimuseum

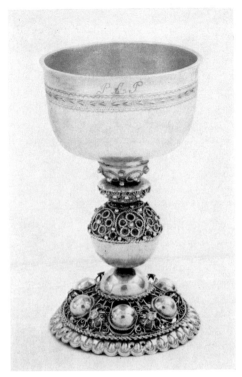

8

in Oslo informed the Department on the basis of a photograph that the cup was not a chalice, and pointed out that it was 'a forgery...composed from the following old elements: a spirit-tumbler (without foot) = the cup, two peasants' silver shirt buttons, a do. large round cuff button and –perhaps–a brooch. You will never find a genuine silver-smith's work constructed as the stem of this cup, with two semi-circular balls soldered together'. It is clear that Dr Dedekam's analysis is correct, and that the cup has been assembled from an early nineteenth century tumbler and the items of peasant costume he lists (the foot is in fact not a brooch but a jacket-clasp, or breast ornament, the globular knop is a hanging button and the ball with a cut-off top is probably another hanging button) to make an ornamental vessel. In all probability Jacobsen's mark applies only to the brooch.

9 BOWL

Copenhagen, c. 1896. Silver, parcel gilt. The bowl rests on four feet cast in a motif of a Japanese fretwork with a cloud motif scrolling among it. This motif is repeated in variant forms in the engraved border round the rim, which forms a series of arches beneath each of which is embossed a floral spray on a punched and matted ground.

MARKS

STANDARD MARK

1. French first standard mark in use from 10 May 1858.

OTHER MARKS

2. A small illegible French mark (? an import mark) on one of the feet.
3. English import mark for 1896–97.
4. JG crowned for Garrard's (see provenance below).

DIMENSIONS H. 8·1 cm. W. (max.) 15·5 cm.

CONDITION Good.

470–1897

PROVENANCE Purchased (£11 4s) from Miss Hanna Hoffmann, 23 St Knudsvei, Copenhagen, per R. and S. Garrard & Co.

Signed under one of the sprays H.H for Hanna Gabrielle Hoffmann (1858–1917). Hanna Hoffmann, a sculptor and silver-chaser, was born on 9 May 1858 at Molde in Norway. She studied painting with Vilhelm Kyhn and O. A. Hermansen, and from 1885 to 1889 attended the Tegne- og Industriskolen for Kvinder (School of Drawing and Industry for Women) in Copenhagen. In 1888 on the recommendation of August Saabye she was admitted to the Academy, where she studied under Th. Stein and became the first woman sculptor to have passed through the Academy. In 1894 she was awarded a travelling scholarship, and from that year until 1905 lived mostly in Paris. Here she executed for Parisian firms the works in silver decorated with *japonoiserie* ornament and stylized floral sprays of which this bowl is an example. The floral sprays are typical of Danish Art Nouveau (see No. 13 below). Later Miss Hoffmann became interested in textiles. In 1912 she studied the technique of dyeing woollen yarn at Mora in Sweden, and later set up a yarn-dyeing establishment at Birkerød, where she died on 26 February 1917 (J.B.H. in *Weilbachs Kunstnerleksikon*, vol. i, 1947, s.v.).

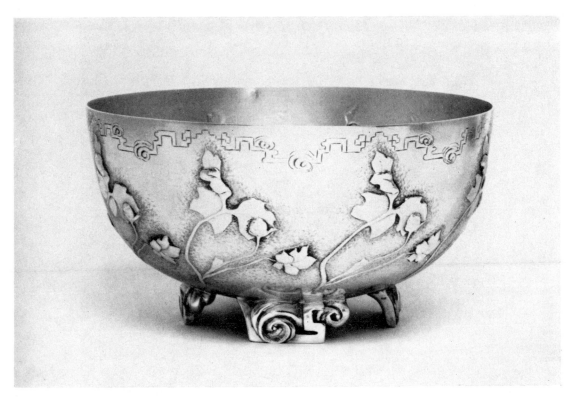

9

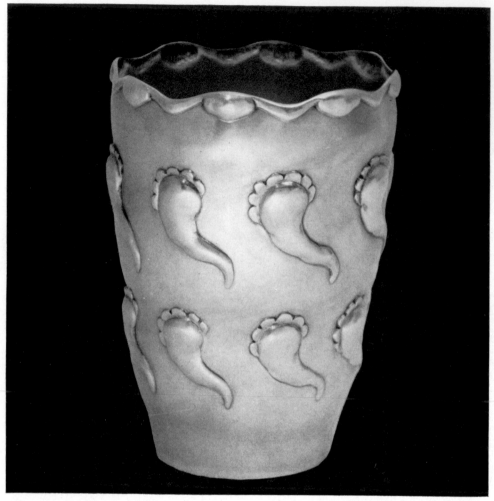

10

10 BEAKER

Copenhagen, 1900. Parcel-gilt. With un-dulating profile, embossed and chased with tongue-like forms resembling sea-anemones. The wavy lip is embossed and chased with cartouche-like forms con-nected by a border of narrow swag-shaped forms. The outside is plain, the inside gilt.

MARKS On the base.
TOWN MARK: Copenhagen for 1900.
MAKER'S MARK: a crown above MICHEL-SEN for A. Michelsen.

WARDEN'S MARK of Sim. Chr. Sch. Groth, warden 1863–1904 (Rosen-berg, 5617).
OTHER MARKS The date stamp 1900 and the stamped initials PM and EL. English import mark.
DIMENSIONS H. 9·5 cm. W. (max.) 7·3 cm.
CONDITION Good.

1612–1900

PROVENANCE Purchased (£5 19s 10d) from A. Michelsen.

See No. 13 below.

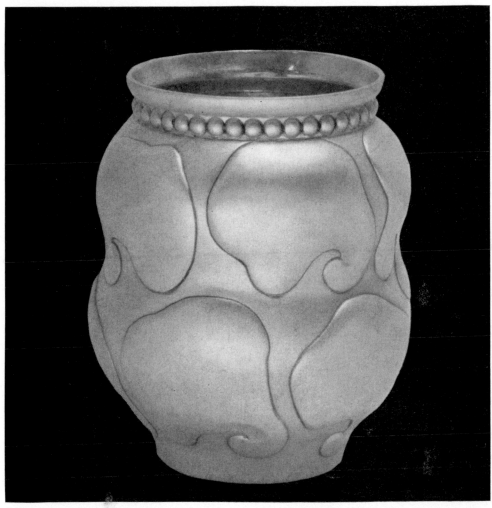

11

11 BEAKER

Copenhagen, 1899. Parcel-gilt. The un-
dulating body is embossed with irregu-
larly shaped cloud-like forms, each with a
curling foot. The neck of the everted rim
(separately cast) is decorated with bead-
ing. The outside is plain, the inside gilt.
Scratched on the base are the numbers
N. 688 and *21/997*.

MARKS On the base.
TOWN MARK Copenhagen mark for 1899.
MAKER'S MARK: AM crowned in an oval
 for A. Michelsen (registered 1893).

WARDEN'S MARK of Sim. Chr. Sch.
 Groth, warden 1863–1904 (Rosen-
 berg, 5617).
OTHER MARKS The date stamp 1899 and
 the initials PM and OM. English im-
 port mark.
DIMENSIONS H. 9·3 cm. W. 8·0 cm.
CONDITION Good.

1613–1900

PROVENANCE Purchased (£7 17s 6d)
 from A. Michelsen.

See No. 13 below.

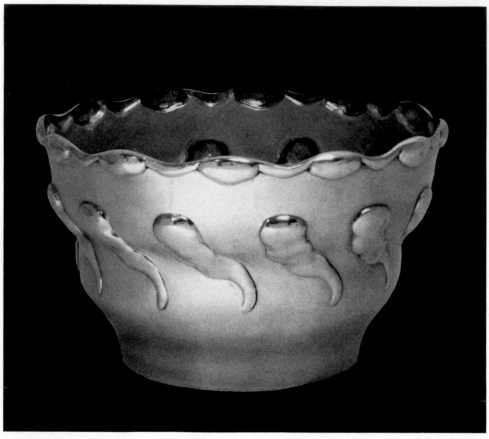

12

12 BOWL

Copenhagen, 1899. Parcel gilt. The profile is of a double curve. The junction of the two curves is decorated with gadroon or tongue-like ornaments embossed and chased in relief and plastically modelled. The wavy lip is embossed with cartouche-like forms connected by a border of narrow swag-shaped forms. The outside is plain, the inside gilt. Scratched on the base is No. 442|48/999.

MARKS On the base.
TOWN MARK of Copenhagen for 1899.
MAKER'S MARK: a crown above MICHELSEN for A. Michelsen.

WARDEN'S MARK of Sim. Chr. Sch. Groth, warden 1863–1904 (Rosenberg, 5617).
OTHER MARKS The date-stamp 1899, and the stamped initials HK and EL. English import mark.
DIMENSIONS H. 7·9 cm. W. (max.) 13·3 cm.
CONDITION Good.

1614–1900
PROVENANCE Purchased (£9 4s 4d) from A. Michelsen

See No. 13 below.

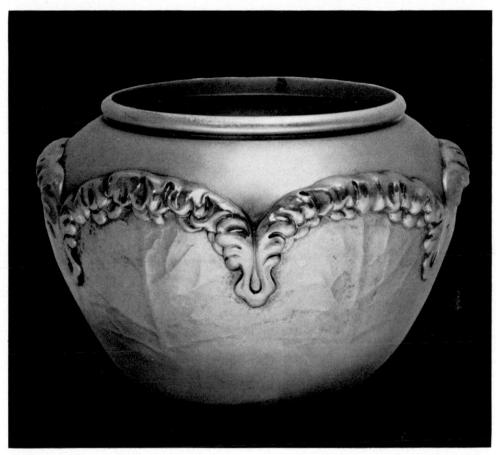

13

13 BOWL

Copenhagen, 1899. Parcel gilt. The curve of the profile is embossed and chased with a continuous pattern of naturalistic cabbage-leaves: each of these motifs curls over at the end to form an arch of forms in high relief. The neck is simply moulded. The outside is plain, the inside gilt.

MARKS On the base.
TOWN MARK of Copenhagen for 1899.
MAKER'S MARK: a crown above MICHEL-SEN for A. Michelsen.

WARDEN'S MARK of Sim. Chr. Sch. Groth, warden 1863–1904 (Rosenberg, 5617).
OTHER MARKS The date-stamp 1899, the initials HK and OM. English import mark. French silver import mark in use from 1893 for countries with customs conventions.
DIMENSIONS H. 10 cm. W. (max.) 15 cm.
CONDITION Good.

1615–1900
PROVENANCE Purchased (£11 19s 10d) from A. Michelsen.

These four pieces of silver, from designs by the celebrated architect and designer Thorvald Bindesbøll (1846–1908), were shown by the great Danish firm of A. Michelsen, jewellers and goldsmiths to the Danish court, at the Paris Exhibition of 1900. The forms are characteristic of Bindesbøll's designs for ceramics and silver in the 1890s and early 1900s. They represent his typically Nordic version of Art Nouveau, with its sturdy heaviness, but the more *japonoiserie* aspect of his art can also be seen in No. 13, with its meticulous rendering of the natural form.

The firm of A. Michelsen was founded in 1841 by Anton (b. 1809, d. 1877), who was appointed Hof- og Ordensjuveler in August 1848 (Bøje, p. 143). The business was taken over on his death in 1877 by his son Carl (1853–1921), who was appointed Hofjuveler in 1880, and Ordensjuveler in 1898, and was a member of the International Jury of the Paris Exhibition of 1900. At first Carl Michelsen's productions were either in traditional Danish style or, in the case of his work for the Danish court, copied from eighteenth century pieces in the Rosenborg collections. He was inspired to change his style and work in a more modern manner by International Exhibitions at which he showed pieces (Malmö, Copenhagen, Chicago) and by the influence of the architect, painter and designer Arnold Emil Krog (1856–1931), who introduced decorative elements, at first influenced by Japanese art, later in a more personal style, into the Royal Copenhagen porcelain factory. Krog's ceramics had a great success when exhibited in Paris in 1889 and greatly influenced Danish goldsmiths. Michelsen's work in the modern styles dates from more or less this time. As the head of the artistic side of his shop he employed the sculptor Niels Georg Henriksen (1855-1922), but he also commissioned designs from Krog, from the painter Harald Slott-Møller (1864–1937) and the sculptor Frederik Hammeleff (1847–1916). Henriksen (for whose views on design see *Tidsskrift for Kunstindustri*, 2 ser., vol. iv, 1898, pp. 130–33) introduced a naturalistic style with an Art Nouveau twist, making much use of floral motifs, into the work of the firm. 'Sous l'inspiration' wrote T.-J. Armand-Calliat and H. Bouilhet, *rapporteurs* of the International Jury of 1900, 'du sculpteur Henrichsen, qui est chargé de la direction artistique de la maison, le décor s'est transformé. Des vases, des coupes, des gobelets ont pris des formes nouvelles dont la simplicité est la caractéristique; par l'emploi d'une seule fleur, ou même par la disposition alterneé d'un seul pétale, l'artiste a su donner naissance à des combinaisons du plus gracieux effet; telles sont les coupes dessinées par M. Bindesboll, dont la base est décorée d'écailles de pomme de pin exécuteés en repoussé, ou des feuilles de trèfle, ou des flots d'où émergent des algues et des poissons, dans une symétrie qui n'exclut pas la liberté d'allure.'

At the 1900 Paris Exhibition Michelsen exhibited a large *surtout*, designed by Krog and Hammeleff, tea-services, jugs, pitchers, and beakers, and a number of pieces of Danish porcelain in silver-gilt mounts designed by Henriksen. These last had a great success at the exhibition and many were bought by French admirers. According to a writer signing Ch.B. ('Danske kunstindustrielle Arbejder paa Verdensudstillingen i Paris' in *Tidsskrift for Industri*, vol. i, 1900, pp. 53–8), Bindesbøll's silver designs received unanimous acclaim at the exhibition for their union of artistic appeal with sensitiveness to the demands of the medium and its techniques, so much so that Slott-Møller's designs were a little too much thrown into the shade. The same article illustrates a range of Michelsen's exhibits, including other

pieces designed by Bindesbøll. As a member of the jury Michelsen could not receive an award, but Henriksen was awarded a gold medal for his designs and other masters and workmen from the Michelsen shop received silver and bronze medals. (Ministère du Commerce &c., Exposition Universelle Internationale de 1900, *Rapports du Jury International*: Groupe xv–*Industries Diverses*, Paris, 1902, *Classe 94, Orfèvrerie*, pp. 307–08.) Michelsen's stand at the exhibition is shown in a photograph reproduced in *Officiel Beretning am Danmarks Deltagelse i Verdensudstillingen i Paris 1900*, Copenhagen, 1902, p. 54. Bindesbøll's silver designs for the firm of A. Michelsen are also discussed by E.

Lassen and O. Wanscher, *A. Michelsen og dansk Sølvsmedekunst*, Copenhagen, 1941, pp. 48–53 (not seen). For Bindesbøll see K. Madsen, *Thorvald Bindesbøll*, Copenhagen, 1943 (with full bibliography); S. Hammershøi, *Thorvald Bindesbøll in Memoriam 1846–1946*, Copenhagen, 1946. For Michelsen see the article by G. Nygaard in *Dansk Biografisk Leksikon*, ed. P. Engelstoft and S. Dahe, vol. xv, 1938, pp. 583–84 (with bibliography), and the English language brochure *A. Michelsen: Royal Court and Insignia-Jewellers of Denmark*, Copenhagen, 1927 (on pp. 9 and 11 are reproduced two pieces designed by Bindesbøll in the same style as those in the Museum).

Danish Spoons

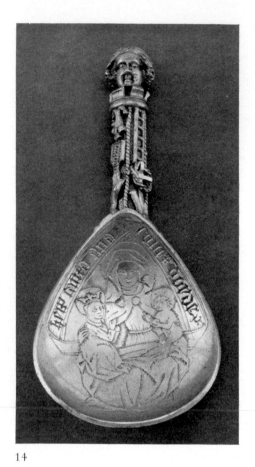

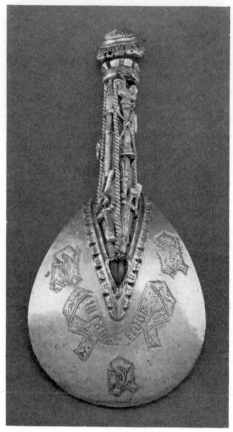

14

14a

14 SPOON

North German or Scandinavian, c. 1500. Silver-gilt. The pear-shaped bowl is engraved with St Anne dressed in cloak and mantle, seated and holding the Infant Christ on her left knee and the Virgin on her right (*Anna Selbdritt*). Above is a band with the Gothic inscription in Low German or Netherlandish: *help santa Ana/sulbe dorde* (*selbst dritte*). The underside of the bowl is engraved with a Gothic majuscule A repeated three times, around a twisted band inscribed in Gothic letters: *sam froue?* The stem is attached to the bowl by a long tongue: the tongue is framed by a v-shaped crocketed border attached to the bowl.

The stem itself is matted in imitation of a tree-trunk, and is decorated with the Instruments of the Passion each separately cast and chased in relief, and soldered to the stem. The head of the stem is formed as the battlemented top of a tower: from it emerges the head of a man wearing a jewelled circlet. At the bottom of the stem on the underside of the bowl is set an animal tooth.

MARKS None.
DIMENSIONS L. 11 cm. W. 4·6 cm. Bowl length 6 cm.
CONDITION Good (see also below).

485–1865

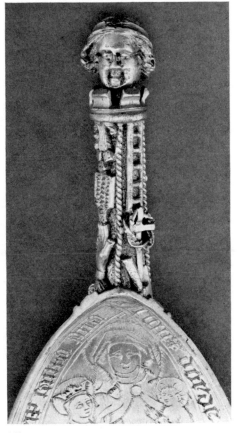

14b

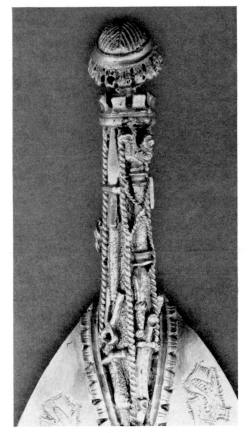

14c

PROVENANCE Purchased (£20) from Dr
Franz Bock, canon of Aachen and his-
torian of medieval art.

This remarkable Late Gothic spoon,
finely cast and engraved, was acquired as
German but was later reclassed as
Scandinavian. It is included in this
catalogue because its general form and
decoration are closely paralleled on a
spoon in the Nationalmuseet, Copen-
hagen, (10700), generally regarded as
unique, where the head surmounts not a
battlemented tower but a knob decorated
with the figures of St George, St Christo-
pher, St Laurence and the Virgin and

Child. On the Copenhagen example (figs.
14 E, F, G), which is slightly longer, the
stem decorated with the Instruments of
the Passion is much shorter, and the Vir-
gin sits on St Anne's left knee. A cavity,
which evidently once held an animal's
tooth like that on the Museum's spoon,
also appears in the same place on the
Copenhagen spoon, but surmounted by a
long stem with a cross-bar at the base, in-
stead of by a rope as on the present spoon.
The lettering of the inscription on the
Copenhagen spoon is Lombardic, not
Gothic as on the Museum's spoon; the
inscription itself is Danish and reads:
MARIA HIELP MEG AF ALLE MINE NØ

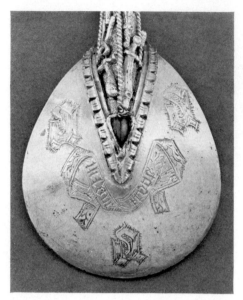

14d

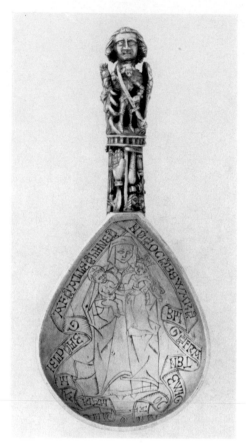

14e

OC BEWAR MEG FRA TEN EWIGE DØH
(Mary help me in all my needs and
preserve me from eternal death). The
engraving on the Copenhagen spoon was
regarded by J. Olrik (*Drikkehorn og
Sølvtøj fra Middelalder og Renaissance*,
Copenhagen, 1909, p. 91, no. 23) as
Danish, but he was less sure of the spoon
itself, which he classes as probably North
German. The spoon was previously in the
Danish Royal Kunstkammer and before
that at Rosenborg, but its early proven-
ance is unknown. E. Lassen (*Ske, Kniv og
Gaffel (Knives, Forks and Spoons)*,
Copenhagen, 1960, pl. 2) suggests that it
was made in Lübeck, at the beginning of

the sixteenth century. Dr Fritze Lindahl
of the Nationalmuseet, Copenhagen,
suggests Cologne or the Netherlands as
possible alternatives.

In a letter of 9 February 1972 Professor
P. G. Foote of University College, who
very kindly examined photographs of the
Museum's spoon together with Pro-
fessor Niels Åge Nielsen of Odense Uni-
versity and Dr Holger Schmidt of the
Nationalmuseet, Copenhagen, writes
that the long inscription 'with its initials
HELP can hardly be Danish but is doubt-
less Low German'. The reading given in
the entry (meaning 'Help St Anne Third
Person') is that proposed by Dr Fritze

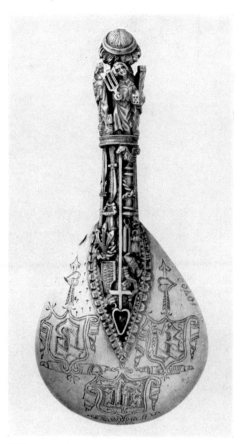

14f

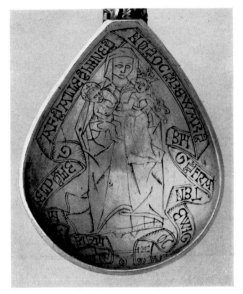

14g

Lindahl, who suggests that the other inscriptions may be blundered or illegible ones, such as are found on several early spoons in the Danish national collections.

For the iconography of St Anne and for her cult, which was particularly popular during the late fifteenth and early sixteenth century, see B. Kleinschmidt, *Die heilige Anna: ihre Verehrung in Geschichte, Kunst und Volkstum*, Düsseldorf, 1930.

The tooth, no doubt a prophylactic charm, was examined by the Natural History Museum, who are unable to identify the species of animal to which it belongs.

In view of the similarity of the Museum's spoon to the Copenhagen spoon and of its excellent condition, it was decided to have the silver and gilding spectroscopically tested at Goldsmith's Hall (1972), by courtesy of the Deputy Warden. The silver was found to tally with an early sixteenth century date and the gilding to be mercury gilding. A possibility therefore is that it was given to a church treasury shortly after it was made, passing into the hands of Dr Bock during the middle of the nineteenth century either directly from the treasury or from a private collection.

15 SPOON

Danish? Early sixteenth century. Silver, parcel-gilt. The broad pear-shaped bowl is engraved with a gilt band with scrolling ends inscribed in Gothic letters: *maria/maria*. In the centre of the band is a roundel containing a Gothic minuscule I on a hatched ground (presumably for Jesus). The stem which is held to the bowl by a 'rat-tail' is shaped as a lopped tree-trunk. To its front is applied a standing figure of a crowned female saint holding a church with a tower in her left hand. The stem is surmounted by a crown with tall crockets: from the centre of this rises the head of a man wearing a cap. His bust is shaped as a hexagon.

MARKS None.

DIMENSIONS L. 13·6 cm. W. 5·8 cm.
Bowl length 7·8 cm.

CONDITION Bowl dented and scratched. See also below.

2264–1855

PROVENANCE Purchased (£10 15s 0d) at the sale of the Bernal Collection (lot 3427) 23 April 1855.

Acquired as German. The lopped trunk of the stem is paralleled on a spoon which was dug up in Kallundborg and is now in the Nationalmuseet, Copenhagen (no. D942). To its stem is applied a relief of the Trinity: the finial is shaped as three acorns. Olrik (*Drikkehorn og Sølvtøj fra Middelalder og Renaissance*, Copenhagen, 1909, p. 90) dated the Copenhagen spoon c. 1500 and called it probably Danish. The head on the knob of the Museum's spoon

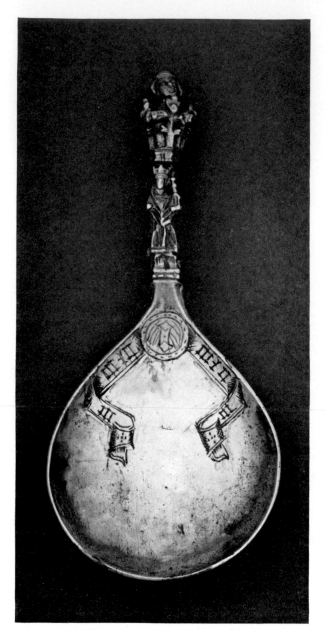

15

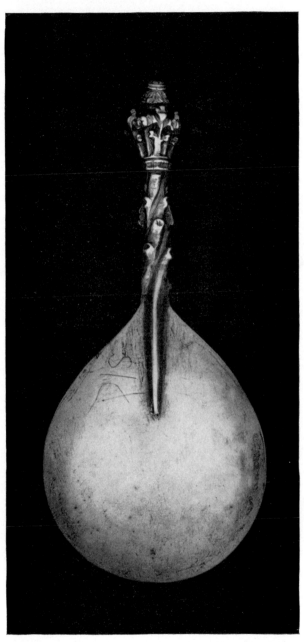

15a

has been soldered on: it is a question whether this is merely a crude repair, or whether the head is a later addition, taken (in view of its hexagonal shape) from a different spoon with a hexagonal stem. E. Lassen, however, believes the spoon to be as originally made. For the Copenhagen spoon E. Lassen (*Ske, Kniv og Gaffel* (*Knives, Forks and Spoons*), Copenhagen, 1960, pl. 3) suggests an attribution to Lübeck, and a dating in the early sixteenth century.

16 SPOON

Copenhagen, 1642. Near-oval bowl. The stem is grooved down the middle of the upper side, the ends of the groove terminating in small swellings on the edge of the bowl. The knop is shaped as a scallop shell. On the underside of the bowl is engraved a merchant's mark (HK) in a wreath composed of two sprays. The letter H is crudely engraved on the inside of the bowl just below the junction with the stem.

MARKS Underside of base of stem.
TOWN MARK Copenhagen mark for 1642.
MAKER'S MARK: JM in monogram (see below) in a shaped shield.
DIMENSIONS L. 17 cm. W. 5·1 cm. Bowl length 6·3 cm.
CONDITION Slight scratching. There is a diagonal joint across the stem.

559–1903

PROVENANCE Purchased (£3 5s 0d) at Christie's, 24 June 1903, lot 120.

The maker's mark is unrecorded. Erik Lassen has expressed doubts about the genuineness of the marks, and some doubt must attach to the spoon as a whole.

16a

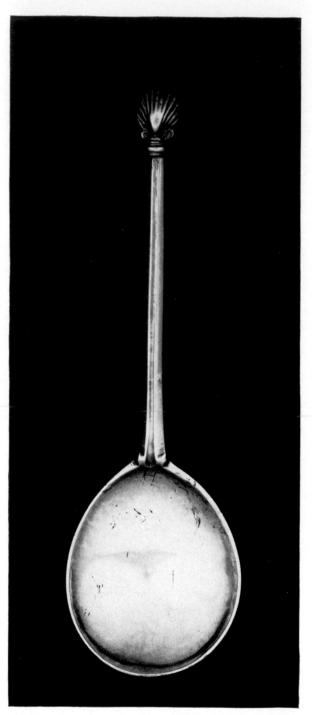

16

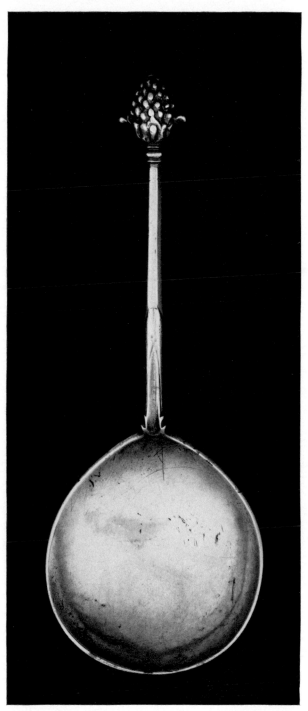

17

17 SPOON

Danish or Norwegian, dated 1649. Broad round bowl. The lower end of the stem is cast and chased with four laurel-leaves. The stem itself is octagonal. The knob (cast in two pieces) is shaped as a bunch of grapes depending from foliage. The back of the spoon is engraved with a three-quarter circle band terminating in scrolling foliated ends and inscribed: PEDER SAMSONSØN 1649. Within this is a later Russian inscription *ОПΣ*.

MARKS None.
DIMENSIONS L. 16·8 cm. W. 6·1 cm. Bowl length 7 cm.
CONDITION Dented and worn.

2000–1898

PROVENANCE Given by Col. F. R. Waldo-Sibthorp.

Acquired as Scandinavian. The crossed ø of the inscription points to an origin in Denmark or Norway. The type is recorded in both countries at the date of the inscription on the spoon.

18 SPOON

Danish or Norwegian, middle of the seventeenth century. Pear-shaped bowl, engraved on the underside with a three-quarter circle band with foliated ends containing the initials PK and MTDW. The junction and lower part of the stem are decorated on the underside with a stylized leaf: on the upper side is a leaf-shaped hollow enclosed by an outline. Above, the stem is four-sided, and decorated with a foliated band. It terminates in a knop shaped as a bunch of grapes depending from leaves.

MARKS None.

DIMENSIONS L. 17·5 cm. W. 5·6 cm. Bowl length 6·4 cm.

CONDITION Bowl much dented and cracked.

654–1890

PROVENANCE Purchased (£2 13s 4d) from Mr A. B. Meidell, 28 Finsbury Square, EC.

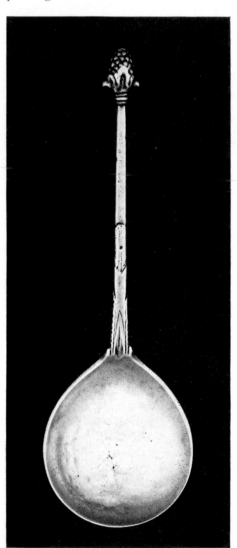

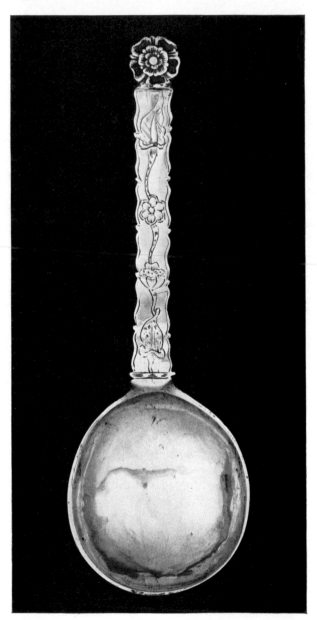

18

19

Acquired as German, early seventeenth century. Spoons with 'grape ends' were equally popular in Denmark and Norway: Erik Lassen believes a Danish origin to be acceptable for this spoon. Comparable spoons are reproduced by Krohn-Hansen and Kloster (*Bergens Gullsmed*, vol. ii, pl. 23).

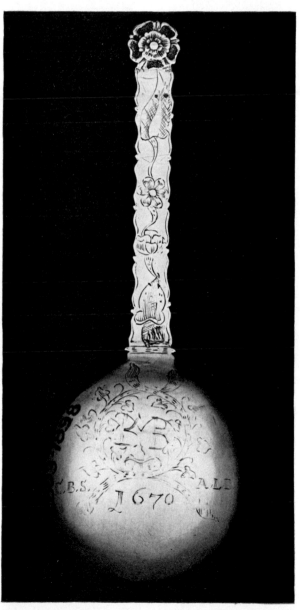

19a

19 SPOON

Danish, dated 1670. The underside of the near-round bowl is engraved with two sprays, intertwined to form a wreath around the initials K M B in monogram. Below is the date 1670. On either side are the (later) initials C.B.S. and A.L.D. The flat handle has a wavy and indented edge, and is engraved on both sides with a stem of flowers and leaves in an outline border. It terminates in a cast and applied double rose (cast in two halves).

MARK Underside of the stem at the base.
MAKER'S MARK: illegible (cut by the engraver's tool).
DIMENSIONS L. 17·2 cm. W. 5·6 cm. Bowl length 6·3 cm.
CONDITION Some denting in bowl.

2003–1898

PROVENANCE Given by Col. F. R. Waldo-Sibthorp (*A Collection of Silver and Silver-gilt Plate...formed by Colonel F. R. Waldo-Sibthorp*, Brighton, privately printed, n.d., p. 32, n. 197).

Spoons of this type are recorded at this date both in Denmark and Norway. A Danish origin is perhaps more plausible for this beautiful example, which was catalogued as Danish when in Waldo-Sibthorp's possession, and as from Copenhagen.

20 SPOON

Danish?, late seventeenth century. The pear-shaped bowl is plain: at the upper end of the underside of the bowl are engraved the initials M.I.S./K.M.D. on either side of a merchant's mark. The lower part of the spreading stem has a ridged upper side, and is engraved at the top end with foliage. This section is separated from the rest by a moulded band. The flat spreading upper section is decorated at the base with two curling leaves, partly engraved and partly cast, from which the rest emerges to terminate in a truncated end of a flattened s-shape engraved with a scroll.

MARK Underside of the stem at the base.
MAKER'S MARK: A C? (the last letter is imperfectly struck, is most probably C, but may be G or O). See below.
DIMENSIONS L. 17·5 cm. W. 5 cm. Bowl length 6·5 cm.
CONDITION Some wear and scratching.

771–1904

PROVENANCE Purchased (£2 12s 6d) from G. Jorck.

Although this spoon is of a type that came into vogue in Scandinavia during the 1620s, the style of the engraving is late seventeenth century. A possible attribution might be to the goldsmith Asmus Christophersen working from 1695 to 1711 at Aabenraa in Denmark, one of whose marks as recorded by Bøje (p. 170, no. 1201) closely resembles the mark on the spoon. According to E. Lassen (*Ske, Kniv og Gaffel (Knives, Forks and Spoons)*, Copenhagen, 1960, pl. 12) spoons of this type were commoner in Bergen than in Denmark, but the maker's mark is not recorded in Bergen.

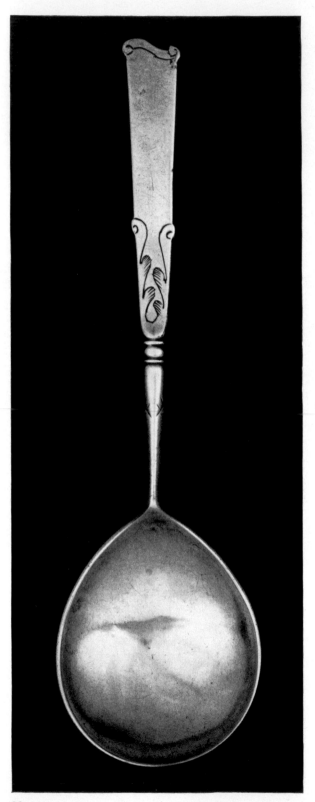

20

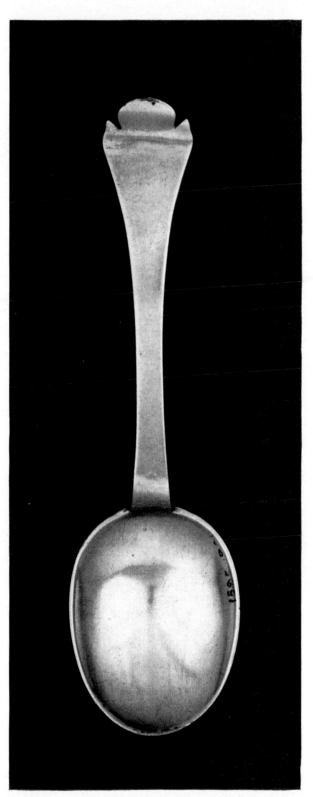

21 SPOON

Danish, dated 1709. The underside of the oval bowl is engraved with two sprays entwined to form a wreath enclosing the initials E.I.D. and the date 1709. The flat stem curves upwards from the bowl and curves inwards and then outwards. The end is shaped as an upturned trifid. On the underside of the stem are engraved the initials J.M./A.H.D. Under these are pounced further initials A.S.S./H.P.D./F and the date 1809.

21a

MARK Underside of the stem at the base.
MAKER'S MARK: I M in a circle (see below).
DIMENSIONS L. 17·6 cm. W. 4·6 cm.
 Bowl length 6·3 cm.
CONDITION Slight wear under bowl.
 1595–1901
PROVENANCE Purchased (18s) from G. Jorck.

Acquired as Danish. The trifid end first appeared in Denmark in the 1660s and later became characteristic (see Boesen and Bøje, *Old Danish Silver*, Copenhagen, 1949, figs. 421, 429–30). A Copenhagen example dated 1698 which they illustrate (fig. 424) is particularly close to the present spoon. The M of the mark on the spoon differs from that of Jens Madsen of Randers, who is mentioned as a goldsmith in Randers from 1683 to 1692 and again in 1696, as given

by Bøje (p. 346, no. 2397) in that the two slanting strokes are shorter. However, Madsen must have had several punches, some of which may well have differed from that reproduced by Bøje, and the year 1709, which is engraved on the spoon, is not necessarily that in which it was made. Compare a spoon made in 1699 but with a garlanded owner's initials and the date 1704 (of the same form as on the present spoon) reproduced by Boesen and Bøje (fig. 436).

22 SPOON

Danish, early eighteenth century. On the back of the oval bowl is engraved a rat-tail decorated with leaves. The flat stem curves inwards and then outwards to form a spreading handle shaped as a rounded triangle. On the underside of the handle are pounced the initials R. K. S.

MARKS None.
DIMENSIONS L. 19 cm. W. 4·6 cm. Bowl length 6·8 cm.
CONDITION Worn and scratched.

M.1789–1944

PROVENANCE Bequeathed by Mr W. T. Johnson.

The attribution to Denmark is proposed by Erik Lassen. Similar spoons made in Bergen in the first two decades of the eighteenth century are illustrated by Krohn-Hansen and Kloster (*Bergens Gullsmed*, vol. ii, pl. 134). The end is really a simplified version of the wavy end.

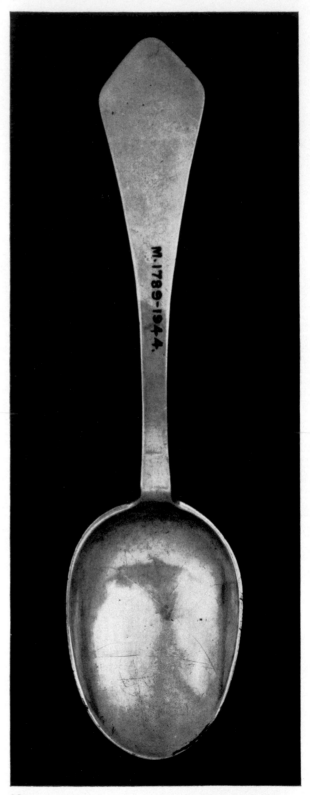

22

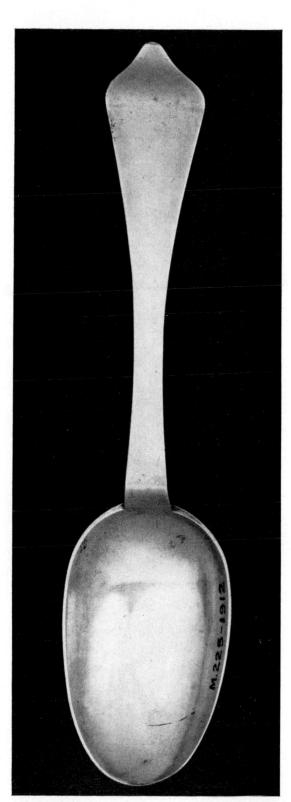

23

23 SPOON

Aalborg, mid eighteenth century. Oval bowl, rising up to join the stem, which has a sharply upturned wavy end. On the underside of the bowl is engraved a rattail decorated with foliage: on the underside of the end are pounced the initials CJS/KHD/KJDU.

MARK On the underside of the stem at the base.
MAKER'S MARK: IK/S in a shield for Jens Kieldsen Sommerfeldt, working in Aalborg 1726–72 (Bøje, p. 181, no. 1282).
DIMENSIONS L. 19·4 cm. W. 4·4 cm. Bowl length 7·5 cm.
CONDITION Some scratching inside bowl.

M.225–1912

PROVENANCE Purchased (£3 with M.223, 224–1912) from G. Jorck.

The oval bowl suggests a mid-century date for this spoon.

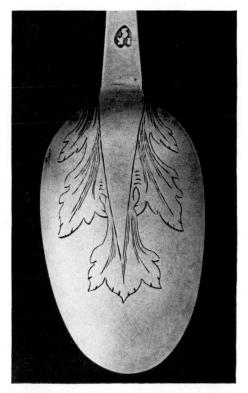

23a

24 SPOON

Danish?, dated 1769. The oval bowl is
engraved on the underside with a scallop
shell surmounted by a broad rat-tail
decorated with leaves. It rises to join the
base of the stem, which is decorated with
a moulded band. Above is a panel with
bevelled edges engraved with diaper:
over this is engraved a flowering stem.
In general form the stem curves first in-
wards and then outwards to terminate in
a downturned trifid end. Pounced on the
underside are the initials G.A.P/C.N.H/
M.N.A and the date 1769. Beneath are
pounced two later sets of initials L.B/AB.

MARK On the underside of the stem at
 the base.
MAKER'S MARK: A.N. (unrecorded).
DIMENSIONS L. 19·6 cm. W. 4·3 cm.
 Bowl length 7·3 cm.
CONDITION Some wear and denting.
 M.223–1912
PROVENANCE Purchased (£3, with M.224,
 225–1912) from G. Jorck.

Acquired as Danish. The end of this
spoon is developed from the trefoil form.

24a

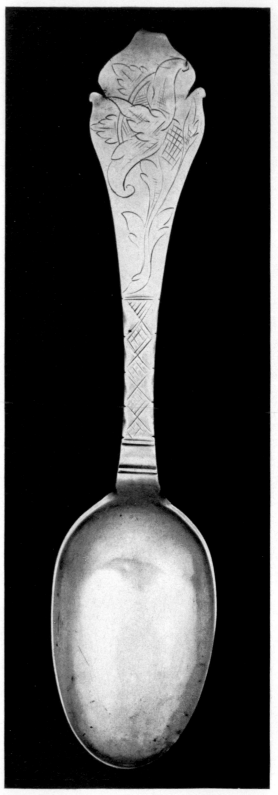

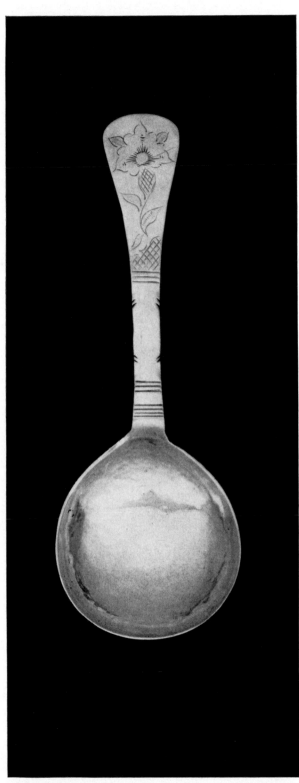

25

25 SPOON

Copenhagen, between 1765 and 1785. Round bowl, its underside engraved on the upper edges with a border whose ends are fringed. At the junction of this border with the stem there is a motif of rays. The upper side of the lower part of the stem is decorated with two incised bands at the base and one at the head; between these it is nicked and bevelled. The upper part has an end shaped as a flat curve: it is engraved with a floral spray.

MARK On the underside.

MAKER'S MARK. AHS in an oblong for Arved Hansen of Copenhagen (b. c. 1738, working 1765–83: Bøje, p. 88, no. 572).

DIMENSIONS L. 15·9 cm. W. 5·1 cm. Bowl length 6·1 cm.

CONDITION Good; some slight denting.

Circ.292–1912

PROVENANCE Purchased (£1 5s) from G. Jorck.

This spoon is a very late example of its type; the form has become conventionalized. The engraved spray, though stylized in a folk manner, shows Rococo influence.

26 SPOON

Copenhagen, 1787 or 1788. Pointed oval
bowl, to which the rising stem is attached
by a ridged tongue. The stem has bevel-
led sides, and spreads out into a fiddle-
shaped terminal. On the upper side of
this are pounced the initials c.j.b.l./
j.r.d.r. On the underside is engraved a
Rococo scroll.

MARKS On the underside of the stem at
the base.

TOWN MARK Copenhagen mark for 1787
or 1788 (see below).

MAKER'S MARK: JRNB (in monogram)
over G or SL, all in a shaped cartouche.

WARDEN'S MARK of Fredrik Fabricius,
warden 1787–1823.

MONTH MARK for 20 March–20 April.

CONDITION Some scratching.

<div style="text-align: right">M.224–1912</div>

DIMENSIONS L. 21·6 cm. W. 4·5 cm.
Bowl length 7·7 cm.

PROVENANCE Purchased (£3 with M.223,
225–1912) from G. Jorck.

The date figure on the Copenhagen mark
is almost obliterated but consists of only
two figures, the first of which is an 8. On
acquisition it was read as 1781, a year
excluded by the warden's mark. Bøje
(p. 22) gives no Copenhagen marks for
1787 or 1788, but these would seem to
be the only possible years for the spoon,
given the features of the mark. The
maker's mark, of curious form (perhaps
copying the marks with pairs of initials
used by English goldsmiths in partner-
ship) is unrecorded. For the fiddle end
and Rococo scroll ornament compare a
pair of Copenhagen forks of 1772 illu-
strated by Boesen and Bøje (*Old Danish
Silver*, Copenhagen, 1949, figs. 460 a–b).

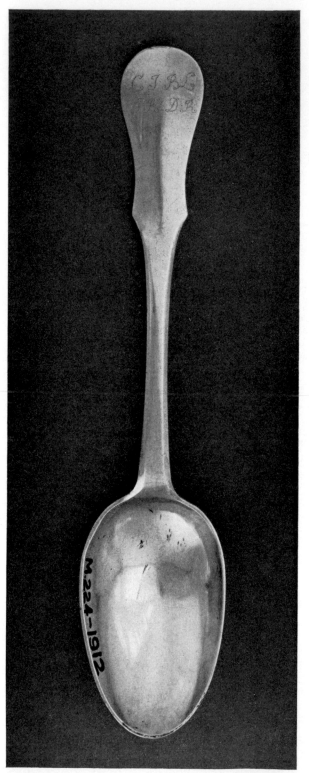

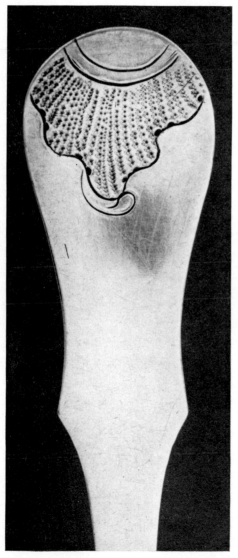

26a

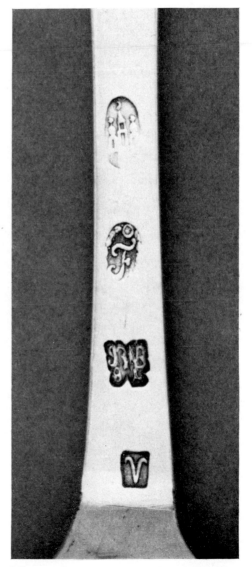

26b

27 SPOON

Copenhagen, 1805. Almond-shaped bowl. The flat stem spreads out to terminate in a blunt-pointed end. It is decorated with a bright-cut border, enclosing a cartouche at the end of the stem; from the cartouche hangs a pendant of foliage. Traces of obliterated initials.

MARKS On the underside at the top.

TOWN MARK: Copenhagen mark for 1805.

MAKER'S MARK: I. KISTNER for Johan Peter Kistner (born c. 1775 – working until 1835). See Boje (p. 123, no. 885) and below.

WARDEN'S MARK of Fredrik Fabricius (warden 1787–1823).

MONTH MARK for 21 December–21 January.

DIMENSIONS L. 21·8 cm. W. 4·6 cm. Bowl length 8·2 cm.

CONDITION Small scratches on back of bowl.

<div align="right">M.54–1914</div>

PROVENANCE Given by Mr Claude D. Rotch.

A pair to No. 28 (q.v.).

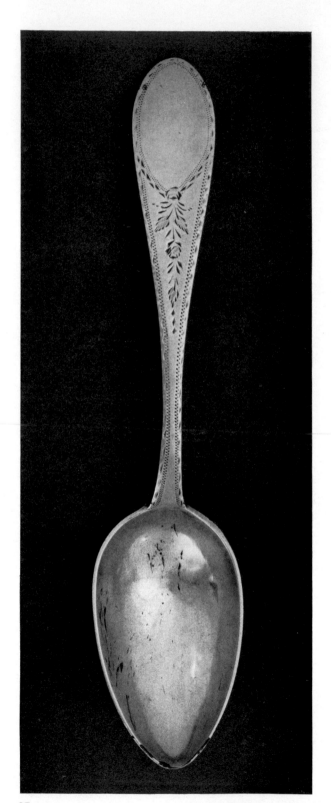

27

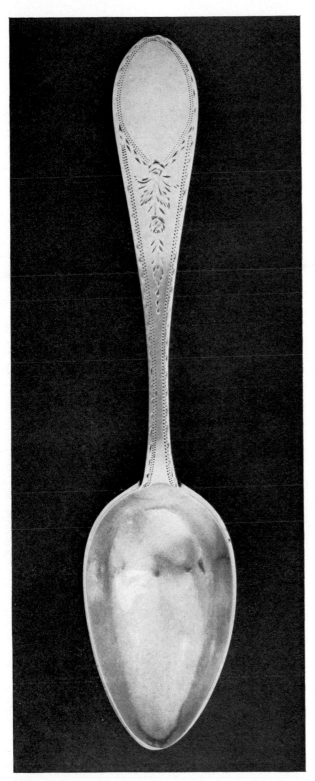

28

28 SPOON
Copenhagen, 1805. A pair to the above
(q.v.).

M.54a–1914

CONDITION Bowl scraped and dented.

The decoration of these spoons is derived
from English neo-classical silver. Bøje
(*loc. cit.*) gives the year 1812 as the date
when Kistner was admitted to burgher-
ship. Is this a misprint for 1802, for there
are no signs that an earlier maker's mark
has been overstamped on these spoons?

Norway

29 DRINKING-HORN

Norwegian, fifteenth century. Cow's horn or the horn of the European bison, mounted in copper gilt. The mount of the mouth consists of a broad lip, with an applied rim. It is held in place by a moulded band whose serrated edge is formed by the rounded ends of an ornament of twin gadroons, which is repeated round the entire circumference. This band is crudely bent round, and is held by three straps (originally four) with similar edging. These are hinged to the band, nailed to the horn itself, and hinged and nailed to the waist-band (see below). The ground between these gadroons is diapered. Around the lip runs the inscription in Gothic letters: *leve got help mir* ('Dear God, help me'). These words are engraved on a diapered ground and separated by broad leaves. The waist of the horn is held by a broad band decorated with engraved leaves on a diapered ground between moulded borders in relief. It has a serrated edge on either side as above. The mount is formed by bending the band of metal round the horn: the junction runs down the top-centre. To it are applied two tubular legs formed by bending over a narrow sheet of thick copper. One of these has three lines engraved round it at the top; the other is undecorated. Two long straps, hinged to the band, run along the horn to the mount of the tip. This is conical and bent over at the end, where it terminates in a knob formed of two half-spheres of openwork foliage and a finial shaped as a stylized rosette. Under the horn, and attached to the two long strips, is a band of plain metal, to which is attached a small rosette-shaped foot.

DIMENSIONS H. 19·4 cm. L. 24·5 cm. Diam. of mouth 11 cm.

CONDITION It has been suggested that the legs may be a later, coarse restoration. But this is most unlikely (compare the very similar legs on the horn reproduced by J. Olrik, *Drikkehorn og Sølvtøj fra Middelalder og Renaissance*, Copenhagen, 1909, pp. 18–20, no. 8, and on a horn in the collection of the University of Oslo reproduced by A. Polak, *Gullsmedkunsten i Norge før og nå*, Oslo, 1970, p. 40, fig. 28). They have been crudely re-soldered to the waist-band. Much of the gilding rubbed and worn away. Dented and battered, especially round the rim of the mouth and the conical mount of the tip. A third long strap that ran from the conical mount to the waist-band along the top of the horn is missing: its place is marked by a hinge on the edge of the conical mount. A short strap is also missing between the waist-band and the lip. A substance of some sort appears to be inserted between the encircling band and the lip of the horn.

2162–1855

PROVENANCE Purchased (£12 10s) as German, fifteenth century, from the Bernal Collection (21 March, 1855, lot 1672: 'A curious horn, mounted with rims and bands of copper gilt, with German inscription, as a drinking-cup').

In style the decoration of this horn is close to that of several horns preserved in Scandinavian collections. Three horns in the Nationalmuseet, Copenhagen are reproduced by J. Olrik (*Drikkehorn og Sølvtøj fra Middelalder og Renaissance*, Copenhagen, 1909, pp. 22–35, nos. 15, 16, 19, figs. 17, 18, 19). Of these no. 15 (Museum no. 10546) and no. 16 (Museum no. 8) are particularly close. The examples in Copenhagen all have claw-feet. Closer still is a horn now in the collection of the University of Oslo (from Elingård in Onsøy) inscribed with the

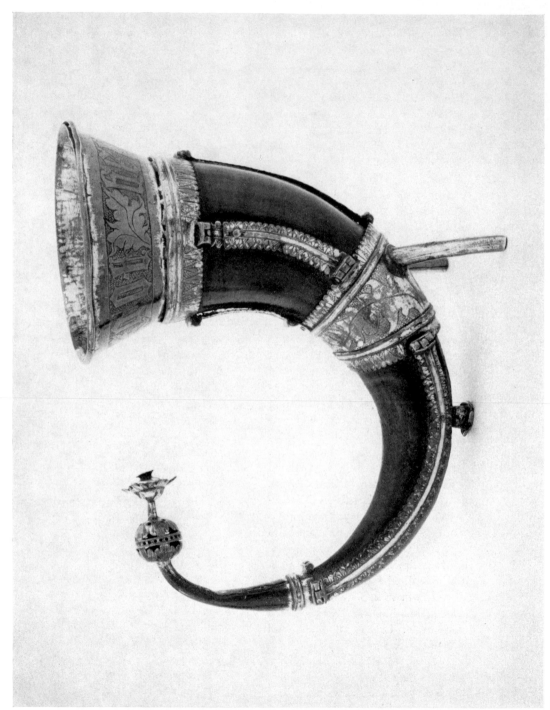

prophylactic inscription: IHECUS NAS-
AREUUS REX IUDEORUM.

Drinking horns of this type were very
popular everywhere in medieval Scan-
dinavia and Iceland. They went out of
domestic use during the late fifteenth
and early sixteenth century, but con-
tinued to appear as 'welcome cups' at
banquets and guild ceremonies. There is
a discussion of them with illustrations in
Th. Kielland, *Norsk guldsmedkunst i
middelalderen*, Oslo, 1927, pp. 179–87,
figs. 159–63, pp. 202–04, figs. 193–206).
The provenance of one of the three rela-
ted horns in Copenhagen (Olrik, no. 15)
is unrecorded but the other two are
described in eighteenth century cata-
logues as Norwegian, and in view of its
close resemblance to the Oslo horn the
present horn can therefore be safely
classed as Norwegian. It dates from the
fifteenth century. The Oslo horn is said
(Polak, *loc. cit.*) to be mentioned in a
document dated 4 August 1433: its orna-
ment is rather more formalized. Accord-
ing to Dr M. Blindheim (in his introduc-
tion to the catalogue of the exhibition
*Middelalder-Kunst fra Norge i Andre
Land*, held in Oslo, 1972, p. 9), the
drinking-horns of medieval Norway were
of two kinds, those made of exotic horns,
imported and mounted in silver and
copper, which were used by the upper
classes, and those of domestic cows and
oxen, decorated with scrolls, figures from
the sagas and animals. The Natural
History Museum say that the horn of the
present example may be either a cow's
horn or that of a European bison: if that
of a bison it was certainly imported into
Norway from Germany or Central
Europe.

30 BEAKER

Norwegian, late sixteenth century. The trumpet-shaped body has an everted moulded rim decorated with a band of zig-zag ornament. Round the upper part is attached a girdle to which is applied a cast foliated branch interrupted by three grotesque masks, each with a hoop from which hangs a corded ring. The lower part is decorated with a ribbed wire girdle to which are attached three masks shaped as Gothic grotesque faces with Renaissance swags beneath. The body is attached to the domed foot by a flange. The base of the foot terminates in a moulded rim decorated with a band of zig-zag ornament: it rests on three crudely cast figures of crouching men in pointed hats playing bag-pipes.

MARK In the base.
MAKER'S MARK: AL in an oval (see below).
DIMENSIONS H. 14·1 cm. Max. W. 7·9 cm.
CONDITION See below.

651–1890

PROVENANCE Purchased (£7) from Mr A. B. Meidell, 28 Finsbury Square, EC.

The beaker was acquired as an Augsburg piece of the early seventeenth century. Subsequently the attribution was changed to Swedish. Its identification as Norwegian is due to Dr Krohn-Hansen, and is supported by comparable pieces illustrated by him in Krohn-Hansen and Kloster (*Bergens Gullsmed*, pl. 14, beaker with mark of Cornelius Hinrichsen, pl. 15, beaker by Lucas Steen). These two examples date respectively from the late sixteenth and early seventeenth centuries. The motif of the foliated bough encircling the upper part of the body, which derives from late fifteenth century German goldsmith's work, suggests that the present beaker is sixteenth rather than seventeenth century in date. The combination of Late Gothic and Renaissance ornament on a Late Gothic form is typically Scandinavian: the foliated branch and masks on a corded band are found on other examples (see a beaker illustrated by P. Fjellström, *Lapskt Silver*, 1962, text, p. 153, fig. 120) and were evidently standard.

The rim of the lip and of the base, the ribbed wire band round the lower part of the body, the band of plain metal to which the foliated bough is attached, the hoops, the corded rings are all later restorations. Dr Krohn-Hansen suggested in 1948 that the AL mark in an oval struck on the lower base-plate might be that of the Bergen goldsmith Andreas Lude (working 1776–96). However, none of the marks that he later gave for Lude in his book on Bergen goldsmiths (*op. cit.*, text vol., p. 351) has an oval cartouche, and the restorations seem to date from the nineteenth rather than from the late eighteenth century. There is no published record of a similar mark in Norway, Denmark or Sweden: since the goldsmiths of Denmark and Sweden have been so thoroughly listed it is probably justifiable to assume that the mark is that of an unidentified nineteenth century Norwegian goldsmith. Oman, *Scandinavian Silver*, pl. 2 (as repaired by Andreas Lude).

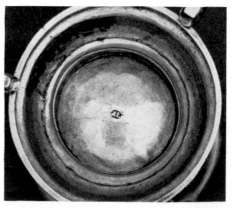

30a

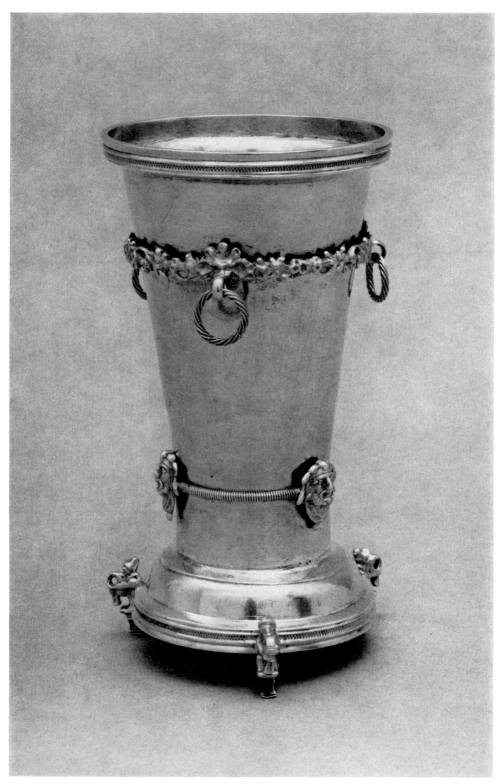

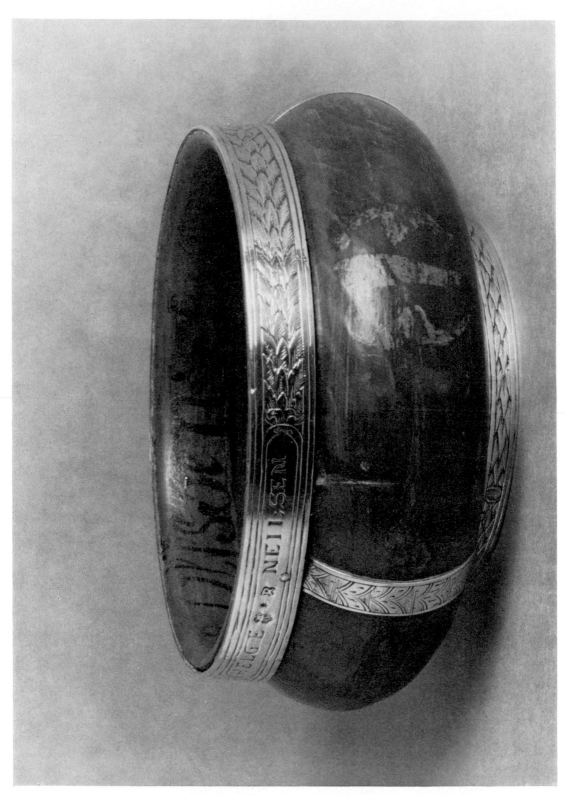

31a

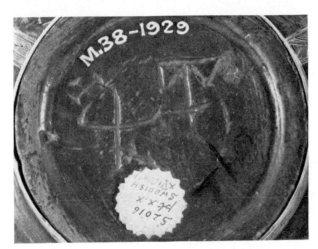

31b

31 MAZER

Norwegian, c. 1600. Painted spruce or larchwood mounted in silver. The bulging wooden bowl is painted with designs in red and white on a blue ground. The predominant motif is a stylized plant motif executed in white, one in each of the three panels. In the base of the foot are cut two merchant's marks. The inside is painted in red round the rim, with the name: *Marcus Ollsjen: Sagen* inscribed on the red in black. The broad band of silver round the rim is engraved with a band of laurel-leaf interrupted by two double roses issuing from a central oval cartouche engraved with the name HELGE✱NEIL.SEN in Roman letters. It is joined to the band round the base by three straps, one also engraved with laurel leaves, the other two with a chevron pattern. The band round the base is engraved with laurel leaf ornament interrupted by two crude circular motifs. In the base of the inside of the bowl is a print inscribed with the Sacred Monogram IHS in Gothic letters.

MARKS

MAKER'S MARK: R barred on an escutcheon.

TOWN MARK?: R in a shaped shield.

DIMENSIONS H. 6·1 cm. Diam. 14 cm.

CONDITION The wood cracked vertically just before the first letter of *Marcus* (see above).

M.38–1929

PROVENANCE Purchased (£40) Messrs S. J. Phillips.

The bowl was acquired as Swedish, sixteenth century. In 1949 Dr G. Boesen of Rosenborg Castle informed the Department that the name Neilsen was unlikely to be Swedish, but might be either Danish or Norwegian. He noted that Neils (Nils) was more frequently used as a name in Denmark than in Norway, and suggested that one of the R marks

might be that of Roskilde. In the shield mark the shape of the R resembles the R in a mark illustrated in Oslo (Kristiania), Kunstindustrimuseum, *Gammel Guldsmedkunst i Arbeider fra 15. til 19. Aarhundrede*, 1909, p. 183, no. 351. This is struck on a tankard dated 1611 (*op. cit.*, p. 64, no. 252) but the shape of the shield appears to be different. The mark of Roskilde would seem to have been a crowned R at the time when the mounts were made if J. Olrik (*Drikkehorn og Sølvtøj*, Copenhagen, 1909, p. 66, no. 12) is correct in interpreting a mark struck on a beaker of c. 1600 in the Danish Nationalmuseet as that of Roskilde. Bøje (p. 364, no. 2521) gives a crowned R as the seventeenth century mark of the town. There is no trace of even a blurred crown above the shield on the bowl and Roskilde is therefore a most unlikely attribution.

Dr Inger-Marie Lie, of the Kunstindustrimuseet, Oslo, kindly informs me that the barred R is a mark well known to Norwegian scholars. The name of the goldsmith has not yet been identified, but he was probably from Bergen and working presumably c. 1600. The mark has so far been found on eleven objects (five spoons and six pieces of church plate) in Western Norway. She can make no suggestion about the identification of the other mark, but thinks that the name Helge Neilsen may well be Norwegian.

52 PEG-TANKARD

Bergen, dated 1652. The plain cylindrical drum (pounced with the later inscription: L:M:S:M:/T:L:D:M:/1833) rests on a high domed and moulded foot. The domed lid has a flat top engraved with an outer band composed of a leafy stem bearing fruit and flowers: a bird pecks the bunch of fruit at the front. Within this is a band with leafy terminations

engraved I.S·⋮·T.H.D. It partly encircles two conjoined shields each bearing a merchant's mark. Below is the date 1652. The thumb-piece is shaped as an acorn (cast in two sections). The scroll-shaped handle is decorated with an applied leaf on an engraved ground and wrigglework borders, and terminates in a shaped escutcheon engraved with a blank cartouche. Within are four pegs. Two inscriptions on the base record the weight.

MARKS In the base.

TOWN MARK: a crowned B for Bergen (not corresponding exactly to any of those reproduced in *Bergens Gullsmed*, p. 346).

YEAR LETTER None.

MAKER'S MARK: OSI in monogram in a shaped shield for Oluf Jørgensen (*Bergens Gullsmed*, p. 115, where mark is inverted, p. 359) working as a goldsmith in Bergen from 1650 until 1700.

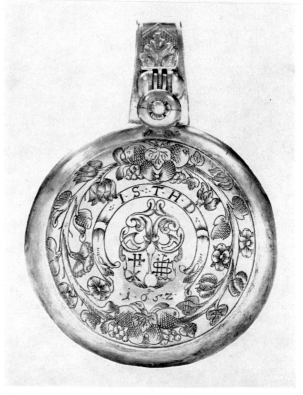

52a

DIMENSIONS H. 17·8 cm. W. (max.) 16·5 cm.

CONDITION Good, except for some dents.

M.30–1948

PROVENANCE Bequeathed by Mrs James (from the collection of her husband, Arthur James).

Oluf Jørgensen, the maker of this fine tankard, is regarded by Krohn-Hansen (*op. cit.*, pp. 115–18, 318) as the most important Bergen goldsmith of his generation. The form is typical of Bergen c. 1650. The pounced inscription on the front records a nineteenth century gift of the tankard.

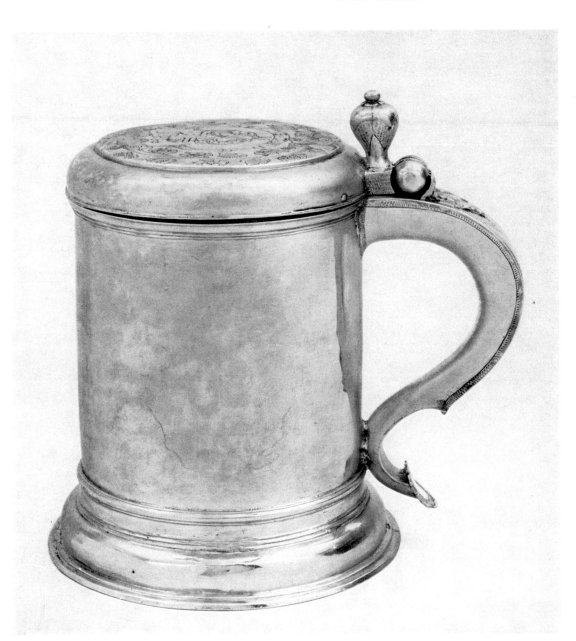

33 TWO-HANDLED DRINKING BOWL

Bergen, last quarter of the seventeenth century. The bowl is shaped into eight flutes: on the centre one of these is engraved on both sides a spray of two palm-branches tied together by a ribbon enclosing (on one side) the initials J.F.M./ E.H.D., on the other the initials HR.O.F./ D.F.M. Each of the flutes has a deeply sunk border: the spandrels formed at the base by the junction of these are decorated with an engraved and punched ornament composed of three stems topped by balls. Between each of these is an oval depression. The base is formed as an oval cartouche with a deeply sunk border: it is engraved with the names: *M: F: Finde/ Salig: Hr: Niels Legangers.* The bowl rests on three ball-shaped feet cast and applied. The scroll-shaped handles are decorated with volutes.

MARK On the base.

MAKER'S MARK: O enclosing an I in an oval for Oluf Jørgensen, working in Bergen from 1650 to 1700 (*Bergens Gullsmed*, p. 359).

MEASUREMENTS H. 5·6 cm. W. 16·6 cm.

CONDITION Right handle re-soldered to bowl, here slightly damaged.

Circ.162–1913

PROVENANCE Purchased (£13) from G. Jorck.

This bowl is of German inspiration in design. T. Krohn-Hansen (*Trondhjems Gullsmedkunst 1550–1850*, Oslo and Bergen, 1963, pl. 129A–C) illustrates three examples of the general type but with spirally fluted sides, made in late seventeenth or early eighteenth century Trondheim, recording (p. 136) that no examples are known to him from elsewhere in Norway, even from Bergen, and that the design is uncommon in Denmark. These three pieces are directly imitated from a group made in Hamburg.

The relation is much closer between the Museum's bowl and a bowl of 1658 by Anders Andersen Heins of Trondheim (Krohn-Hansen, *op. cit.*, pl. 128A) with feet added later in the Rococo style. This has a body composed of eight flutes and scroll-handles closely resembling those on the Museum's bowl. For Jørgensen see M.30-1948 (No. 32). No other Bergen example of this design appears to be recorded, and the bowl is therefore of considerable rarity. Fortunately its original owners have been identified by Dr Jorunn Fossberg of the Norsk Folkmuseum, Oslo. The initials J.F.M./E.H.D. are those of Johan Clausen Frimann (b. 1630–d. 1706), manager and owner of great landed estates in Western Norway, and his second wife Else Henningsdatter Smith. The date of their marriage is unrecorded, but their first child was born in 1681.

The initials HR.O.F./D.F.M. are those of Otto Finde, parson in Volda from 1687 to 1741 and his second wife, Drude Frimann, daughter of Johan Clausen Frimann by his first wife Maria Fuiren. Their date of marriage is not recorded, but their first child was born in 1698. The inscribed names M. F. FINDE/ SALIG HR. NIELS LEGANGERS are those of Maria Fuiren Finde (b. 1700–d. 1777), daughter of Otto Finde and Drude Frimann, who married in 1728 Niels Leganger (1682–1747), parson in Os by Bergen from 1704 to 1747.

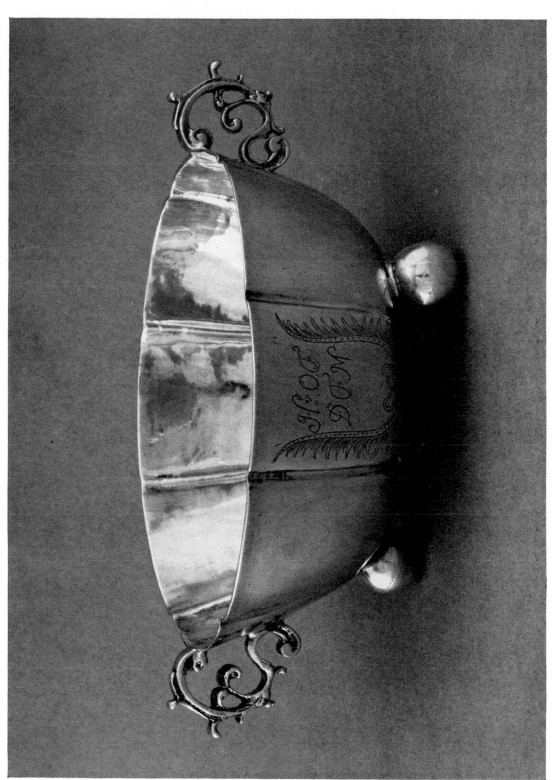

34 PEG TANKARD

Bergen, dated 1689. The cylindrical body has a moulded rim, and is surmounted by a domed lid. It rests on three feet in the form of eagle claws grasping a ball. The scroll-shaped handle, terminating in a shaped escutcheon, is attached to the rear foot and to the body by soldering. It is surmounted by a thumb-piece in the form of a lion rampant whose front paws rest on a ball above the lid. The body is boldly chased and engraved with floral decoration: in the centre are engraved two crossed branches of palm, with the Danish inscription

> *O Gúd dú est Ennú Saa Rig*
> *Som dú Haffúer. voeret Eúindelig*
> *Tie dig Star alt. mit Haab*
> *Min Siael Beúar og. giör*
> *Hende Rig*
> *Saa Haffúer. iej. nock*
> *Eúindelig.*

('O God, thou art still as rich/as thou hast been eternally/To thee stands all my hope/ Preserve my soul and make it rich/ So have I enough eternally.') Beneath the palms the initials EHS/MID are crudely engraved. The lid is engraved with a floriated stem enclosing a three-quarter medallion whose frame is inscribed: *1689 Hinrich. Farnauw∗Echte. Castens. Weijlandt.* Inside the medallion are a pair of shields among mantling of foliage: that on the left is inscribed HNF in monogram, that on the right has a dove bearing an olive branch. The handle is decorated with an engraved foliated stem. The lion and ball and the eagle claws are chased. The interior is marked with six pegs. The base bears two early inscriptions recording the weight.

MARKS On the base.

MAKER'S MARK of Michel Vahl of Bergen, working from 1687 until 1704 (*Bergens Gullsmed*, p. 358). Struck four times.

DIMENSIONS H. (max.) 19·5 cm. W. (including handle) 18·5 cm.

CONDITION Crack and repair in lid under rear paws of lion. Some denting along lower rim of body. See also below.

M.42–1949

PROVENANCE Bequeathed by Mr F. J. Varley, who was already in possession of it by 26 March 1919.

For Michel Vahl (b. c. 1658) see *Bergens Gullsmed* (p. 156). Floral baroque ornament appeared in Bergen in the 1660s, and remained the most popular form of ornament for goldsmith's work until the end of the century (see the discussion of the style by Krohn-Hansen in *Bergens Gullsmed*, pp. 315–16). The crudely engraved initials beneath the laurel are a later addition.

All persons who took up a craft or trade in Bergen had to be registered as burghers (*borger*). Hinrich Farnou, from Minden in North Germany, became a burgher in 1626. His son Hinrich, whose name is engraved on the present tankard, became a burgher in 1680, but there is no mention of his profession in Bergen's *Borgerbok*. The family seem to have been small traders: a Hans Jostsen Farnouw, who was probably a nephew of the Hinrich of the tankard, traded in furs, and another Hinrich, who became a burgher in 1718, kept a small shop for country folk. Of the Wejlandts, the family of Hinrich's wife, we know that Carsten, who became a burgher in 1706, was a baker and that his brother was a skipper. (Information kindly communicated by Dr A. Polak.)

There is a marked disparity in style between the chased decoration of the body and the engraved decoration of the lid, which fits a little loosely. A surprising feature is that the base of the thumb-piece, instead of resting flush on the top of the handle below, as is usual, is raised above it and is narrower. However, it appears to be a replacement. Both the

technique of chasing and the all-over decoration are exceptional in Bergen at this period: hence it is possible that the body was originally plain except for the inscription and spray and that the chased decoration was added a little later.

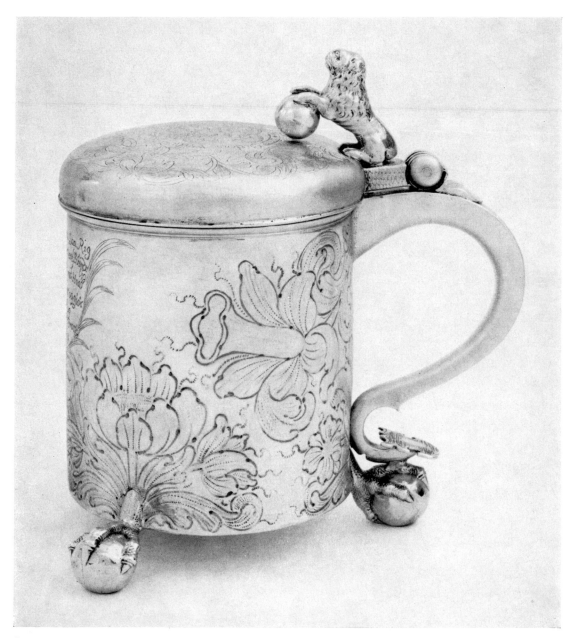

35 PEG-TANKARD

Strømsø (Drammen), c. 1680. Parcel-gilt. The cylindrical body is engraved with a garden scene. To the left stands a man dressed in the costume of a late seventeenth century gentleman, with high-heeled shoes, baggy breeches, frogged coat and lace cravat, his long locks falling on his shoulders. He stretches out his right hand to pluck an apple. Beyond are two other trees with sprays and foliage. On one of the sprays is perched an exotic bird (a Chinese phoenix). In the centre is a shield of arms, *a bird (hawk or parrot?) standing on the ground*, richly mantled and surmounted by a helm from which rises a crest in the form of three

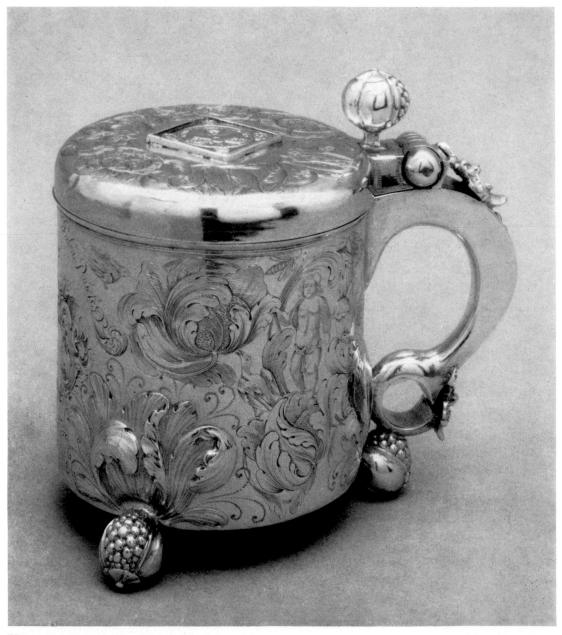

sprays of flowers. Above is an arched ribbon which terminates in a scrolling leaf at either end: this is inscribed: *Jens OlúfSön. Dortea. Póuels. D.* Beneath is engraved a third name: *Olle JensSön.* To the right is a child, naked except for a cloak and loin cloth, standing among scrolling floral Baroque tulips and roses and foliage, with a bird, an exotic insect and a parrot above and another bird among the foliage. Above each of the three feet, which are cast in the shape of bursting pomegranates, the body is embossed and chased with a tulip-flower. In the vertical-sided lid, in a plain engraved medallion, is set a square frame containing a gilt memorial medal of King Frederick III of Denmark. The obverse of this, on the top of the lid, shows: (1) in the upper half a crown over the monogram F 3 with clouds on either side and beneath; (2) in the lower half, an orb, a sword and sceptre crossed and two crowns on a field. At the top is the inscription: MANET ULTIMA COELO (the last crown awaits him in Heaven). Around the circular frame enclosing these are four shields containing (reading clockwise from the top): (1) the arms of Denmark; (2) the arms of Sweden; (3) the arms of Delmenhorst; (4) the arms of Norway. The reverse (visible inside the lid) shows a rocky ground with the sun rising in the East. On it is an obelisk with a lion resting at its base: the obelisk is inscribed: ANIMAE AETERNAE FRIDER III OPTIM: PRINCIP:. Above runs the inscription DAN. NOR. VAN. GOT. REX. Outside the circular frame enclosing this motif, at the four points, are the inscriptions: (1) NATVS./18. *Marti.* 1609; (2) CORONATVS/3 *Novemb.* 1648; (3) REGNAVIT/*Annos.* 22; (4) OBIT/*9. Febr. 1670.* The lid is engraved with a band of Floral Baroque flowers and foliage around the central medallion. The thumb-piece, like the feet, is shaped as a bursting pomegranate. The scroll-shaped handle is decorated with a line of bosses down the outside: to it are applied two cast and chased grotesque masks, one below the hinge and one at the foot. A leaf is engraved and chased above the one, below the other. Down the gilt inside of the tankard runs a row of pegs.

MARK On the base.
MAKER'S MARK: HNM in a shaped shield, for Hans Nieman the Elder (b. c. 1630, master in Strømsø 1679–1721). See below.
DIMENSIONS H. 15·4 cm. W. (max.) 18·7 cm.
CONDITION One or two dents on rim. Gilding renewed. See also below.
PROVENANCE Purchased (£299 with Nos. M.485 to 490–1910) as 'Scandinavian' from Marius Hammer, Strandgaden 57, Bergen, Norway. Hammer was the well-known Bergen goldsmith and dealer. According to a minute by the then Director of the Museum, Sir Cecil Harcourt-Smith, he had 'the most important collection in Norway of Old Norwegian and other silver'.

M.488–1910

The remarkable quality of the tankard was recognized by H. P. Mitchell on acquisition: 'exceptionally beautiful engraving...an unusually fine specimen of Scandinavian work'. Until recently the tankard was classed as Danish, by an unidentified maker, c. 1680 (as in Oman, *Scandinavian Silver*, 1959, pl. 11). The mark, however, is certainly that of Nieman (see Oslo (Kristiania), Kunstindustrimuseum, *Gammel Guldsmedkunst i Arbeider fra 15. til 19. Aarhundrede*, 1909, p. 177, p. 25, no. 92). Nieman was born c. 1630, and worked from 1679 in Strømsø, where he died in 1721 (for his dates see Drammens Museum, *Gullsmedkunst i Drammen*, exh. cat. by K. Mellbye Gjesdahl and H. Alsvik, May–June 1972, p. 6).

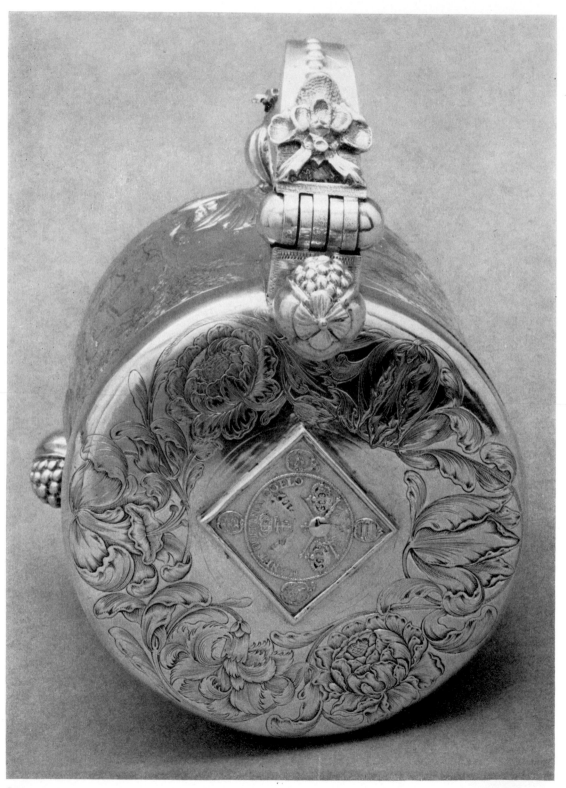

35a

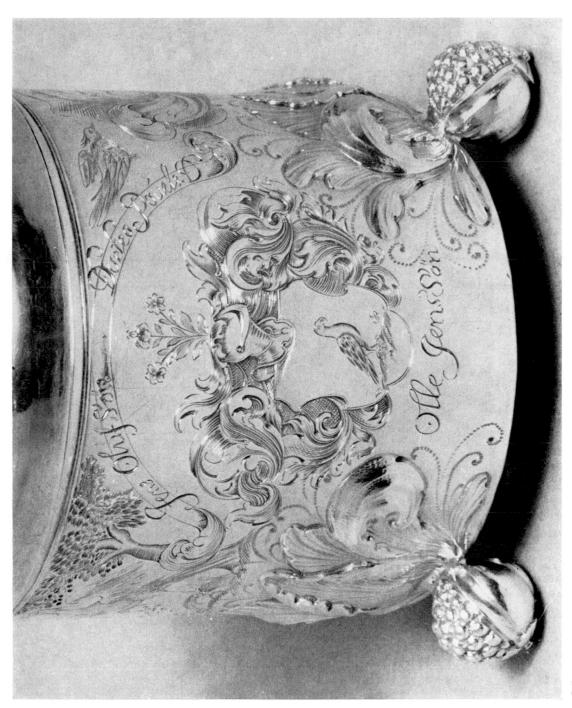

Strømsø, incorporated in 1615, lies on
the southern side of the Drammen river,
some 20 miles S.W. of Oslo, and now
forms part of the modern town of Dram-
men. The ironmaster Jens Olufsen
Bruun, whose name is inscribed on this
tankard together with that of his wife
Anna Dorthea Povelsdatter (d. 1709) was
born c. 1653 and was buried on 29 July
1707. He was a joint owner of the Hassel
ironworks in Eiker and from 1691 to
1699 tenant of the ironworks at Kongs-
berg. In addition he owned the estate of
Berg near Kongsberg. By his wife he had
five children, one of whom was the Olle
Jenssön Bruun whose name is also in-
scribed on the tankard. Olle was pur-
veyor to the silver mines at Kongsberg
and died in 1714 (see *Norsk slektshi-
storisk tidsskrift*, vol. ii, Oslo, 1930, p.
288; J. K. Bergwitz, *Kongsberg 1624–
1924*, Kra, 1924, pp. 141, 219; informa-
tion and references kindly communi-
cated by Dr Henning Alsvik of Dram-
mens Museum.) For the stove-plates and
other work of artistic interest produced
at Bruun's works see A. Nygård-Nilssen,
Norsk Jernskulptur, vol. 1, Oslo, 1944,
pp. 124 ff, 136 ff, 165 ff.) This work also
gives some biographical information
about him (vol. i, p. 280, no. 120, p. 296,
no. 4). His wife's monogram PVD ap-
pears with his on stove-plates. Dr Alsvik
and Dr K. Mellbye Gjesdahl consider
that the tankard was certainly made as a
christening gift for the baptism of Olle
Jenssön. The symbolism of the design is
difficult to interpret but they suggest
that it may refer to the birth of Olle,
who would then be figured in the naked
child.

For the memorial medal of King
Frederick III, which was issued in 1670
in two versions, see G. Galster, *Danske og
Norske Medailler og Jetons*, Copenhagen,
1936, p. 125. The medallist is unknown.
It is likely that the medal is a later inser-
tion, since the outline of the engraved
medallion enclosing it appears to have
been partly erased.

35d

36 BEAKER

Norwegian, first half of the eighteenth century. The body, which has an everted rim, is engraved with three circular panels on a matted ground. Two contain flowers, the third a foliated cartouche which presumably once contained initials. The beaker rests on three plain ball feet. On the band above the ornament are pricked the initials *Hr. F. S.*

MARKS On the base.
MAKER'S MARK: GK. Struck three times.
DIMENSIONS H. 6 cm. W. 5·5 cm.
CONDITION Poor. Rubbed, worn and feet
 battered.

1913–1898
PROVENANCE Given by Col. F. R. Waldo-
 Sibthorpe.

The GK (the G is joined to the K by a stroke across the top) who made this rather crude beaker does not appear to be recorded. The beaker was acquired as Danish, probably eighteenth century, but is in reality of Norwegian origin (an opinion kindly confirmed by Dr J. Fossberg). The style of the engraving is that of the first half of the eighteenth century: the form is one current in the second half of the seventeenth century and the early decades of the eighteenth. A comparable example made in Northern Norway and dated 1733 is reproduced by Fjellström, pl. 11: 13 a & b (see also p. 150 for an example dated 1667).

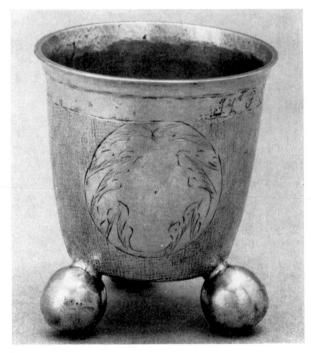

36

36a

37 BEAKER

Kristiania (Oslo), dated 1738. Shaped as a truncated cone, with everted rim. Engraved on the front is a heart containing the engraved initials L A S and the date 1738. Under the initials is crudely pounced a second, later set M J D. The opposite side is engraved with a pendant motif of leaves, a pine-cone and scrolls, on which is perched a bird. To either side is a spray of acanthus leaves disposed around a tall pedestal from whose edge

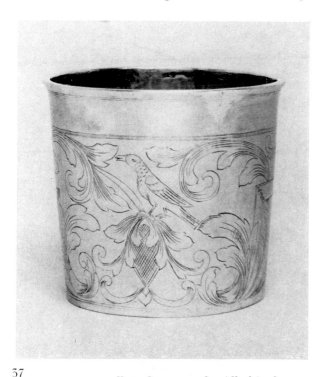

37

a scroll curls outwards. All this decoration is separated from the rim by a plain band, pounced above the heart with the initials E. M. L. D.

MARKS On the base.
MAKER'S MARK: RA/P in a shaped cartouche, struck twice, for Romanus Andersen Pharo of Kristiania. See below.
CONDITION Lip cracked and repaired.
DIMENSIONS H. 7·7 cm. W. 8·5 cm.
M.572–1911

PROVENANCE Purchased (£6 16s 6d) from G. Jorck. H. P. Mitchell, recommending the beaker in a minute of 17 June 1911 wrote that 'it is evidently Danish or German work...The decoration of engraved foliage is done with spirit in a very simple manner–this and the unusual proportions of the object would I think make it a very useful addition to our collection.' Supporting, Watts wrote: 'The Beaker is of rather uncommon type and I should be glad to have it for our collection.'

This fine and notably heavy beaker was tentatively attributed to Poland until the preparation of this catalogue. The maker's mark is recorded in Kristiania Kunstindustrimuseum, *Gammel Guldsmedkunst*, 1909, pp. 183, 80–2, nos. 332, 337, on a beaker dated 1738 and a tankard-lid dated 1744, both in Kra collections in 1909. A closely comparable beaker of 1749 with the same or very similar decoration by Romanus Andersen Pharo of Kristiania (b. c. 1712, burgher 1725–c. 1757) is illustrated by H. Grevenor and Th. B. Kielland (*Guldsmedhaandverket i Oslo og Kristiania*, Oslo, 1924, p. 92). The two versions of Pharo's mark which these authors give (p. 390) are different from the mark on the present beaker. They appear, however, to date from 1746 and later, and Dr Fossberg has kindly confirmed that the mark on the present beaker is an earlier form of Pharo's mark.

37a

38 'WELCOME CUP'

Bergen, c. 1745–50. The foot, stem and
body are separately made. The domed
lid is surmounted by a putto holding a
cylinder sheath in his right hand and, in
his left a scroll (?). He stands on a winged
globe. These two features are separately
cast and attached to the lid beneath by a
screw. The lid is decorated with mixed
Bérain and rocaille motifs on a matted
ground rising into a Late Baroque
baldacchino form. This decoration, like
the decoration on the bowl beneath, is
chased. The bowl has a moulded rim,
under which is a band of decoration on a
matted ground consisting of Louis XIV
trophies alternating with panels of inter-
lacing Bérain scrollwork containing
rocaille shells. The narrow waist of the
bowl is decorated with three figurated
scenes divided from each other by: (1) a
trophy of musical instruments; (2) a
table surmounted by vessels, by a cane
and by a fan; (3) a conventional late
Baroque ornamental trophy. The scenes
between are: (1) a maiden chained to a
rock in a rocky landscape (probably for
Andromeda); (2) Cupid seated on a
bridge holding a trumpet, with a town-
scape in the background; (3) Cleopatra
seated in a garden, arms outflung in
despair. Below its swelling bulge the bowl
is decorated with three panels of strap-
work, rocaille and other ornaments, be-
tween each of which is an antique mask
or head. The narrow bulging element at
the base has ornament of engraved and
chased leaves on a matted ground. The
stem below has a spool-shaped neck with
a central moulding, to which are applied
three scroll brackets. The knop beneath
is decorated with six panels, three of gad-
roons alternating with three of grotesque
heads. It terminates in a hexagonal
moulded base fastened to the foot by a
screw. The bulge at the top of the foot
has a band of Louis XIV strap ornament
with rocaille shells: the dome of the foot

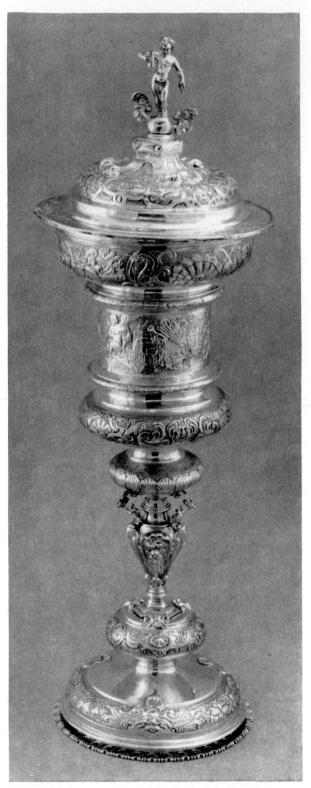

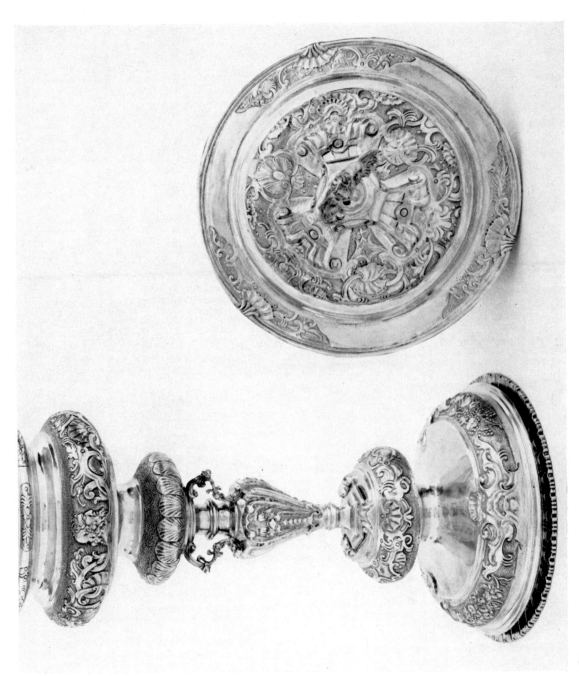

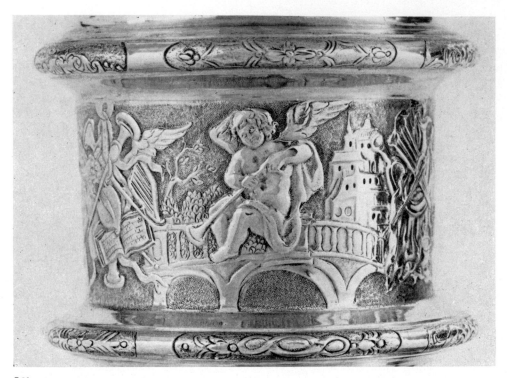

38b

is decorated with three grotesque heads in the auricular style, two panels of fruit and foliage and one of vine-stems and grapes. The ribbed foot is notched round the edge.

MARKS None.

DIMENSIONS H. 39·1 cm. Diam (max.) 13 cm.

CONDITION The boy once held an emblem (probably a flag), which passed through the sheath in his right hand and evidently fitted into a socket in the globe on which he stands.

M.70, 70A–1909

PROVENANCE Given by Mrs H. J. Pfungst.

A note made at the time of acquisition reads: 'Mr. Murray Marks' (of Messrs. Durlacher) from whom this cup was bought, 'calls it a diploma work and attributes it to Samuel Goudig of Dresden, 1740–50 stating there is work by him at Dresden.' The cup was correctly identified as either a 'master-piece' or as a guild-cup presented by a candidate for admission to the Bergen guild by Th. Krohn-Hansen and R. Kloster (*Bergens Gullsmed Kunst*, vol. ii, pl. 99). A cup of this form, which originated in the sixteenth century, was the prescribed test for admission to the Bergen guild until 1758. Krohn-Hansen and R. Kloster illustrate a number of examples from the eighteenth century made for this purpose and for ceremonial use at banquets given by guilds. The absence of marks on this piece suggests that it may be a 'master-piece', rather than a cup for guild use. A cup ceased to be the prescribed form for aspirants to the goldsmith's guild in Bergen in 1758, when a Copenhagen workman, Anthon Bredenbeck, insisted on presenting a coffee-pot, as was customary in the Copenhagen guild and elsewhere in Norway and Denmark. After the guild had refused to accept this domestic article in place of the

traditional ceremonial cup as evidence of skill, Bredenbeck appealed successfully to the royal authorities in Copenhagen and with their assistance was admitted into the guild. After this insistence on a cup ceased (Krohn-Hansen and Kloster, *op. cit.*, vol. i, p. 325). The Bergen guild seems to have clung to the cup as a useful means of restricting admission since it was too expensive and too useless an article for the ordinary journeyman to make.

The Rococo style, of which there are elements in this cup, was introduced into Bergen in the early 1740s, and the date c. 1740, proposed by Krohn-Hansen and Kloster (*op. cit.*, vol. ii, pl. 99) and accepted by Oman (*Scandinavian Silver*, pl. 18), is possibly a trifle on the early side. The Bérain style which is dominant in the cup was brought to Bergen c. 1704 by Johannes Reimers the Younger, who is known to have used engravings by Daniel Marot.

39 BEAKER

Strømsø (Drammen), dated 1767. Parcel-gilt. The beaker rests on three plain ball feet. The barrel body is embossed and chased with a spray in the Floral Baroque style, between a line of punched dots a the base and another below the rim. Above the upper line of dots the beaker is gilt: a pounced inscription on this gilt band reads: *Peter Klein, Anna Catherina Klein* 1767. The rim and the inside are also gilt

MARK On the base.

MAKER'S MARK: PK over 63 in a shaped shield for Peder Johansen Kruse of Strømsø, (b. 1732, master 1763, burgher in Strømsø 1764, d. between 1785 and 1797). See Oslo (Kristiania) Kunstindustrimuseum, *Gammel Guld-smedkunst i Arbeider fra 15. til 19. Aarhundrede*, 1909, p. 182, no. 342; p. 88, no. 377, and Drammens Museum, *Gullsmedkunst i Drammen 1660–1900*, exh. cat. by K. Mellbye Gjesdahl and H. Alsvik, May–June 1972, pp. 22–23.)

DIMENSIONS H. 8·2 cm. Diam. (max.) 7·8 cm.

CONDITION Crack in base.

M.41–1925

PROVENANCE Purchased (£5) from E. S. Attenborough.

On acquisition this fine beaker was described as Baltic, a classification retained until the preparation of this catalogue. The figures 63 in the mark were wrongly interpreted as indicating the date 1663, according to a system known to have been current in Scandinavia during the eighteenth century. Dr Jorunn Fossberg of the Norsk Folkmuseum, Oslo, kindly informs me that the inscribed date 1767 is likely to be that when the beaker was made, since she knows of numerous instances when a maker kept a special year (e.g. that of his mastership) in his mark for many years.

The beaker is therefore a late example of a type which is found in Scandinavia from the later decades of the seventeenth century. H. Grevenor and Th. B. Kielland (*Guldsmedhaandverket i Oslo og Kristiania*, Kristiania (Oslo), 1924, pp. 41, 53, 71, 76) reproduce examples, covered and uncovered, made in Kristiania, which range in date from 1663 to 1727. For similar beakers made in western Norway see Krohn-Hansen (*Bergens Gullsmed*, vol. ii, pl. 74, all dated by him c. 1700) and *id.* (*Trondhjems Gullsmedkunst 1550–1850*, Oslo and Bergen, 1963, pl. 103, dating from 1684 onwards). A. Polak (*Gullsmedkunsten i Norge før og nå*, Oslo, 1970, p. 60, fig. 42) reproduces a covered beaker very similarly decorated made by Hans Nieman of Strømsø (see No. 35) between 1679 and 1721. Both the form and the Floral Baroque decoration were so popular that they persisted with some varia-

tions until the last decades of the eighteenth century. An example from 1778, even later than the Museum's beaker, by the same maker, Peder Kruse, is listed in Drammens Museum, *Gullsmedkunst i Drammen 1660–1900*, May–June, 1972, p. 23, no. 225.

Peter Möller Klein (1736–80), whose name appears in the inscription on the present beaker, was a wealthy merchant, ship-owner and timber exporter who lived at Tangen in Drammen, and also owned an estate called Austad in Skoger, near Drammen. His wife Anna Catherina Lohrmann was born in Kongsberg in 1740 and died in Christiansfeld in 1801. They were married on 25 October 1765. (See Odd. W. Thorson, *Drammen: En norsk Östlandsbys utviklingshistorie*, Drammen, 1962: information and references kindly communicated by Dr Henning Alsvik of Drammens Museum.)

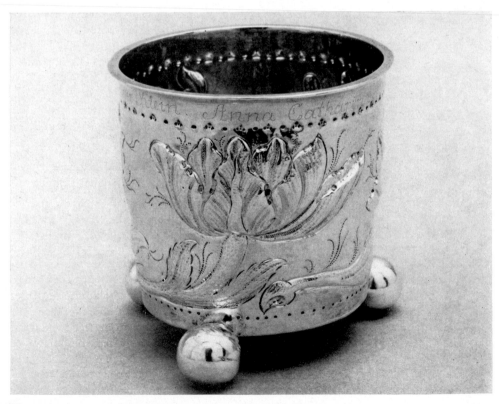

40 BEAKER

Kristiania, third quarter of the eighteenth century. Parcel-gilt. The trumpet-shaped body, with gilt everted rim, is girdled round its upper part by a gilt moulded band with a strawberry leaf upper edge. To this are soldered six loops from which hang six gilt concave discs, each with a corded wire round the edge. Round the lower part is soldered a gilt corded band to which are applied three gilt cast cherub heads. Below the band of gilding round the rim runs a broad band

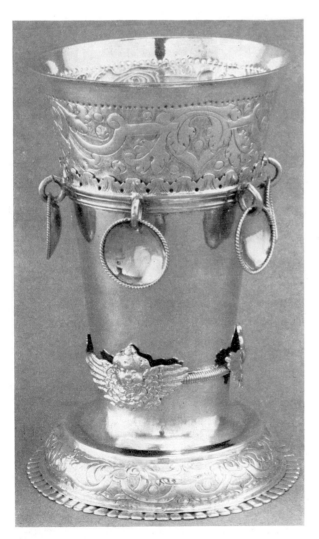

40

of foliated scroll-work stems interlaced in the manner of Bérain ornament, the whole on a matted ground. The domed foot has a similar band of decoration: it has a gilt ribbed-base with scalloped edge, separately made and attached. The inside is gilt.

MARKS On the base.

TOWN MARK: a crowned c enclosing another motif (incompletely legible). See below.

MAKER'S MARK: ER in a shaped cartouche. See below.

DIMENSIONS H. 13·2 cm. Diam. 8·8 cm.

CONDITION Good, except that some of the gilding is worn.

1879–1898

PROVENANCE Given by Col. F. R. Waldo-Sibthorp.

The maker's mark is that of Ernst Peter Michelsen Rømer (1719–77), who was working as a goldsmith from 1747 in Kristiania (Oslo [Kristiania] Kunstindustrimuseum, *Gammel Guldsmedkunst i Arbeider fra 15. til 19. Aarhundrede*, 1909, p. 176, no. 160). For an inventory of his possessions taken in 1778 after his death, for Rømer himself and for reproductions of three pieces by him in international styles see H. Grevenor and Th. B. Kielland (*Guldsmedhaandverket i Oslo og Kristiania*, Oslo, 1924, pp. 316–319, 391, 421–39, figs. on pp. 115, 163, 178). The identification is supported by the crowned c of the town mark, since the town mark of Kristiania from c. 1629 until c. 1785 consisted of a crowned c with two, later four figures for the year (cf. Grevenor and Kielland, p. 387). The beaker from which Rømer's mark is reproduced in *Gammel Guldsmedkunst* appears from the description given (p. 10, no. 34) to be markedly similar to the present example, with six gilt concave discs on the upper band, three cherub heads on the lower band and Louis XIV ornament.

41 WAGER CUP

Bergen, 1794. Parcel-gilt. In the form of a girl, slender and narrow-waisted, wearing a *rebato* (stiffened upstanding collar) and a low-cut waistcoat over a French farthingale skirt. The waistcoat is decorated with rosettes on a matted ground. The skirt is decorated with floral motifs, chased and engraved, arranged in panels. Round her neck is a necklace, terminating in a pendant: a four-stranded chain hangs from her shoulders. On a broad gilt band round the lower edge is the inscription: *adet: Premie for Halsen Vunden af Kiöbmand og Contorisk Egen handler Hr Christoper Ellerhusen/Bergenske Skÿdje Selskab 1794*. On her head the girl holds a U-shaped support with dentellated edge in which hangs a small bowl chased and engraved with floral ornament and decorated beneath with a little knob. The upper part of the figure is cast in two sections. The inside of the skirt, which forms the principal cup, is gilt, as is the inside of the bowl.

MARKS On the base of the farthingale.

TOWN MARK of Bergen in the form used from 1793 to 1795 (*Bergens Gullsmed*, p. 347).

ASSAY MARK: MP for Mattias Pettersen, warden from 1790 until 1812.

YEAR MARK: 94 for 1794.

MONTH MARK for 21 June–22 July.

MAKER'S MARK: PCB in a shaped oblong for Peder Christensen Beyer, working in Bergen from 1774 until 1808 (*Bergens Gullsmed*, p. 360).

DIMENSIONS H. 19·3 cm. W. (max.) 7·8 cm.

CONDITION Good, but the gilding has been renewed.

1902, 1902A–1898

PROVENANCE Presented by Col. F. R. Waldo-Sibthorp.

The costume was identified on acquisition as seventeenth century. It should be compared with the costume of c. 1605–1610 worn by Anne of Denmark in a portrait by Marcus Gheeraerdts the younger in the collection of the Duke of Bedford (see R. Strong, *The Elizabethan Image*, exh. cat., Tate Gallery, 1969–70, no. 160). The hair-dressing, jewellery and clothes are fairly realistically shown on the cup, though the seams of the bodice and skirt have been much simplified (note contributed by Mrs Madeleine Ginsburg of the Department of Textiles).

Wager or maiden cups of this general design were still typical productions in late eighteenth and early nineteenth century Bergen: three ranging in date from 1782 to 1819 are reproduced in *Bergens Gullsmed*, vol. ii, pl. 158. The Museum's example is of excellent quality and finish. The type originated in Late Renaissance Germany and Holland. According to R. Kloster (in *Bergens Gullsmed*, p. 329) it was highly fashionable in Bergen during the eighteenth century. The inscription reads in translation: 'Second prize for the neck [*of the popinjay*] won by Counter-member and Merchant Christoffer Ellerhusen. Bergen Shooting Society, 1794.' An attempt has been made to erase the date. The Bergenske Skydeselskab (Bergen Shooting Society) was founded in 1769, and several pieces of Bergen silver from the eighteenth century which were awarded by it as prizes in competitions for shooting at the popinjay still survive, e.g. a covered goblet by H. B. Hind (working 1757–76) decorated with a bird finial and an engraved scene of popinjay shooting, and a tea-caddy of 1785, third prize for hitting the right wing (repr. Krohn-Hansen, *Bergens Gullsmed*, pl. 149, 167r).

Christoffer Ellerhusen, who won this wager cup as a prize in 1794, was born on 6 June 1757 and died on 18 February 1816. He was a merchant from Sultz in Mecklenburg-Schwerin and settled in

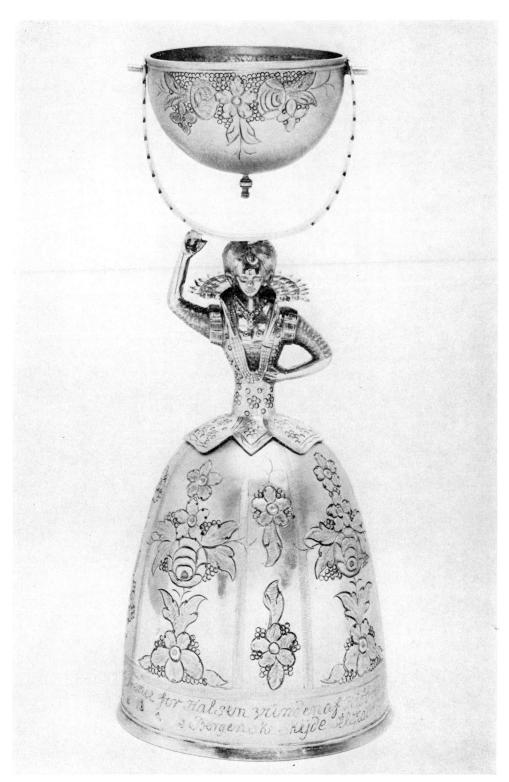

41

Bergen on 30 August 1772, probably
having been attracted there because his
mother's father, another merchant from
Sultz named Pytter, had also settled in
Bergen. On 8 January 1787 he married
Gertrud Hellen Pytter, by whom he had
ten children. (A. M. Wiesener, *Dødsfald
i Bergen 1765–1850*, Bergen, 1925:
reference and information kindly com-
municated by Dr A. Polak.)

42 BEAKER

Bergen, 1795. Parcel-gilt. The body is
shaped as an inverted cone, with an
everted rim gilt on both the outside and
inside. The upper part of the body is
girdled by a broad gilt moulded band, to
which are applied three gilt rosettes with
hoops protruding from the centre, and
three plain hoops. From these last hang
three concave disks. Round the neck of
the foot, masking the junction of body
and foot, runs a gilt corded band. The
domed base has a flanged edge: to this
are attached three gilt feet in the form
of a classical mask over a hoof. Pricked
on the base are the initials M:H:S:. and a
merchant's mark incorporating M and a
cross. A Gothic letter *n* is engraved on
the foot.

MARKS On the base.
TOWN MARK of Bergen.
WARDEN'S MARK: P for Matthias Petter-
 sen (warden 1790–1812).
YEAR MARK: 95 for 1795.
MONTH MARK for 22 May–21 June.
MAKER'S MARK: HB above 1795 for Hans
 Joergen Michaelsen Blytt, working
 1790–1821 (*Bergens Gullsmed*, p. 353).
DIMENSIONS H. 16 cm. W. 9·8 cm.
CONDITION Three concave disks or orna-
 ments missing from hoops on rosettes.
 Dented and repaired.
 M.570–1911
PROVENANCE Purchased (£17) from G.
 Jorck.

For Hans Joergen Michaelsen Blytt see
Thv. Krohn-Hansen and R. Kloster (*Ber-
gens Gullsmed*, pp. 258–60). His mark as
struck on this piece differs from those
they reproduce in that it is in an oval,
not in the square with canted corners
which they show for a mark struck by
Blytt in 1795.

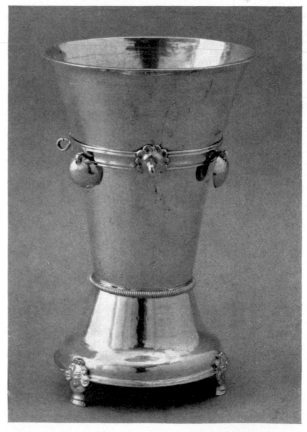

43 BEAKER

Bergen, 1797. Parcel-gilt. The body, which is shaped like an inverted cone, has a gilt everted rim. The upper part of the body is girdled by a moulded band, with eight hoops soldered to it from which hang eight gilt concave discs edged with corded wire. Between the gilt rim and the moulded band is a band of four fish (formerly gilt) in relief on a matted ground. A second moulded band is applied round the lower part of the body: to this four hoops are soldered from which hang four more discs. The band of decoration between the upper and lower bands consists of a neo-classical laurel swag on a matted ground. The neck of the foot is enriched by a band of cast beading: the foot proper terminates in a beaded edge. The top of the broad base is chased with a neo-classical swag on a matted ground: its side is concave. The inside is gilt.

MARKS On the base.

TOWN MARK of Bergen

WARDEN'S MARK: MP for Matthias Pettersen (Warden 1790–1812).

YEAR MARK: 97 for 1797.

MONTH MARK for 20 March–20 April.

MAKER'S MARK: AL for Andreas Lude (working 1776–96).

DIMENSIONS H. 13·6 cm. W. 9 cm.

CONDITION A dent in the body, two discs lacking a piece of their corded edge.

1880–1898

PROVENANCE Given by Col. F. R. Waldo-Sibthorp.

For Andreas Lude (1743–96) see Krohn-Hansen and Kloster (*Bergens Gullsmed*, pp. 253–55). This piece was evidently made after his death, when his shop passed to his widow. Lude's workshop produced some of the most sophisticated silver of late eighteenth century Bergen: this beaker must have been made for a humbler class of client, perhaps a fishing-captain. According to Krohn-Hansen and Kloster MP was used by Pettersen as his goldsmith's mark: here, however, and on M.45–1909 (No. 44) it is found as his warden's mark.

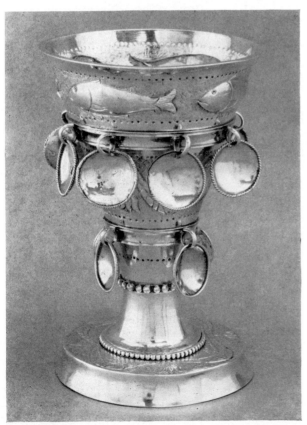

44 BEAKER

Bergen, 1797. Parcel-gilt. The body is shaped like an inverted cone, with everted rim, and is encircled by two moulded bands. To the upper band are applied six loops, from which originally hung three gilt-lozenge shaped ornaments and three circular discs stamped with a plant motif. To the lower band are applied three cast cherub-heads, and three hoops, from which hang a circular disc and a lozenge. The neck of the foot is held by a corded band. Between these three bands are broad bands of rosette and foliage ornament, chased on a matted ground. This decoration is repeated on the upper surface of the circular base, which has a concave side, and is joined to the neck by a trumpet-shaped stem.

MARKS On the base of the foot.

TOWN MARK of Bergen.

WARDEN'S MARK: MP for Matthias Pettersen (Warden, 1790–1812).

YEAR MARK: 97 for 1797.

MONTH MARK for 21 June–22 July.

MAKER'S MARK: JSH for Johan Salomon Hind (working 1792–1817).

DIMENSIONS H. 12 cm. Diam. 8·6 cm.

CONDITION One disc and one lozenge missing from upper band, and one ornament from lower.

M.45–1909

PROVENANCE Purchased (£14) from G. Jorck.

For Hind (b. 1766) see Krohn–Hansen and Kloster (*Bergens Gullsmed*, p. 267).

The beaker was recommended for acquisition because the collection of Scandinavian silversmith's work 'is found to be of considerable use to students'. The lozenge-shaped ornaments are known as 'Lapp leaves', and are typical of silver made for the Lapp market (see P. Fjellström, *Lapskt Silver*, Stockholm, 1962, p. 298). Dr Fjellström emphasizes the importance of Bergen as the earliest centre for Lapp silver.

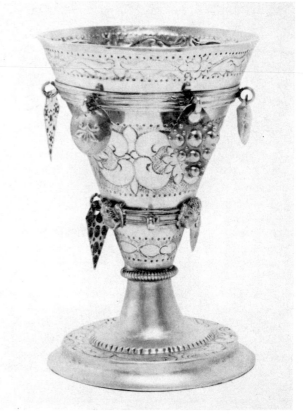

44

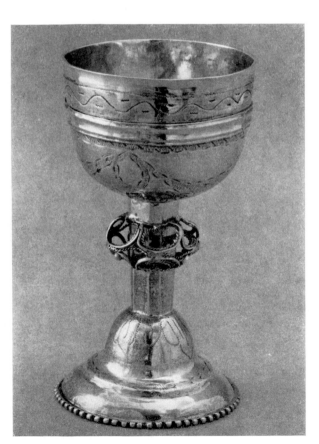

45

45 DRINKING CUP

Bergen, 1802. Parcel-gilt. The bowl, which has a gilt everted rim, is encircled by a moulded band. Between this and the gilded band round the rim is a band of wavy ornament engraved in wrigglework between two lines in the same technique. The lower part of the bowl is decorated with crude engraved neo-classical wreaths and swags, above a calyx of leaves in the wrigglework technique. The octagonal stem has an openwork knop of filigree, whose panels where once filled with a filigree coil (only one now remains). The domed foot is decorated with a leaf-pattern round its upper edge and a laurel wreath on the upper surface of the first moulding of its base. It terminates in a convex moulding with pearled edge. The inside is gilt.

MARKS Inside the foot.
TOWN MARK of Bergen.
WARDEN'S MARK: P for Matthias Pettersen (Warden 1790–1812).
YEAR MARK: 1802.
MONTH MARK for 20 April–22 May?
MAKER'S MARK of Johan Salomon Hind (working 1792–1817).
DIMENSIONS H. 12·3 cm. W. 6·5 cm.
CONDITION Much dented. See description above and also below.

M.311–1919

PROVENANCE Bequeathed by J. G. Joicey, Esq.

For another piece by Hind see M.45–1909 (No. 44, q.v.). The stem is so crudely made and joined to the bowl and foot that considerable doubt must be felt as to whether it is original. Krohn-Hansen (*Trondhjems Gullsmedkunst,* Oslo and Bergen, 1963, pl. 107) reproduces a beaker by Benjamin Dreier (working 1811–c. 1844) with domed foot which has a ball-shaped knop.

Norwegian Spoons

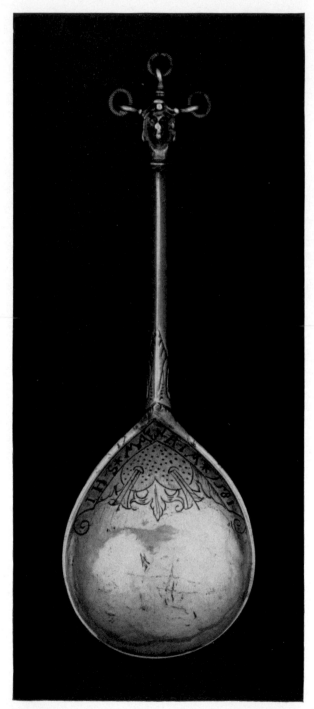

46 SPOON

Bergen, dated 1581. Parcel-gilt. The
bowl is pear-shaped, and is engraved on
the upper part of the inside with a scroll-
ended band inscribed: IHS.MA/RIA.
1581. Beneath this is a heart pierced by
two arrows on a background of foliage.
The junction of stem and bowl is also
decorated with a leaf as is the lower part
of the ridged stem. The knob (cast in two
halves and attached to the end of the
stem by a lap joint) is shaped as two
addorsed female heads surmounted by a
gable headdress: to it are attached three
hoops, from each of which hangs a corded
ring. On the back of the bowl are en-
graved the initials GMD above a mer-
chant's mark.

MARKS On the underside of the stem at
the base.
MAKER'S MARK: HT in monogram for
Hans Threkill of Bergen, working
from 1578 to after 1583 (Krohn-
Hansen and Kloster, *Bergens Gullsmed*,
p. 355, no. 16).
DIMENSIONS L. 15·4 cm. W. 5 cm. Bowl
length 6·5 cm.
CONDITION Bowl dented and rubbed.

M.494–1910

PROVENANCE Purchased from M. Ham-
mer, Strandgaden 57, Bergen,
Norway.

The mark was at one time incorrectly
identified as that of the Danish gold-
smith Hans Traegaard, working in Co-
penhagen from 1609 to 1634 (Bøje,
p. 32, no. 139). The date on the spoon,
which is certainly contemporary, of itself
makes this an impossible attribution.
Two spoons by Threkill are illustrated by
Krohn-Hansen and Kloster (*Bergens
Gullsmed*, vol. ii, pl. 18). They are
of different design from the present
spoon but a number of Bergen spoons of
the early seventeenth century repro-
duced by these authors (see e.g. pls. 20–1)
compare with it in form and decoration.

Compare also the Trondheim spoon of
c. 1590 illustrated in Krohn-Hansen,
Trondhjems Gullsmedkunst, Oslo and
Bergen, 1963, pl. 213D). For Threkill see
Bergens Gullsmed, pp. 53–5, 307. The
form of the headdress suggests that the
head is original. Compare the very simi-
lar knop (without rings) on a Swedish
spoon by Nicolaus Brun (working 1636–
1662) of Västerås in the Nordiska
Museet, Stockholm (reproduced by Käll-
ström and Hernmarck, *Svenskt Silver-
smide*, vol. i, Stockholm, 1941, fig. 402).
But the comparison also suggests that the
finial of the present spoon has been
shortened and the hoops and corded rings
added, probably in the late eighteenth
or nineteenth century.

47 SPOON

Norwegian, late sixteenth century. Parcel-gilt. The pear-shaped bowl is engraved with a band bearing the inscription: SI✱DEVES✱PRO NOBIS✱ QVIS✱CONTRA✱NOS. Beneath this is a heart pierced by two arrows on a ground of foliage. The lower end of the upper side of the ridged stem is also decorated with an engraved leaf. The knob (cast in two halves and attached by a lap joint) is formed as two addorsed cherub heads surmounted by a finial.

MARK On the underside of the stem at the base.

MAKER'S MARK: a merchant's mark, in the form of a cross, with arms led from the bottom of the vertical, and that on the left crossed.

DIMENSIONS L. 16·5 cm. W. 5·4 cm. Bowl length 6·8 cm.

CONDITION Scratched. Bowl probably a little reburnished: the outline of the border seems to have been refreshed.

M.229–1924

PROVENANCE Purchased (£20) from Mr Lionel A. Mills, 84 Brompton Road, SW7.

The inscription is a debased form of the Latin *Si deus est pro nobis quis contra nos* (If God is with us, who shall prevail against us). The tentative attribution to Norway is based on the close resemblance between this spoon and M.494–1910 (No. 46, q.v.), which is dated 1581 and is by Hans Threkill of Bergen. No Trondheim or Bergen mark resembling that on the spoon is recorded.

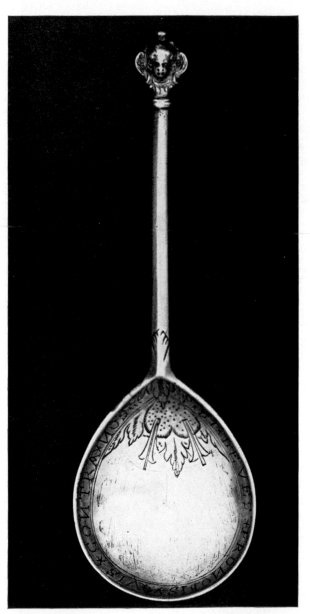

47a 47

48 SPOON

Bergen, dated 1611. Silver, parcel-gilt. The near-round bowl is engraved on the gilt inside with a six-petalled rosette in a circle: the spandrels between the petals are left plain but the segments without are hatched. Round the bowl is a plain border with the inscription: LARIS*MA . . . (rest illegible) O*1611. The underside of the bowl is of plain silver with an engraved gilt border (partly worn away). The lower part of the stem is shaped as an oblong panel, gilt and engraved with a guilloche motif and banded with mouldings. The twisted upper stem is ungilt. The knob is formed by a gilt ball resting on foliage. It has a girdle in relief round the middle, and is topped by a coronal of foliage from which rises a finial.

MARK On the underside of the stem.
MAKER'S MARK: GF in monogram for Gierdt Frølich (see Krohn-Hansen and Kloster, *Bergens Gullsmed*, p. 61, no. 33).
TOWN MARK: a crowned B for Bergen.
DIMENSIONS L. 15 cm. W. 5·5 cm. Bowl length 6 cm.
CONDITION Re-gilt. See also above.

<div align="right">2267–1855</div>

PROVENANCE Purchased (£4 10s 0d) at the sale of the Bernal collection (23 April 1855, lot 3430).

Acquired as French. The correct identification is due to a Scandinavian scholar (Dr Krohn-Hansen?). Frølich had completed his apprenticeship by 1597, and was working independently in 1608. He is last heard of in 1617. The date inscribed on the spoon is therefore likely to be near that of its manufacture.

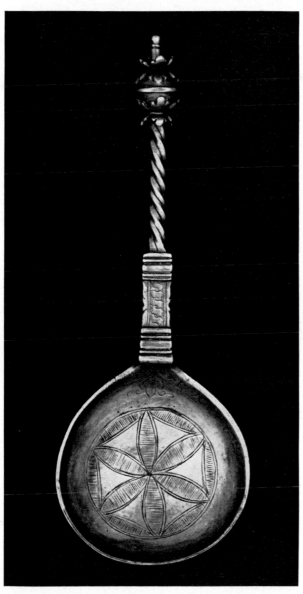

49 SPOON

Norwegian, early seventeenth century.
Parcel-gilt. The near-round bowl is en-
graved just below its junction with the
stem with a rosette in a roundel. The
twisted stem rises from a moulded base
and terminates in a round globe-shaped
nut held by a quatrefoil of stylized
leaves above and below, and by a girdle
round the centre. The ball is topped by a
small finial. On the underside of the bowl
are engraved the initials H.O.D.

MARKS None.
DIMENSIONS L. 14 cm. W. 5·6 cm. Bowl
 length 6·3 cm.
CONDITION Bowl scratched and dented.
 Gilding worn. See below.
 M.632–1910
PROVENANCE Bequeathed by Mr George
 Salting (Salting Bequest, no. 3770).

Acquired as Scandinavian. The spoon is
of Norwegian type. There is a discrep-
ancy between the condition of stem and
knop, which are fresh and unscratched,
and that of the bowl.

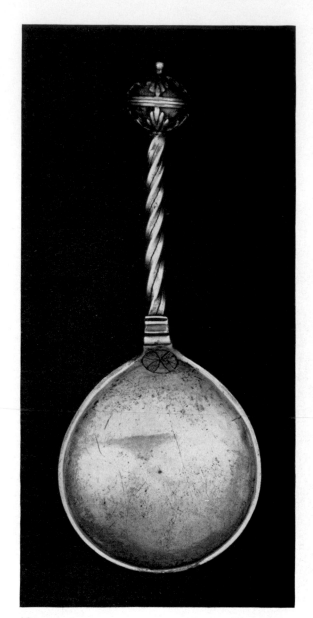

49

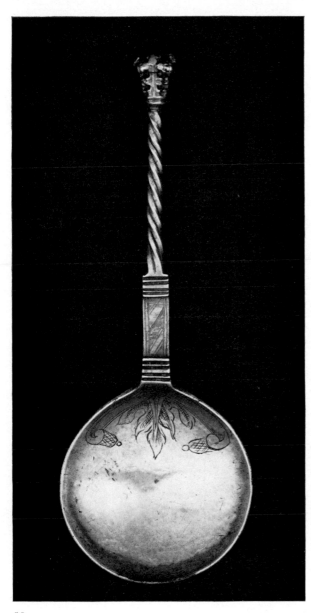

50

50 SPOON

Norwegian, c. 1620–30. Parcel-gilt. The round bowl is decorated with a scrolling band enclosing an acanthus leaf. The lower part of the stem consists of an oblong panel whose upper side is engraved with sloping bands, and has bands of mouldings at either end. Above, the stem is twisted. The knop is formed of four stylized Gothic leaves, cast and applied, enclosing a finial topped by a rosette. The underside of the panel at the lower end of the stem is plain.

MARKS None.
DIMENSIONS L. 15 cm. W. 5·4 cm. Bowl length 5·9 cm.
CONDITION Re-gilt. Good, except for some denting.

M.492–1910
PROVENANCE Purchased (£44 with M.491 to M.494–1910) from M. Hammer, Strandgaden 57, Bergen, Norway.

Acquired as Norwegian. Spoons of this general type were made in Bergen during the first decades of the seventeenth century—compare the illustrations in Krohn-Hansen and Kloster (*Bergens Gullsmed*, vol. ii, pls. 18–19). The examples with the same form of stem and bowl which they reproduce date from c. 1620–38, and have a ball-shaped knop. They reproduce a spoon of c. 1600 by Hans Threkill which has a Gothic leaf-shaped knob like the present spoon, but its stem is entirely twisted. A date c. 1620–30 seems plausible for the present spoon, and an attribution to Bergen possible.

51 SPOON

Norwegian, c. 1630. Silver-gilt. The round bowl is engraved with the Sacred Monogram IHS above a heart pierced with arrows in a roundel. The lower end of the spoon is shaped into the resemblance of the base of a capital. From it rises the twisted stem, which terminates in a ball-knob surmounted by a finial. The underside of the bowl is engraved with the initials MHS.

MARK On the underside of the stem at the base.

MAKER'S MARK: AR in monogram in a shaped shield (unrecorded).

DIMENSIONS L. 13·8 cm. W. 5·8 cm. Bowl length 6·5 cm.

CONDITION Gilding almost entirely worn away: crack in the edge of the bowl: dented, worn and scratched.

768–1904

PROVENANCE Purchased (£2 3s 4d) from G. Jorck, acting for Josef Nachemsohn of 31 Østergade, Copenhagen.

The spoon was acquired as Swedish. Dr Fossberg kindly informs me that it is of a well-known Norwegian type. For a generally comparable spoon made in Trondheim c. 1630 see Krohn-Hansen (*Trondhjems Gullsmedkunst*, pl. 213c); for another made in Stavanger between

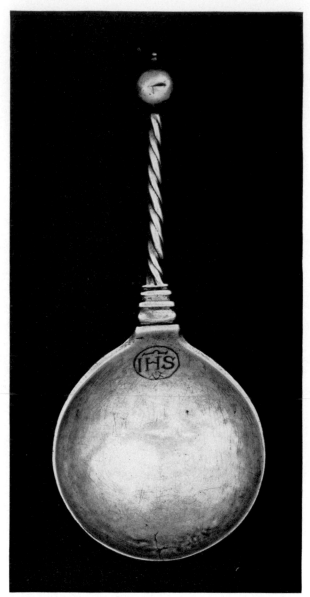

51

1618 and 1654 see Th. Kielland and H. Gjessing, *Gammelt Sølv i Stavanger Amt*, Stavanger, 1918, pl. iii, p. 73, no. 8. In these, however, the lower panel of the stem is longer.

51a

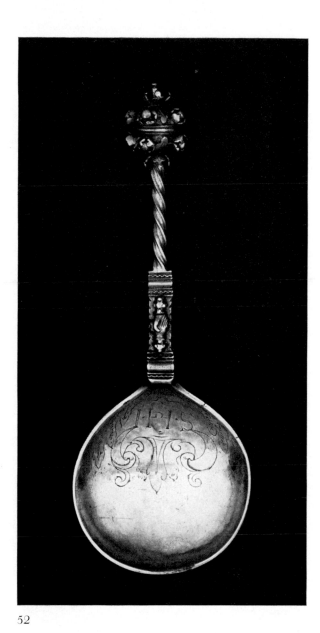

52

zig-zag) cast in relief at either end. Above, the stem is twisted. The knop is ball-shaped—the ball being clasped by a quatrefoil above and below a moulded girdle. The intervals of the quatrefoils are set with flower-heads, cast and applied, four above and four below the girdle. The finial consists of a flower with upstanding stamen, cast and applied. The underside of the bowl is finely engraved with a stylized double-rose of the type called 'Tudor': on the back of the panel of the stem are engraved the initials N:L:SH.

MARKS None.
DIMENSIONS L. 16.5 cm. W. 6 cm. Bowl
 length 6.9 cm.
CONDITION Some slight denting.
 M.493–1910
PROVENANCE Purchased (£44 with
 M.491 to 494–1910) from M. Hammer, Strandgaden 57, Bergen, Norway.

This large and handsome spoon was acquired as Scandinavian, seventeenth century. The type is one current in Bergen in the 1620s and 1630s, when the plain ball found in the earlier versions of this design began to be richly ornamented (Krohn-Hansen and Kloster, *Bergens Gullsmed*, p. 311, vol. ii, pl. 20).

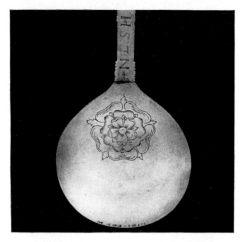

52 SPOON
Norwegian, c. 1630. Silver, parcel-gilt. The near-round bowl is engraved with two half-leaves forming a foliated cartouche, in which is engraved the Sacred Monogram I.H.S. The lower part of the stem consists of an oblong panel, with two clasped hands applied in relief on the upper side and a band of mouldings (two

52a

53 SPOON

Norwegian, c. 1630. Parcel-gilt. The upper half of the fig-shaped bowl is decorated with a strap-work frame enclosing a stylized foliated spray. In the border on either side is the inscription IESVS/MARIA. The lower part of the stem is shaped as an oblong panel with a band of mouldings cast in relief at either end of the upper side. Between these the surface of the panel is engraved with a pattern of sloping bands alternately hatched and dotted. The upper part is a twisted spiral, topped by a flange of foliage, on which rests a ball knob (made in two sections). The knob is surmounted by a finial in a cresting of foliage. On the underside of the bowl the initials WOS are crudely engraved over the earlier initials OSM above a merchant's mark.

MARK On the underside at the base of the stem.

MAKER'S MARK: a merchant's mark of hour-glass form in a shaped shield.

DIMENSIONS L. 15·3 cm. W. 5·5 cm. Bowl length 6 cm.

CONDITION Bowl cracked on the right side: dented and scratched. Ball knob dented.

653–1890

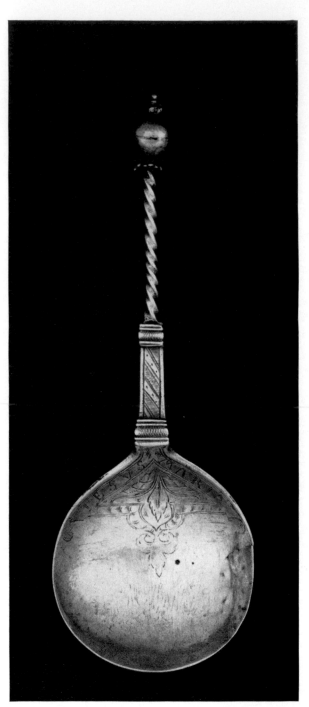

53

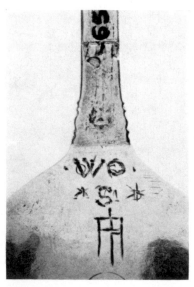

53a

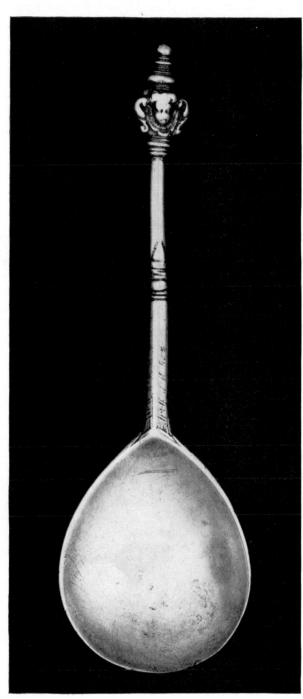

54

PROVENANCE Purchased (£2 13s 4d) from Mr A. B. Meidell, 28 Finsbury Square, E.C.

The maker's mark is not recorded, but for comparable spoons from Bergen see Krohn-Hansen and Kloster (*Bergens Gullsmed*, vol. ii, pls. 19–20). All seem to date from the 1620s or 1630s. A Trondheim example, without the foliated flange, of c. 1630 is reproduced by Krohn-Hansen (*Trondhjems Gullsmed-kunst*, pl. 213).

54 SPOON

Norwegian?, second quarter of the seventeenth century. Silver-gilt. Pear-shaped bowl. The underside is engraved with a swag, beneath which is a semi-circular ribbon with scrolled ends from which hang pendants. This is inscribed: ALBRECHT: HAADENBARCH. Beneath is a shaped shield formerly bearing a charge. Over it are inscribed the later initials A. A.S:T above a merchant's mark. The lower part of the stem is engraved with two bands of chevron ornament; the middle is decorated with crudely formed moulded bands (see below). The knop is formed of two addorsed cherub heads between scrolling leaves and is topped by a moulded finial.

MARKS None.

DIMENSIONS L. 16·4 cm. W. 5·1 cm. Bowl length 6·3 cm.

CONDITION Much worn and rubbed. Piece inserted in the middle.

<div align="right">Circ.548–1910</div>

PROVENANCE Purchased (£5) from M. Hammer, Strandgaden 57, Bergen, Norway.

Acquired as Swedish, seventeenth century. The ownership inscription of Albrecht Haadenbarch appears to be

more or less contemporary with the
spoon; if so a Swedish origin is unlikely
since Haadenbarch is not a Swedish sur-
name. The type is one found throughout
Scandinavia: Erik Lassen, however, is
inclined to think it Norwegian, not
Danish.

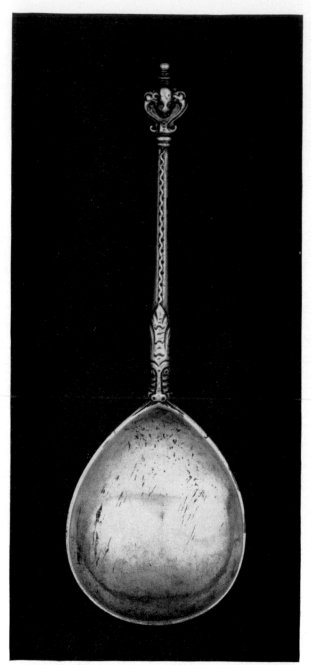

55

55 SPOON

Norwegian, second quarter of the seven-
teenth century. Silver, parcel-gilt. The
pear-shaped bowl is plain. The end of the
stem is finely shaped as a dragon's head
terminating above and below in a leaf-
shaped motif. Above, the upper part of
the stem is decorated with a zig-zag motif
in relief. The knob is formed as two
addorsed cherub masks framed in volutes
and surmounted by a finial.

MARKS None.

DIMENSIONS L. 14·8 cm. W. 4·8 cm.
 Bowl length 6 cm.

CONDITION The bowl has been heavily
 reburnished. There seem to be traces
 of repairs at the shoulders. Gilding
 rather worn.

M.630–1910

PROVENANCE Bequeathed by Mr G.
 Salting (Salting Bequest, no. 3768).

On acquisition described as Scandinavian,
seventeenth century. Subsequently
identified as Swedish, first half of the
seventeenth century.

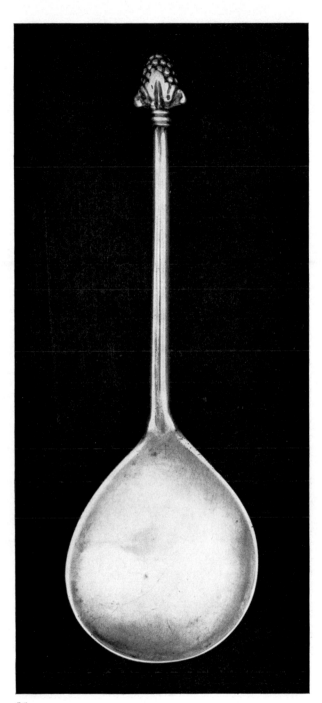

56

56 SPOON

Stavanger, mid seventeenth century (before 1654). Oval bowl. The stem is grooved down the middle of the upper side. The finial is shaped as a bunch of grapes depending from foliage. On the upper edges of the underside of the bowl are engraved the names: HENDRICH: HANSEN:S:LISEBET:IENS.D.

MARKS Underside of stem at base.

TOWN MARK: a crowned S in a shaped shield for Stavanger.

MAKER'S MARK: JK in monogram in a shaped shield for Jochum Kirsebom, working 1618–54.

DIMENSIONS L. 15·9 cm. W. 5 cm. Bowl length 6 cm.

CONDITION End of bowl worn away on right edge. What appears to be a crudely formed merchant's mark is scratched on the underside.

Circ.553–1910

PROVENANCE Purchased (£4) from M. Hammer, Strandgaden 57, Bergen, Norway.

The identification of the marks is due to Dr Inger-Marie Lie, of the Kunstindustrimuseet, Oslo. The engraved names are contemporary with the spoon: Dr Lie suggests that their bearers were probably townsfolk of Stavanger. Spoons with grape-ends were made in Norway from c. 1630–40.

56a

57　SPOON

Trondheim, mid seventeenth century (before 1660). Parcel-gilt. The pear-shaped bowl is engraved with a scrolling band filled with strapwork and foliated motifs, enclosing a stylized fleur-de-lis. At the base the stem is shaped as a dragon's head clasping the bowl: this terminates on all four sides in a leaf-shape overlapping four more leaves. Above, the upper part of the stem is decorated down the middle with a band of zig-zag ornament in relief. The florid knop is composed of two addorsed cherub-masks rising from a capital and sur-mounted by a finial. On the underside of the bowl are engraved the initials M B S.

MARKS On the underside of the stem at the base.

MAKER'S MARK: A A conjoined in a shaped shield, for Anders Andersen Heins (d. 1660) of Trondheim (see Krohn-Hansen, *Trondhjems Gullsmedkunst*, p. 158).

DIMENSIONS L. 15·6 cm. W. 5·4 cm. Bowl length 6·3 cm.

CONDITION Good.

M.629–1910

PROVENANCE Bequeathed by Mr G. Salting (Salting Bequest, no. 3767).

On acquisition described as Scandinavian, seventeenth century. Subsequently iden-tified as Swedish, first half of the seven-teenth century. The mark, though rather smudged, is certainly that of Heins, who was already working in Trondheim in 1644 but whose birth-date and date of mastership are not recorded. The type of stem is recorded there as early as 1597 (see Krohn-Hansen, *op. cit.*, pl. 213e). A spoon closely similar in design and decor-ation made between 1620 and 1640? by Jost Albertszenn of Bergen is illustrated by Krohn-Hansen and Kloster (*Bergens Gullsmed*, vol. ii, pl. 22).

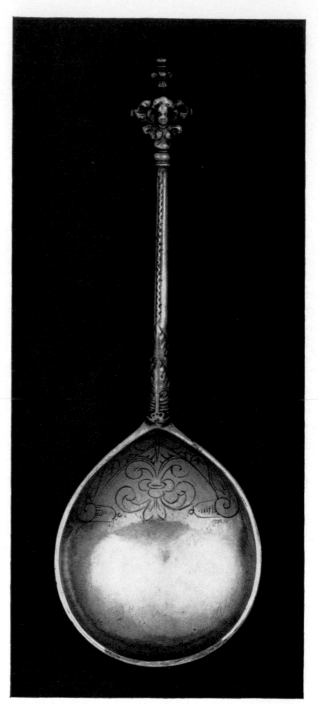

57

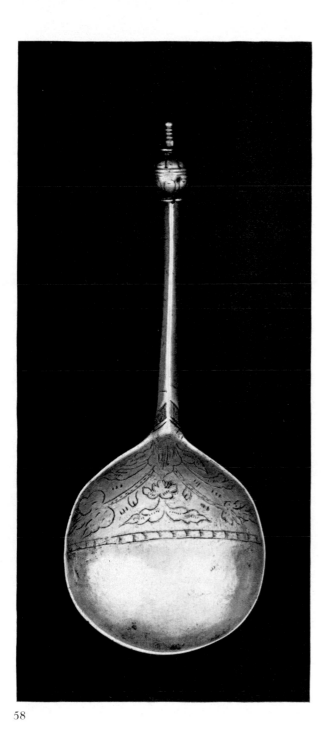

58

58 SPOON

Bergen?, mid seventeenth century. Parcel-gilt. The fig-shaped bowl is decorated across its upper part with an engraved floral spray on a gilt ground. The stem is four sided: at the junction with the bowl it is engraved on the upper side with a hatched chevron. The knob is formed as a gilt ball engraved with gadroons on either side of the central band: above and below are small circular flanges, from the upper of which rises a finial. Traces of an inscription on both sides of the upper sides of the stem.

58a

MARKS On the back of the bowl.

ASSAY MARK Italic M B in monogram over 1740 in a shaped cartouche, the mark used by Magnus Bessel, first assaymaster of the Bergen guild, on his appointment in 1740.

OTHER MARKS: 13 and L, struck beside the assay-master's standard mark (see below).

DIMENSIONS L. 14·1 cm. W. 5·5 c.m. Bowl length 6 cm.

CONDITION Bowl dented and scratched, some wear round edge. Ball dented.

652–1890

PROVENANCE Purchased (£2 13s 4d) from Mr A. B. Meidell, 2 Finsbury Square, EC.

This is clearly an older spoon re-marked for sale. Compare the Bergen spoons reproduced by Krohn-Hansen and Kloster, *Bergens Gullsmed*, vol. ii, pls. 20–1. What can be seen of the inscriptions also indicates an earlier date. The mark struck on this spoon is that used by Bessel in 1740. After a long resistance offered by the Bergen Guild to the appointment of an assay-master, largely on the ground that the standard of silver, which had been officially fixed at the $13\frac{1}{2}$ weight-mark, was too high for Bergen, where most work was refashioned from metal obtained from old pieces of the 12 to $12\frac{1}{2}$ mark, Bessel, a former master of the guild, was appointed assay-master or warden in 1740. The 13 L (13 löd) evidently indicates the silver standard he found the spoon to possess. No example of this type of standard mark is recorded by Krohn-Hansen and Kloster (*Bergens Gullsmed*, pp. 324, 348–49).

59 SPOON

Norwegian?, mid seventeenth century. Silver, parcel-gilt. The broad fig-shaped bowl is engraved below the junction of stem and bowl (effected by the rising of the bowl) with a leaf. The tapering stem rises from a moulded base and has a flattened twisted pattern. The knop is formed of four stylized Gothic strawberry leaves: to the intervals between them are attached hoops, from which are suspended corded rings. A broken finial rises from the concave swelling which is contained in these leaves.

MARKS On the underside of the stem at the base.
MAKER'S MARK: FP in monogram in a shaped shield, struck twice.
DIMENSIONS L. 13 cm. W. 6·5 cm. Bowl length 7 cm.
CONDITION Right edge of bowl damaged: dented, finial broken. Bowl rehammered to a disconcerting sharpness.

48–1864

PROVENANCE Presented by George Moffatt, Esq.

Acquired as Norwegian, seventeenth century. Examples of the type with rounded stem are also recorded in Sweden from the last quarter of the sixteenth century: compare two reproduced by Källström and Hernmarck, *Svenskt silversmide*, vol. i, 1941, figs. 158–59 and the spoon of 1630–50 attributed to Wemart Wemartsson of Norrköping in the

59a

Kunstindustreemuseet, Copenhagen, re-
produced in E. Lassen, *Ske, Kniv og Gaffel*
(*Knives, Forks and Spoons*), Copenhagen,
1960, no. 9. Presumably the finial was
originally a hoop for another ring (com-
pare a Norwegian spoon of related design
reproduced in I. M. Kvaal Lie, 'Renes-
sancesølv fra Skien – en gullsmed og hans
bakgrunn' in Oslo, Kunstindustri-
museet, *Arbok*, 1965, p. 27, fig. 1). Dr
Holmquist would prefer an attribution
to Denmark or Southern Sweden.

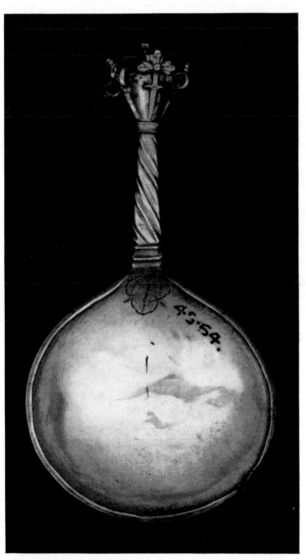

60 SPOON

Norwegian or Danish, second half of the
seventeenth century. On the back of the
bowl, of rounded pear-shaped form, with
a steep junction to the stem, are engraved
the initials FAS/./EBD encircled by two
sprays forming a wreath. On the upper
side the lower part of the stem is shaped
as a dragon's head: above it is separated
into two unequal sections by sunk
mouldings. Down the middle runs a zig-
zag moulding in relief. The knop is
shaped as two addorsed cherub heads
topped by a finial.

MARKS None.
DIMENSIONS L. 16·6 cm. W. 5·1 cm.
 Bowl length 6 cm.
CONDITION Dented and worn. See also
 below.

M.491–1910

PROVENANCE Purchased (£44 with 492
 to 494–1910) from M. Hammer,
 Strandgaden 57, Bergen.

Acquired as Scandinavian, seventeenth
century. The general type is found
throughout Scandinavia, but an attribu-
tion to Norway seems plausible, and a
date in the second half of the seventeenth
century probable. However, the cherub-
head knop is flat-soldered on to the end
of the spoon, and not jointed or plugged
like the other examples in the collection,
and, as its wear and proportions are not

consistent with those of the rest of the spoon, it is probably a later addition. E. Lassen says that a Danish origin would be equally acceptable.

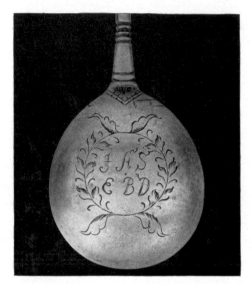

60a

61 SPOON

Norwegian, dated 1689. The oval bowl is engraved on the underside with two sprays tied by a bow encircling the initials s.i.s./n.c:d and the date 1689. Initials and date are rather crudely engraved. The bowl rises to its junction with the stem; at the junction its edges are flattened and then bevelled. The stem curves inwards and then outwards to a trifid end: it is engraved on both sides with a flowering spray, a tulip spray on the upper side, a rose on the lower, within an outline border.

MARKS Underside of the stem at the base.

MAKER'S MARK: SR in a circle.

DIMENSIONS L. 17·7 cm. W. 5·2 cm. Bowl length 6·5 cm.

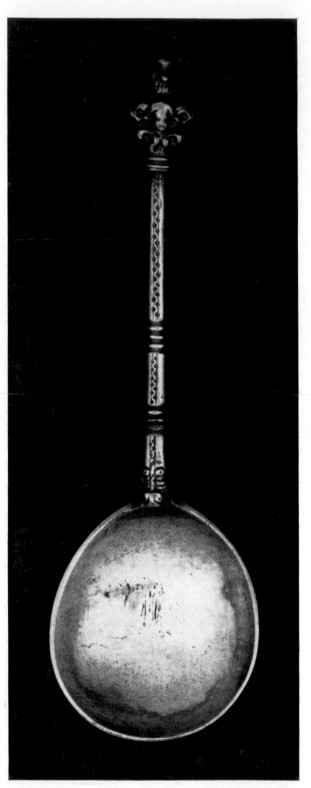

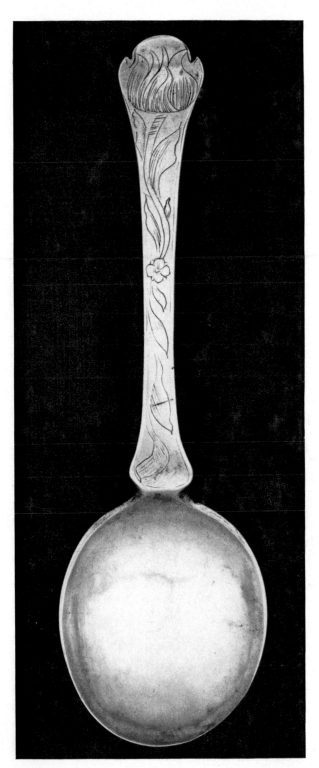

CONDITION Edge of bowl dented and worn on right.

Circ.295–1912

PROVENANCE Purchased (£1 5s) from G. Jorck.

The design of this spoon is transitional between one current in the middle of the seventeenth century and the rat-tailed trifid of its last decade. It was acquired as Danish and the type was current in Denmark (cf. the Copenhagen example dated 1698 reproduced by Boesen and Bøje, *Old Danish Silver*, Copenhagen, 1949, fig. 424), but Erik Lassen rejects a Danish origin. The maker's mark is not recorded, and the first letter, which is of curious form, perhaps could also be read as G or C (but compare Bøje, no. 1275, which is quite close to it in form).

61 61a

62 SPOON

Bergen, dated 1691. The pear-shaped bowl is engraved on the underside with two sprays forming a wreath enclosing the inscription: L.B.S.S./J.L.D./1691. It curves upwards to join the spreading stem. The upper side of the lower part of the stem is bevelled between two moulded bands. The upper part is engraved with a flower, a cartouche containing a scene of a building, and a stem bearing a rose, to whose outline the end is shaped. On the under-side a second rose is engraved in the same position. The rest of the underside is flat.

MARK On the underside of the stem at the end.

MAKER'S MARK: O encircling an I for Oluf Jørgensen of Bergen, working 1650–1700 (Krohn-Hansen and Kloster, *Bergens Gullsmed*, p. 359).

DIMENSIONS L. 18·1 cm. W. 5·0 cm. Bowl length 6·2 cm.

CONDITION Sundry initials crudely scratched on the underside of the stem: bowl cracked and much worn on the right side.

<div align="right">M.483–1910</div>

PROVENANCE Purchased (£2 10s 0d) from G. Jorck.

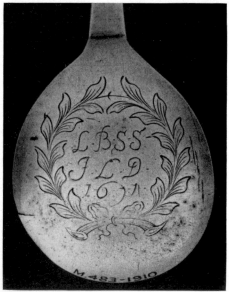

62a

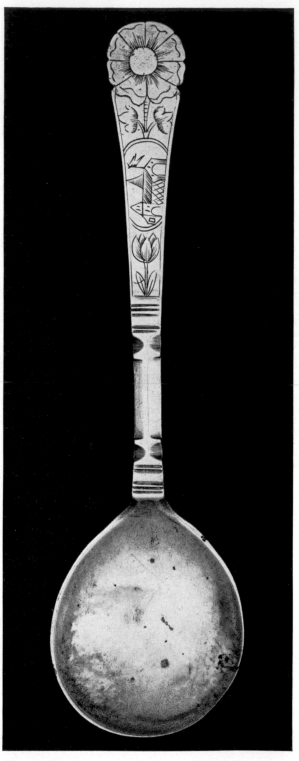

62

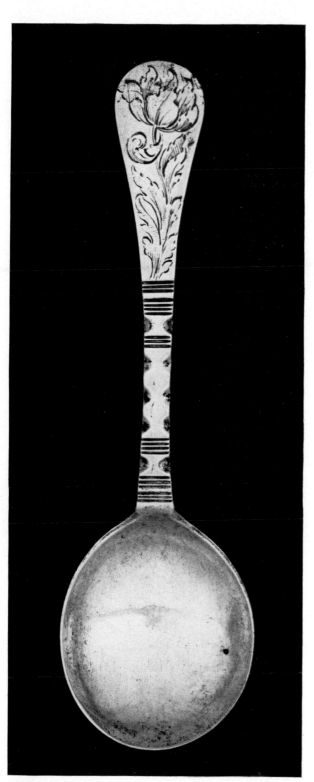

63 SPOON

Norwegian, last quarter of the seventeenth century. Oval bowl slightly bevelled on the upper edges. The underside of the bowl is engraved with a border which extends three quarters of the length of the sides: this is plain except for a little hatching at the upper and lower end. Between this is engraved a scrolling band with foliated ends. The flat stem consists of two sections. A longer lower section is marked off on the upper side by chased mouldings. Between these are bevelled indentations; at the upper and lower ends these make spool-shaped forms marked off by incised mouldings. In the central panel they make a baluster form. The upper section expands into a rounded end and is engraved with a foliated stem and a flowering tulip in the Floral Baroque style. Pounced on the underside are the initials M M S: M M D.

MARKS None.
DIMENSIONS L. 18 cm. W. 5·1 cm. Bowl length 6·5 cm.
CONDITION As usual, some wear on the bowl: flawed on the underside of the upper end, creating some loss of silver.
Circ.333–1910
PROVENANCE Not recorded.

A comparable spoon by the Bergen goldsmith Johannes J. Reimers the Elder (working 1667–1722) is reproduced by Krohn-Hansen and Kloster (*Bergens Gullsmed*, vol. ii, pl. 132). The maker's mark may have disappeared as a result of the flaw (see condition): a date in the last quarter of the seventeenth century is plausible for this spoon, though if made for the rural market it may be later.

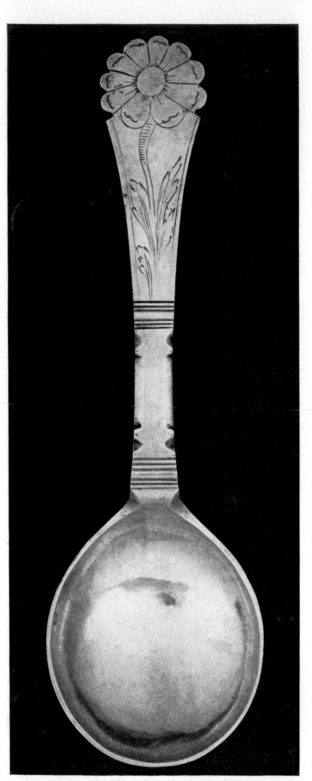

64 SPOON

Bergen, between 1704 and c. 1737. Oval
bowl, engraved on the underside with a
three-quarter circle band with foliated
ends, bearing the engraved initials
E.S.S: AJD. The edge to either side is
partly outlined with a border having two
hatch-marks at either end. The upper
edges of the spoon are bevelled towards
the junction with the stem, which is
divided into two sections. The upper side
of the lower section is formed as a panel
with two incised bands on either side of a
bevelled horizontal moulding at either
end. The member between is indented
and bevelled into a double baluster with
elongated central stem. Above, the upper
section splays out into a flower, whose
form is partly engraved and partly indi-
cated by the shaped outline of the end. It
rises from an engraved foliated stem. The
flower is repeated on the underside in
slightly different form. Also scratched on
the underside is the inscription N5.

64

MARK On the underside of the stem.

MAKER'S MARK: IIS in an oval for Jørgen
Jørgensen Egelsdorf, master in Bergen
from 1704 until after 1737 (*Bergens
Gullsmed*, p. 356).

DIMENSIONS L. 18·4 cm. W. 5·6 cm.
Bowl length 7 cm.

CONDITION Some faint scratches.

Circ.334–1910

PROVENANCE Purchased (£1 5s) from G.
Jorck.

IIS in an oval is also recorded as the mark
of Joen Joensen (working 1713–49) in
Naestved (Bøje, p. 322, no. 2188), but
the present spoon seems far more likely
to be of Bergen origin on stylistic grounds
– compare a very similar spoon by Jacob
M. Steen (working 1722–40) reproduced
by Krohn-Hansen and Kloster (*Bergens
Gullsmed*, vol. ii, pl. 90). A date c. 1730
is probable for the Museum's spoon,
which is likely to have been produced for
the country market.

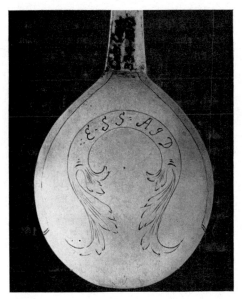

64a

65 SPOON

Bergen, dated 1730. The bowl, of rounded pear-shape form, is engraved on the back with foliated ornament encircling the inscription: H:O:S:/R:N:D/ 1730. The lower part of the spreading stem is bevelled on the upper side between two moulded bands: the upper part is engraved with a foliated stem and has a rounded end. The underside of the stem is flat.

MARK On the underside of the stem.

MAKER'S MARK Italic JJE for Jørgen Jørgensen Egelsdorf of Bergen, working 1704–after 1737 (*Bergens Gullsmed*, p. 356).

DIMENSIONS L. 17·4 cm. W. 5·3 cm. Bowl length 6·5 cm.

CONDITION Worn: dented.

769–1904

PROVENANCE Purchased (19s 3d) from G. Jorck.

Acquired as Swedish, first half of the eighteenth century. Later tentatively attributed to Norway. For a late spoon of similar shape and decoration see Krohn-Hansen and Kloster (*Bergens Gullsmed*, vol. ii, pl. 132). The type was current in the last three decades of the seventeenth century (*op. cit.*, vol. i, p. 316; vol. ii, pls. 89–90) but continued to be made for rural clients into the eighteenth century. Krohn-Hansen believes it to be of distinctive Norwegian origin, and terms it the 'Norwegian Baroque Spoon'. But compare Boesen and Bøje (*Old Danish Silver*, Copenhagen, 1949, fig. 436) for a similar Danish spoon of 1699 made in Nakskov.

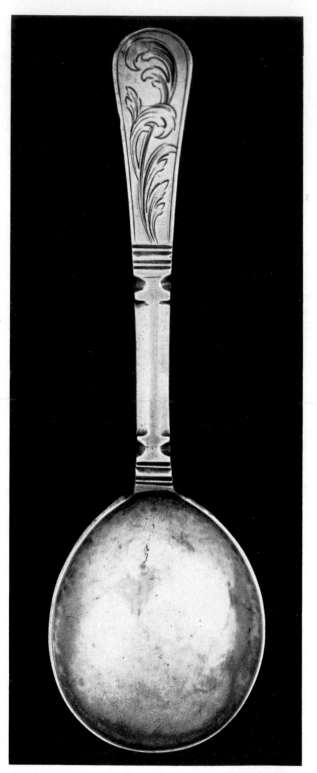

65

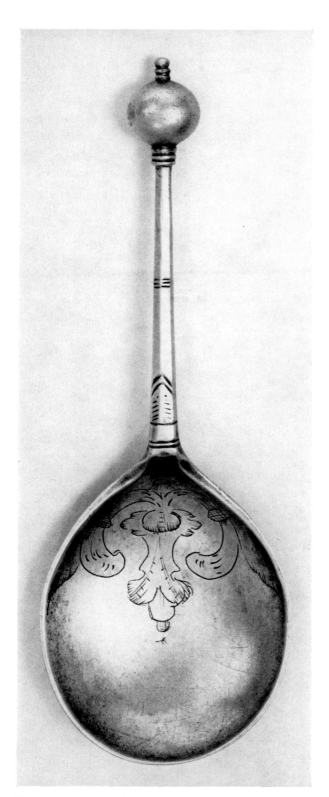

66 SPOON

Norwegian, early eighteenth century. The oval bowl is engraved on the upper half with two leaves enclosing two foliated scrolls, from which hangs a pendant leaf and flower. The upper edges of the bowl are broad and flat: it rises to join the stem, which is flat underneath and is ridged on top. At its lower end it is engraved with a band and a stylized leaf: at its top is a cast globular ball resting on three rings and surmounted by a finial.

MARKS None.
DIMENSIONS L. 16·7 cm. W. 5·9 cm. Bowl length 7·6 cm.
CONDITION Scratched.

2001–1898

PROVENANCE Given by Col. F. R. Waldo-Sibthorp (*A Collection of Silver and Silver-gilt Plate...formed by Colonel F. R. Waldo-Sibthorp*, privately printed, Brighton, n.d., p. 83, no. 200).

The spoon was catalogued by Waldo-Sibthorp as from Sköne, and was identified on acquisition as Swedish. It is of Norwegian type: roughly comparable spoons which seem to be the origin of the type are reproduced by Krohn-Hansen and Kloster (*Bergens Gullsmed*, vol. ii, pl. 20) and Krohn-Hansen (*Trondhjems Gullsmedkunst*, pl. 213). These range in date from c. 1590 to c. 1630: the comparative naturalism of the ornament of the bowl in the present spoons and its debased stem point to a later date for the present spoon: Dr Fossberg suggests the early eighteenth century.

67 SPOON

Bergen, between 1711 and 1759. Oval bowl. The underside is engraved with the initials M.H.S.H. The edges are bevelled towards the junction with the stem, whose end is shaped as a flat panel decorated on the upper side by mouldings. The stem is shaped as a twisted spiral and terminates in a round ball topped by a small plain finial.

MARK On the underside of the stem at the base.

MAKER'S MARK: HB in an oval for Hans Pettersen Blytt, working in Bergen 1711–59 (Krohn-Hansen and Kloster, *Bergens Gullsmed*, p. 353).

DIMENSIONS L. 15·7 cm. W. 5·6 cm. Bowl length 6·5 cm.

CONDITION Right lower edge of the bowl worn: bowl much scratched.

Circ.332–1910

PROVENANCE Purchased (£1 5s) from G. Jorck.

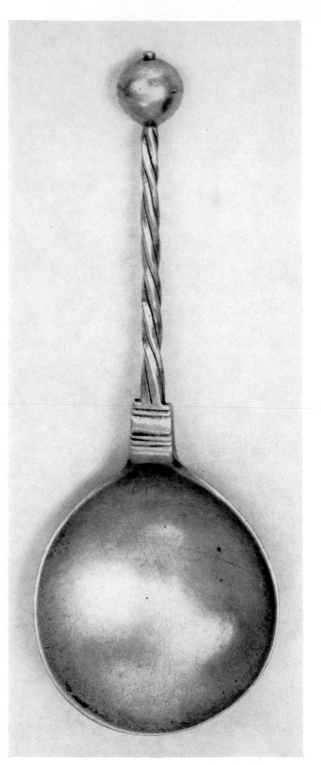

68 SPOON

Norwegian, first half of the eighteenth century. Pear-shaped bowl, engraved with a stylized rosette and a border of zig-zag, both on a roughly hatched ground. To the lower part of the handle is applied a corded rib terminating in a ribbed boss: the upper part is pierced to form two trapezoids filled with criss-cross bars forming a pattern of a central lozenge surrounded by triangles. From each of six loops at the corners hangs a corded ring: from the seventh loop at the top centre once hung another ring.

MARKS On the front of the stem to either side of the rim.
MAKER'S MARK: PR?
TOWN MARK Illegible, but apparently incorporating at least two towers.
DIMENSIONS L. 13·2 cm. W. 6·0 cm.
CONDITION See above.

2006–1898

PROVENANCE Given by Col. F. R. Waldo-Sibthorp.

For illustrations see p. 220.

Acquired as Scandinavian, seventeenth or eighteenth century. Four closely comparable spoons made for the Lapp market in Trondheim and Bergen, and with a date range from 1711 to 1759 are reproduced by P. Fjellström, *Lapskt Silver*, Stockholm, 1962, pl. 15: 85, 89, 94a & b, 98. According to E. Klein ('Lapsk Hornslöjd och Nordiskt Silversmide' in Nordiska Museet, *Fataburen*, 1922, pp. 65–88) spoons of this design are the earliest known to have been especially made for the Lapp market. As with all spoons made for the Lapps, they are copied or imitated from Lapp prototypes in elk or reindeer horn which themselves in turn were sometimes derived from Scandinavian spoons. The typology is traced by Klein.

69 SPOON

Trondheim, dated 1776. Round bowl. The lower part of the stem consists of a large and a small bevelled panel separated by incised mouldings. The upper part is engraved with a flowering tulip and has a round end. A band with foliated ends is engraved on the underside of the bowl. On the underside of the end of the stem are pounced the initials K:E:D and the date 1776.

MARK On the underside of the stem.

MAKER'S MARK: TAF for Tore Andreas Friis, working in Trondheim 1756–77 (Krohn-Hansen, *Trondhjems Gullsmedkunst*, Bergen, 1963, p. 198).

DIMENSIONS L. 16·8 cm. W. 5·6 cm. Bowl length 6·6 cm.

CONDITION Bowl dented and worn.

M.322–1940

PROVENANCE Bequeathed by Mr Arthur Hurst.

A spoon of traditional form and decoration (see No. 65) now much debased and at this date probably produced for the rural market.

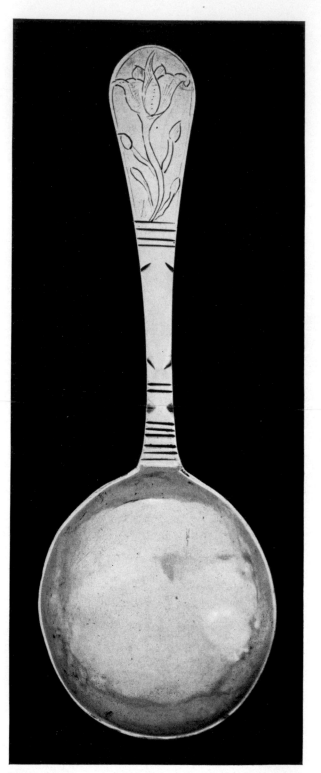

69

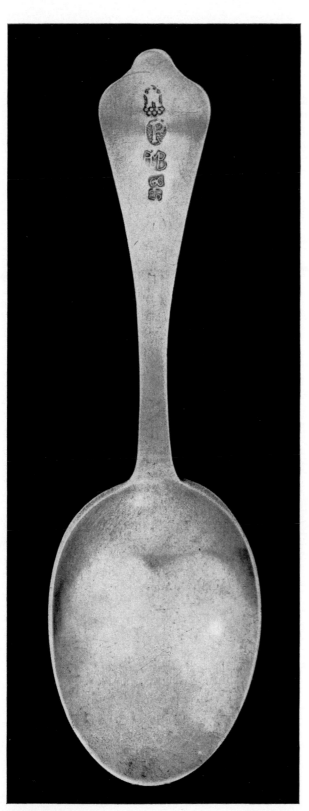

70 SPOON

Bergen, 1806. Large oval bowl, engraved on the underside with a rat-tail from which leaves spread out. The flat stem spreads out into an upturned wavy end: on the underside of this are pounced the initials WSS/BPD.

MARKS On the upper side of the stem.

TOWN MARK The castle surmounting seven balls of Bergen.

WARDEN MARK: P in an oval for Matthias Pettersen, warden from 1790 to 1812.

YEAR MARK: 06 for 1806.

MONTH MARK for the period 21 June until 22 July.

MAKER'S MARK: PMB for Peter Michael Blytt, master from 1790 to 1836. For all these marks see Krohn-Hansen and Kloster (*Bergens Gullsmed*, pp. 347–49, 360).

DIMENSIONS L. 17·4 cm. W. 5 cm. Bowl length 7·2 cm.

CONDITION Some wear and scratching and in the bowl some denting also.

<div align="right">1007–1905</div>

PROVENANCE Given by Messrs Child & Child.

71　SPOON

Bergen, mid 19th century. The pear-shaped bowl is long and shallow. It is engraved in wriggle-work with a border of sloping bands and a medallion of lozenge-ornament. The stem is shaped as an inverted Y with a plate between the arms: on the underside it extends over the bowl in the form of a leaf. The underside is decorated with an engraved zig-zag border. The Y itself is a cast threaded stem: to the long arm is attached a plate of two double scrolls engraved and pierced with seven holes for rings.

MARKS On the underside of the bowl.

TOWN MARK Bergen (the seven balls only: compare that for 1848 reproduced in *Bergens Gullsmed*, p. 347).

STANDARD MARK: 13½ L.

MAKER'S MARK: ACM for Andreas Christian Møgelvang, working 1844–73 (Krohn-Hansen and Kloster, *Bergens Gullsmed*, p. 350).

OTHER MARKS Two other marks, one of a bird perched on an M, the other (in an oval) illegible.

DIMENSIONS L. 12·7 cm. W. 5 cm. Bowl length 7·3 cm.

CONDITION Rings wanting.

2004–1898

PROVENANCE Given by Col. F. R. Waldo-Sibthorp.

For illustrations see p. 220.

For a closely similar spoon made in Bergen in 1856 for the Lapp market see P. Fjellström, *Lapskt Silver*, pl. 15: 21a. The two unidentified marks are probably vendor's marks stamped over the year mark and month mark of Bergen. They are possibly of Russian origin.

72　SPOON

Norwegian, late nineteenth century. Parcel-gilt. The inside of the flat pear-shaped bowl is engraved with a medallion containing a figure of Christ set on a scroll inscribed: *ego sum via/veritas et vita* on a wrigglework ground. Medallion and scroll are gilt. The upper part of the stem is ridged and gilt and has corded edges. It is set with a Gothic niche containing a cast group of the Virgin and Child. The underside of the stem is flat. The knop is formed of four fleur-de-lys stems enclosing an octagonal finial topped by a ball. This is gilt.

MARKS None.

DIMENSIONS L. 15·2 cm. W. 5·5 cm.

CONDITION Immaculate.

917–1902

PROVENANCE Given by Walter Child, Esq., of 35 Alfred Place West, South Kensington, SW.

This spoon, offered and accepted as a Scandinavian work of c. 1500, belongs to a well-known class of imitation Gothic spoons produced during the late nineteenth century for the tourist market. One of the largest specialists in this type of work was the goldsmith Marius Hammer of Bergen (see Introduction and Dr A. Polak, *Gullsmedkunsten i Norge før og nå*, Oslo, 1970, p. 166). It was Hammer who pointed out to the Museum in October 1910 that the present spoon is

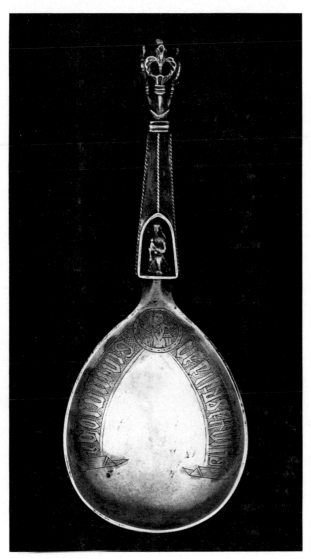

72

'a reproduction of an original in the possession of Lord Swaythling. A considerable number of these reproductions of this spoon have been made'. A note in the Departmental Register reads 'A similar spoon; apparently original, was in the J. E. Taylor collection, sold at Christie's July 1893'. The style of the present spoon is a curious amalgam of Gothic, late seventeenth century and nineteenth century forms, Neo-Gothic and peasant.

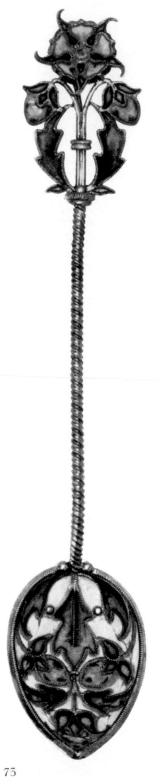

73

73 SPOON

Kristiania, 1893. Silver-gilt, the circular bowl decorated in *plique-à-jour* enamels with a conventional scrolling spray of flowers and foliage. The stem and knop are formed of stylized scrolling foliage and buds topped by a flower, all in the same technique.

MARKS None.
DIMENSIONS L. $5\frac{5}{8}$ in. Diam. $2\frac{1}{8}$ in.
CONDITION Good.

1265–1893

PROVENANCE Purchased (£2 1s) from J. Tostrup, Carl Johans Gade, 25, Kristiania, from a large consignment (69 objects in all) of 'transparent enamel work' forwarded on approval by this firm. The consignment was received on 20 December. Only thirteen pieces, all spoons except for two hat-pins, were purchased, some for distribution to provincial museums.

Reproduced in A. Polak (*Gullsmedkunsten i Norge før og nå*, Oslo, 1970, p. 111, fig. 106). See No. 76 below.

74 SPOON

Kristiania, 1893. Silver-gilt. The elliptical bowl is decorated in the *plique-à-jour* technique with a scrolling spray of flowers and foliage. The stem and knop are set with leaves and flowers in the same technique.

MARKS None.
DIMENSIONS L. $4\frac{3}{4}$ in. W. of back $2\frac{13}{16}$ in.
CONDITION Good.

1266–1893

PROVENANCE Purchased (£1 13s 3d) as above.

Reproduced in A. Polak (*loc. cit.*). See No. 76 below.

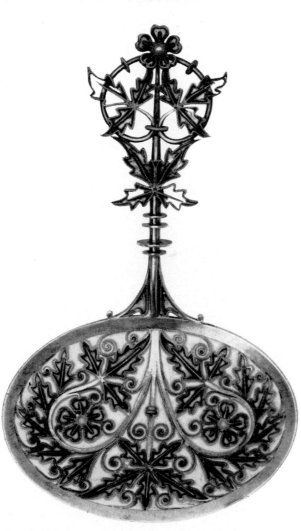

75 SPOON

Kristiania, 1893. Silver-gilt, the pointed bowl decorated in the *plique-à-jour* technique with a floral spray: the knop is set with leaves and flowers in the same technique.

MARKS. None.
DIMENSIONS L. 4¾ in.
CONDITION Good.

1273–1893

PROVENANCE Purchased (13s) as above.

These three spoons were all bought as 'by J. Tostrup'. They are works of the firm founded by Jacob Tostrup (1806–90) of Kristiania, who imported modern mechanized methods of manufacture and a new, more fashionable sense of design into Norwegian silver (see A. Polak, *op. cit.*, pp. 90–1, 165). Enamel decoration was popularized throughout Europe by the Vienna Exhibition of 1873 and the Budapest Exhibition of 1884. Olaf Tostrup visited both these exhibitions and was inspired by them to work in enamel. *Plique-à-jour* enamel had been reintroduced into goldsmith's work by Ferdinand Thesmar (1843–1912) of Paris, and for two decades the technique was used in Norway for a number of works in a sophisticated style. The Tostrup firm and another Norwegian goldsmith, David Andersen, sent works executed in it to the Paris Exhibition of 1900. The judgement of the *rapporteurs* of the Jury International on the Tostrup exhibits is interesting enough to be quoted. 'M. Tostrup a une exposition remarquable, et l'émail y tient une large place. Nous retrouvons chez lui des coupes, des vases en émail translucide dont notre collègue français, le délicat artiste qu'est M. Thesmar, nous a fait admirer les heureuses combinaisons. Ce n'est pas un mince éloge à faire à M. Tostrup que de dire que ses émaux translucides nous ont rappelé les œuvres de notre compatriote, mais, nous devons

ajouter, sans les faire oublier. Une en-
tente très juste des colorations, une
grande habileté de main d'œuvre, des
montures fines et élégantes étaient le
caractéristique des objets exposés' (T. J.
Armand-Valliat and H. Bouilhet in Mini-
stère du Commerce &c., Exposition Uni-
verselle Internationale de 1900, *Rapports
du Jury International*, Groupe XV, *In-
dustries Diverses*, Paris, 1902, *Classe 94,
Orfèvrerie*, p. 326). According to Dr A.
Polak (*op. cit.*, pp. 110–11) Tostrup's be-
gan working in *plique-à-jour* c. 1890. For
the commercial success of Norwegian
enamel work among the public for Art-
nouveau see No. 76, below.

76 SPOON

Bergen, 1898. Silver, gilt and enamelled.
The bowl is decorated in the *plique-à-jour*
technique with a stylized spray of blue
flowers (with yellow centres) and green
flowers (with centres in two shades of
dark green) on a pink ground. The stem,
twisted in the upper part, terminates in a
spray of a green flower and three blue
flowers like those in the bowl and in the
same technique.

MARKS None.
DIMENSIONS L. 14·4 cm. Bowl W. 3 cm.
CONDITION Good.

933–1898

PROVENANCE Purchased from Marius
 Hammer of Bergen (as from De
 Keyser's Royal Hotel Ltd, Blackfriars,
 EC).

For some account of Hammer see Intro-
duction, p. 11. Dr A. Polak (*Gullsmed-
kunsten i Norge før og nå*, Oslo, 1970, p.
111) notes that Hammer specialized in
producing these Art-nouveau spoons in
plique-à-jour enamel, many with a view
for sale to tourists visiting Bergen. The

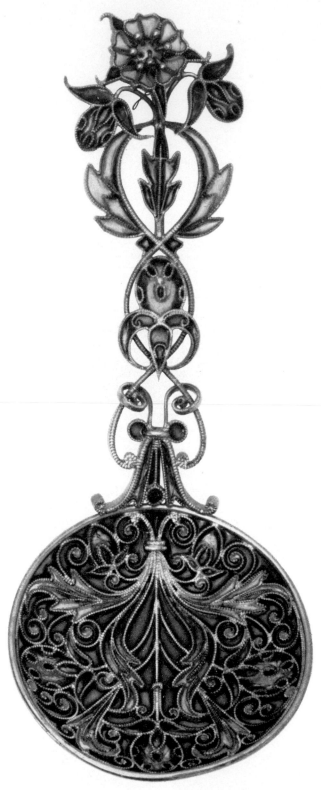

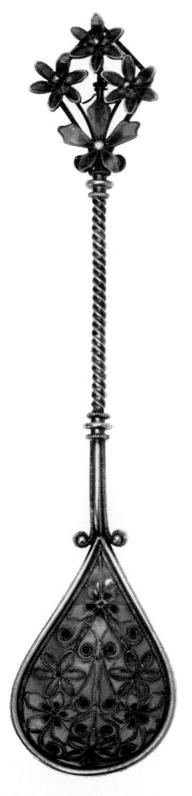

popularity in England of spoons in 'Norwegian enamel work' can be gauged from Liberty's catalogues. In 1895–96 'Liberty & Co. Ltd draw special attention to their exclusive stock of Norwegian Enamel and Silver-Gilt Goods. The designs, carried out in varied coloured translucent and opaque enamels, are unique and novel, and the workmanship is of the finest. This Enamel and Silver Ware is particularly adopted for Yule-Tide Gifts.' A silver-gilt jam spoon 'the top decorated with translucent enamel and the bowl with varied coloured enamels' was offered as such a gift for 18s 6d. At Yule-Tide 1898 a whole range of 'Norwegian Brilliant Enamel Work (Silver Gilt)' was offered with the note that 'the present stock of this original and beautiful Jewellery is exceptionally full and varied. The examples comprise both the most brilliant translucent and opaque enamels, are of excellent workmanship, and have been specially and exclusively produced in Norway for Messrs Liberty'. 'The spoons were sold singly or in the usual cases of half a dozen. For Yule-Tide 1899 the firm had got in a new stock also 'exceptionally full and varied', now as 'especially suitable for Complimentary Presents'.

76

Sweden

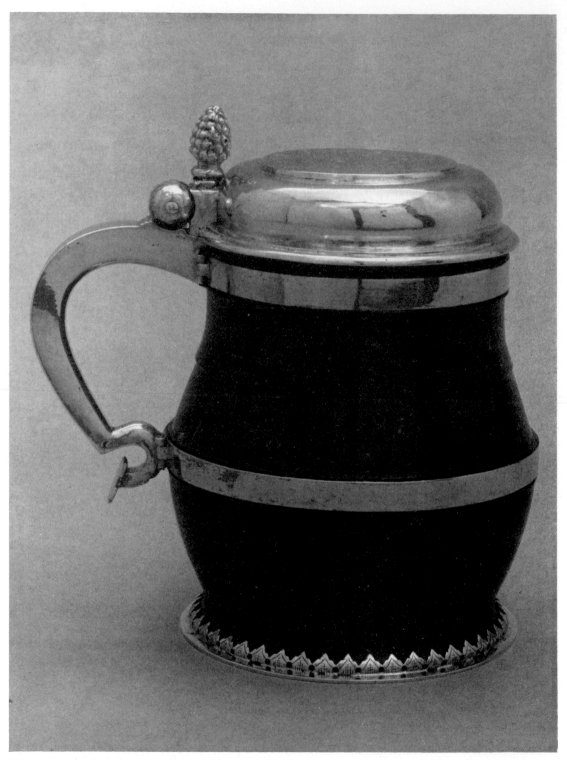

77 TANKARD

German or Swedish, dated 1643. Serpentine, mounted in silver-gilt. The baluster-shaped body of serpentine is held by two broad bands of silver below the rim and round the waist. The base is held in a metal foot with strawberry-leaf edge. The scroll-shaped handle terminates in a plain shaped shield and is attached to the two bands, as well as being hinged to the lid. The lid is domed, and engraved with two coats of arms (dexter, *party per pale, six martlets, crest a wolf*: sinister, *an estoille, crest two arms holding a candle*). Above the dexter shield are the initials GSF: above the sinister BGS. Below is engraved the date 1643. The thumb-piece is cast in the form of a pineapple.

MARKS None.

DIMENSIONS H. 15·8 cm. Diam. (max.) 11·2 cm.

M.31–1953

PROVENANCE Bequeathed by Dr W. H. Hildburgh F.S.A. (ex loan 4653).

On acquisition the tankard was classed as German. Subsequently (1959) it was re-classed as Swedish when the arms were identified by B. Lagercrants of the Nordiska Museet, Stockholm, as those of George Fleetwood (1605–67) and his wife Brita Gyllenstjerna (1606–53). Fleetwood (for whom see *Dictionary of National Biography*, s.v.) was the second son of Sir Miles, of Cranford and Aldwinkle, Northants, receiver of the Court

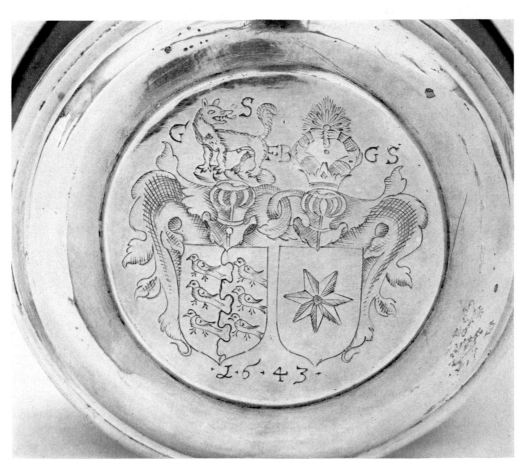

77a

of Wards. In 1629 he raised a troop of horse, joined the army of Gustavus Adolphus in Germany and was made a lieutenant-colonel by the King. Returning to England, he raised a regiment of foot with which he went back to Germany in 1630. He was made a Swedish knight on 3 June 1632, and in 1636 was sent on a mission to England. He married Brita Gyllenstjerna in 1640, and by her had four sons and two daughters. In 1641 he was commandant of Greifswald and Colberg in Pomerania. He returned permanently to Sweden in 1653, and on 1 June 1654 was made a baron by Queen Christina. In the following year he was sent to England by Charles X as Envoy Extraordinary to Cromwell on a return mission after Bulstrode Whitelocke's embassy in 1653–54. He was raised to the rank of a Swedish lieutenant-general in 1656. He left England in 1660, died on June 1667 and is buried at Nyköping.

There is a lively sketch of Fleetwood in Whitelocke's journal (*A Journal of the Swedish Embassy in the years 1653 and 1654*, ed. H. Reeve, vol. i, London, 1855, p. 418): 'Sir George Fletewood, an English gentleman visited and performed many civilities and kindnesses to Whitelocke. He came into this country many years past, with some of his countrymen, to serve the King Gustavus Adolphus, from whom he had great favour, and was made a colonel and afterwards governor of a town, and a major-general. He married an heir in this country, by whom he had several children, and a fair estate, and was now settled here, and well beloved at Court and in the army, and in the country, as if he had been a native of it. He is a gentleman of a good family and of much honour and integrity, and of particular friendliness to Whitelocke, with whom he was often here, and did very good offices for Whitelocke, and informed him of many material and useful matters: he

also had the news of the Queen's design to quit the Crown, and was one of the first without-doors that acquainted Whitelocke with that news.'

Tankards with serpentine bodies are rare in Sweden at this date, and it may be that the original attribution to Germany, where they were frequently made, is the correct one.

78 TANKARD

Nyköping, c. 1670. Parcel-gilt. The cylindrical body is plain except for the gilt moulded rim and a gilt band beneath it. It rests on three cast ball-feet shaped as fruit and foliage; above each, applied to the body, is a leaf-shaped plaque. Both feet and plaques are gilt. The top of the lid is gilt and engraved

78

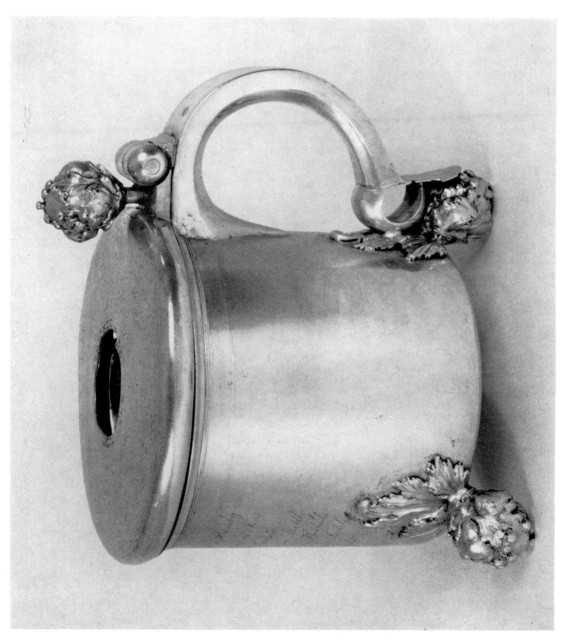

with a scrolling foliated stem on which three birds are perched. In the centre is a plain silver border engraved with a Hebrew inscription; this formerly encircled a thaler of King Gustavus Adolphus (reigned 1611–32). The thumb-piece is of the same shape and design as the feet: the scroll-handle, which is hinged to the lid, is decorated on the outside with a plain engraved gilt band and terminates in a shaped shield. The inside is gilt.

On the front is engraved a nineteenth century inscription

> *Till Namndemannen Joh:*
> *Holmstedt i Ramby/på Midsommer*
> *dagen 1858. Ett Tacksamt Min =/*
> *ne of endel Landtbrukare i Lont*
> *Hacksta./Weckholm, kungshusby,*
> *Thorsavi, Lillkyrka, Wallby/*
> *Willbergga, Litslena, Husby*
> *Sjutålft och Herkuls = /berga*
> *Socknanr,—for̊ hans i många år*
> *Serdeles/binanågna beredvillighet i*
> *Ultöfrandet/af fin Wetrinår kuns*
> *kap.*

MARKS On the base.

TOWN MARK The castle of Nyköping (*Sven. Silv.*, p. 485).

MAKER'S MARK: a device (incompletely struck), which is unrecorded.

DIMENSIONS H. (max.) 17·7 cm. W. (max.) 14·7 cm.

CONDITION The thaler of Gustavus Adolphus was stolen during the War. The feet crudely re-soldered. Interior gilding renewed.

M.50–1912

PROVENANCE Purchased (£44 1s 6d) from Herr M. C. Hirsch, Norrlandsgatan 16, Stockholm.

The inscription records the presentation of the tankard on Midsummer Day 1858 to the veterinary surgeon Johan Holmstedt of Ramby by the farmers of villages in his practice.

79 TANKARD

Stockholm, c. 1670–75. Parcel-gilt. Plain cylindrical body, with gilt moulded rim and a gilt band running underneath. The three ball-feet are cast in the form of a bunch of flowers and fruit: above each of them, applied to the body, is a leaf-shaped plaque cast in relief with a design of two boys on either side of a vine. Both feet and plaques are gilt. To the lid, which is mostly gilt, is applied an ungilt circular medallion engraved with a coronet above two monograms in a border of Louis XIV ornament (see below): this is applied, according to a note made at the time of acquisition, over a monogram AVMLD. The medallion is encircled by two intertwined sprays of flowers and foliage forming a wreath. The thumb-piece has the same form as the lid: the back of the scroll-shaped handle is embossed and chased with fruit and flowers. The thumb-piece and the decoration of the handle are both gilt. On the base is inscribed: 125 lod./H:M:S: S:U:D:/1765. Beneath the 1765 is a crudely scratched merchant's mark. The inside is gilt.

MARKS On the base.

TOWN MARK: the crown of Stockholm (*Sven. Silv.*, p. 33, no. 20).

MAKER'S MARK of Henrik Möller the Elder (*Sven. Silv.*, p. 62, no. 162?).

DIMENSIONS H. 20·5 cm. Width of body 15·7 cm.

CONDITION Gilding renewed (see below).

M.485–1910

PROVENANCE Purchased (£299, with M.485 to 490–1910) from M. Hammer of Bergen.

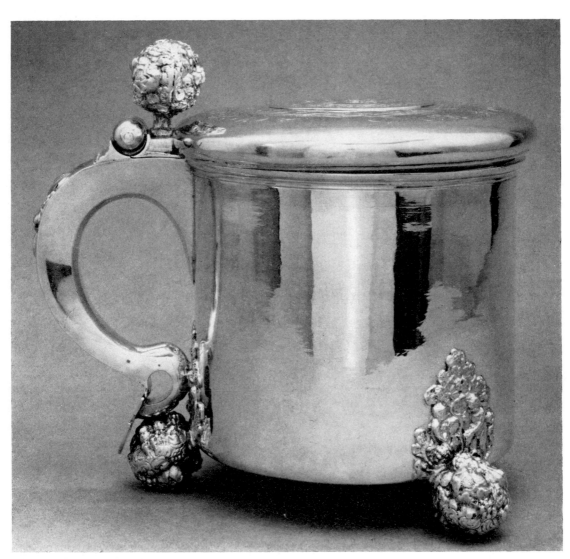

79

Henrik Möller the Elder, maker of this tankard, was born in Lübeck in 1615, and became a master at Stockholm in 1645. He died in 1690. This tankard must have been made quite a number of years before 1689, when the Stockholm mark was changed to St Erik's head, since *Sven. Silv.* lists four different forms of the crown as succeeding it. As noted at the time of acquisition, the medallion applied to the lid is a replacement, dating from the second quarter to the middle of the eighteenth century. The coronet on it is a Swedish gentleman's coronet.

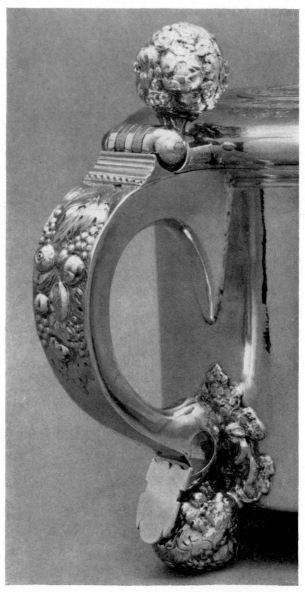

79a

79b

80 TANKARD

Stockholm, c. 1680. Parcel-gilt. The body, except for the gilt band round the rim, is boldly embossed and chased with scrolling foliage and flowers in the Floral Baroque style. Three of the flowers are gilt: the rest is left ungilt. The lid, which is hinged to the handle, is embossed and chased with a central gilt flower, round which runs a border of flowers and foliage. The three feet and the thumb-piece are formed as large cast buds. The harp-shaped handle (cast in two halves) is decorated on the outside with four up-curling laurel leaves. On the gilt band beneath the everted rim of the body is the inscription: *Henrich Erichson: Britha-Isaac. Dotter.* The inside is completely gilt. On the base is the inscription: *57 Lodh* and an inventory number: A. III No. 9.

MARKS On the base.
TOWN MARK: the crown of Stockholm (*Sven. Silv.*, p. 33, no. 22).
MAKER'S MARK of Johan Nützel (*Sven. Silv.*, p. 75, no. 251).
DIMENSIONS H. (including thumb-piece) 16 cm. Diam. of body 12·6 cm.
CONDITION The gilding renewed.

283–1878

PROVENANCE Bequeathed by Mr George Mitchell (as Nuremberg, seventeenth century).

Johann Nützel (the name also appears as Nijsel or Nüssel), the maker of this fine tankard, was from Nuremberg. He settled in Stockholm in 1674, becoming a master in October 1676. In 1689 he became court goldsmith to Queen Hedvig Eleonora and in 1699 madè for her the first Swedish teapot of which any record exists. The date of the Stockholm crown mark struck on the tankard seems not to have been definitely established. But it must date from 1676 or later and from some years earlier than 1689, when St Erik's head was introduced as the Stockholm mark, for *Sven. Silv.* lists two different forms of the crown-mark as succeeding it. Oman (*Scandinavian Silver*, pl. 10) suggests a date c. 1680.

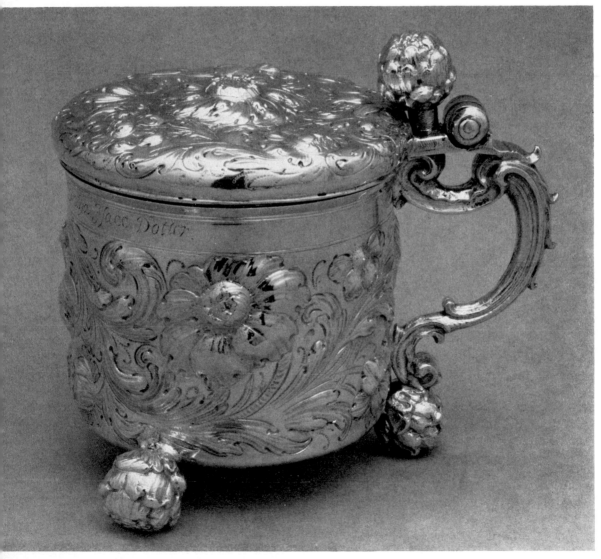

80a

81 TANKARD

Stockholm, 1691. Parcel-gilt. The cylindrical body is plain except for a gilt moulded rim and a gilt band running beneath. The three gilt ball-feet are cast and chased in the form of a bunch of leaves and flowers held by two ribbed spurs on either side. Applied to the body above each of them is a shaped gilt plaque, decorated with a male and female sea-god clasped in an embrace on a ground of foliage. The gilt thumb-piece is shaped like the feet and is topped by a small finial. The scroll-shaped handle is gilt on the outside, which is embossed with leaves and fruit and terminates in a shaped cartouche. The bulging lid is engraved with a gilt band of flowers and foliage in the Floral Baroque style encircling a plain central medallion, which is engraved with the initials OPCS in monogram framed by two sprays of palm leaves. The inside is gilt. The initials OPS are roughly engraved on the foot.

MARKS On the base.

TOWN MARK: the St Erik's head of Stockholm, full-face, in use between 1689 and 1702 (and also found until 1706) and 1711–13 (found up till 1716). It corresponds to *Sven. Silv.*, p. 33, no. 26, and seems to have been struck again over an imperfect first striking.

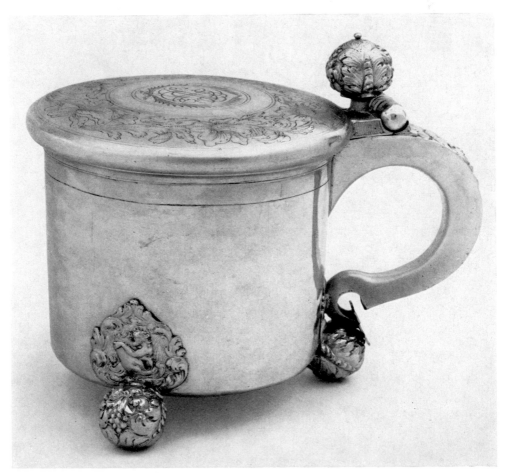

81

MAKER'S MARK of Ferdinand Sehl the Elder, working in Stockholm from 1688 to c. 1731 (*Sven. Silv.*, pp. 84–5, closer to no. 379 than to no. 370, though this is illustrated with the same combination of marks as on the tankard.)

YEAR LETTER: C for 1691.

DIMENSIONS H. (max.) 18·2 cm. W. (max.) 22·7 cm.

CONDITION Good. Gilding of the inside renewed.

765–1904

PROVENANCE Purchased (£55 17s) from G. Jorck.

On acquisition the marks were misread as those for 1761, but it was recognized that this magnificent tankard must have been made in the late seventeenth century. Sehl, its maker, was a German who settled in Stockholm in 1688.

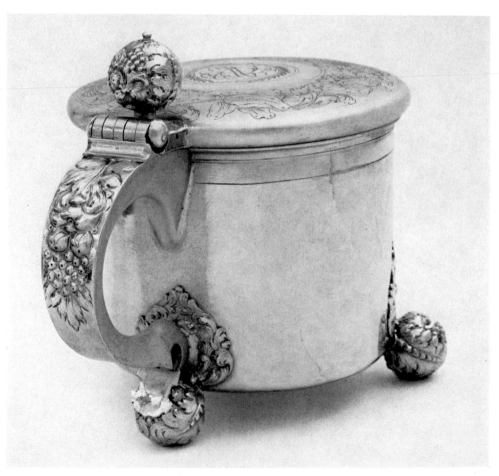

81a

82 TANKARD

Stockholm, 1696. Silver, parcel-gilt. The cylindrical body is plain, except for the gilt moulded rim and a gilt band beneath. It rests on three gilt ball feet, shaped as fruit and foliage; above each of them, applied to the body, is a plaque in the form of a plant motif composed of a stem supporting a flower and flanked on either side by a a scrolling leaf. The top of the lid is decorated with a gilt band engraved with a scrolling Floral Baroque spray, laden with leaves and bearing a rose and tulip. This encircles a plain medallion engraved with the Italic inscription: *Jonas Anderson. Mÿr: Anna Maria Stois Löfft:* encircling the pounced initials *P:O:S:C:L:D.* and the engraved name of *J Lisananti.* The thumb-piece is of the same form and design as the feet, but has a small finial on top. The scroll-handle is embossed on the outside with an apple and a spray of vine leaves and bunches of grapes suspended on a ribbon: it terminates in a shaped shield. The inside is gilt. Lightly scratched on the base is the date 1766.

MARKS On the base.

TOWN MARK: St Erik's head full-face, the Stockholm mark introduced in 1689 (corresponds to one of the three versions in *Sven. Silv.*, p. 33, nos. 25–7).

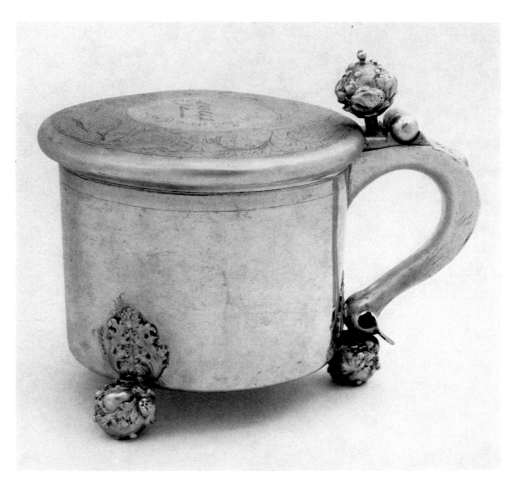

82

MAKER'S MARK of Christian Henning (working from 1692 until 1716 and after: died 1738). See *Sven. Silv.*, p. 87, no. 408.

YEAR MARK: H for 1696.

DIMENSIONS H. 18·9 cm. W. 22 cm.

CONDITION See below.

Circ.411–1912

PROVENANCE Purchased (£70) from G. Jorck for the Department of Circulation.

The long inscription encircling the other two is the older, and possibly early eighteenth century in date: the pounced initials date from c. 1800, the engraved name from the middle or late nineteenth century. It is more than likely that these last two inscriptions replace an engraved device or coat-of-arms which was removed to make room for the first of them.

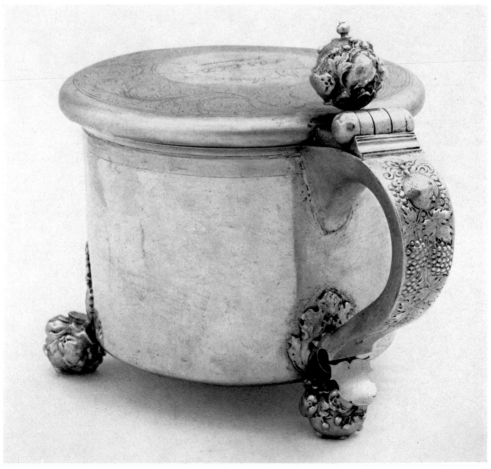

82a

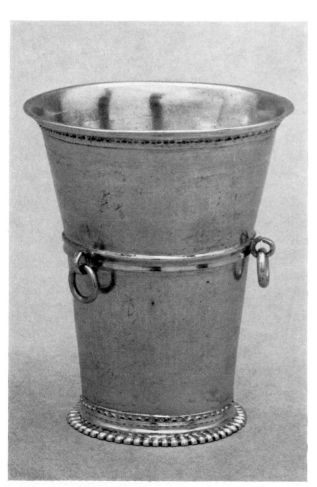

83

83 BEAKER

Stockholm, 1723. Parcel-gilt. The trumpet-shaped body is encircled by a gilt moulded band to which are attached three hoops each hung with a ring. The narrow moulded rim (gilt both outside and inside) terminates in a band of zig-zag ornament in relief: the zig-zag ornament and a band on the body beneath it are gilt. The base-ring is decorated with a band of zig-zag ornament in relief and mouldings: the foot is radially ribbed. Both ring and foot are gilt.

MARKS On the base.

TOWN MARK: the St Erik's head of Stockholm (*Sven. Silv.*, p. 34, no. 37).

MAKER'S MARK of Rudolf Wittkopf (*Sven. Silv.*, p. 83, no. 359).

YEAR MARK Scrolled L for 1723.

DIMENSIONS H. 9 cm. Diam. (max.) 7·6 cm.

CONDITION Some light scratching and denting.

M.487–1910

PROVENANCE Purchased (£4) from M. Hammer, Strandgaden 57, Bergen, Norway.

Since Wittkopf (master in 1687) died on 18 April 1722 this piece must have been made in his shop. He is described by E. Andrén (*Swedish Silver*, New York, 1950, p. 43) as the most skilful of the German-born silversmiths working in Stockholm in the late seventeenth and early eighteenth century: he produced a fine silver-gilt covered beaker decorated with filigree and enamel now in the National Museum, Stockholm.

84 TANKARD

Arboga, between 1727 and 1735. Parcel-gilt. The drum, lid and base are inset with silver coins, arranged to form a pattern, as follows.

LID

Centre. King Frederick and Queen Ulrica Eleonora of Sweden, dated 1727.

Clockwise from the bottom

1. King Charles XII of Sweden, dated 1718.
2. King Charles IX of Sweden, dated 1609.
3. King Gustavus Adolphus of Sweden, dated 1632.
4. Queen Christina of Sweden, dated 1642.
5. King Charles Gustavus of Sweden, dated 1654.
6. King Charles XI of Sweden, dated 1686.

They are set in a rosette-shaped motif, engraved on the lid. This has a matted ground, on which is relieved a frame of Bérain ornament encircling the central coin of Frederick and Ulrica Eleonora. To this central frame are attached ornamental motifs which divide the outer coins from each other.

Round the edge is engraved the inscription (outer line): *hwad Tnu/älen-eller/ dricken/eller hwadj/giören. så/görer;* (inner line) *alt-/Gudi/-til/-ähro/i. Cor. 10/ V=31.*

Drum. Cylindrical in form, with a moulded rim terminating in a band of zig-zag ornament in relief. Beneath this is a broad band of plain gilding; underneath runs a band of coins, separated by Bérainesque motifs on a matted ground. These coins taken in order from right to left from the centre, are of:

1. King John III of Sweden, dated 1578.
2. King Frederick III of Denmark, dated 1659.
3. King Christian IV of Denmark, dated 1638.

4. Christian? (title illegible) dated 1624.
5. Oliver Cromwell, dated 1653.
6. Augustus, Duke of Saxony, dated 1573.
7. Christian Wilhelm, Margrave of Brandenburg, Administrator of the Archbishopric of Magdeburg and the Bishopric of Halberstadt, dated 1613.
8. Louis XIV, King of France, dated 1704.
9. Emperor Rudolph II, dated 1603.

On the ungilt silver beneath, a damaged coin is set between each foot (see below under condition). From the centre to right they are:

1. Much damaged. The inscription on the obverse reads: ...ENT.../1598/ VIG.ILATE D ...: that on the reverse: MO.NO.ARG.ORDIN.? TRAT.
2. Frederick, Duke of Brunswick-Lüneburg, dated 1619. Much damaged.
3. Much damaged. The inscription reads: NVMMVS.RE ... ORATEN-SIS. On the reverse, a fleur-de-lys and the inscription: SOLIVS*VIR-TVTIS*FLOS*PERPETVVS.

The base is set with three silver coins. These are of

1. George William, Duke of Brunswick-Lüneburg, dated 1652.
2. Name illegible, Duke of Brunswick-Lüneburg, dated 1668.
3. Frederick Ulrich, Duke of Brunswick-Lüneburg, dated 1631.

The gilt, ball-shaped feet are very finely cast and chased with fruit and foliage and are applied to the drum by a shaped motif in the form of fruit and foliage. The ball-shaped thumb-piece is likewise very finely cast and chased with fruit, foliage, and Bérainesque scroll-work and is surmounted by a finial. The scroll-shaped handle is embossed with the figure of

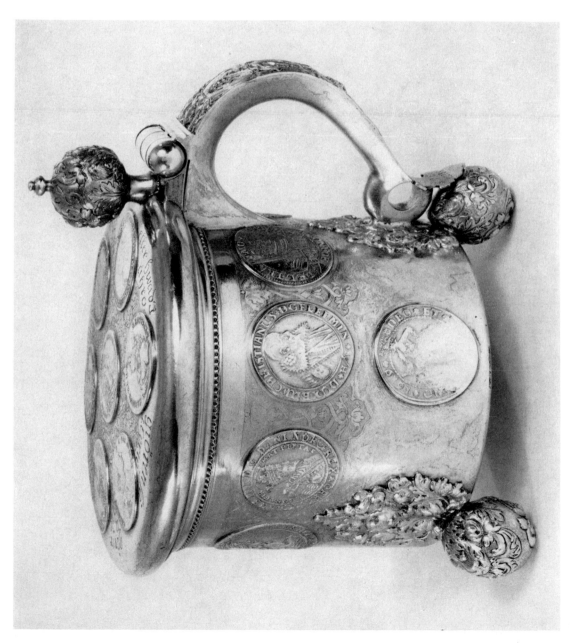

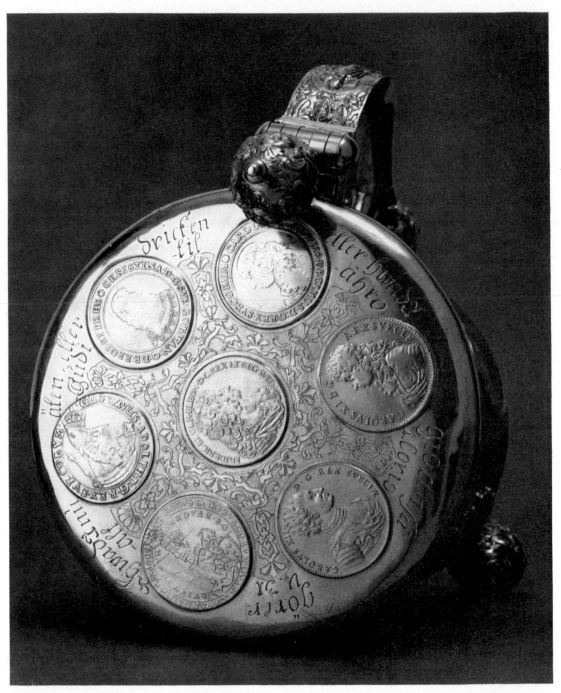

84a

Fame in a cartouche; above and below it is decorated with strapwork, fruit and foliage and other ornamental motifs surrounding an antique female head (*above*) and a lion's head (*below*). It terminates in an escutcheon engraved with the inscription: *J.P.E./AO. 1735*. On the base is engraved the weight (152⅜ lod.) of the tankard in an early hand.

MARKS On the base.

TOWN MARK: the eagle of Arboga (*Sven. Silv.*, p. 210).

YEAR LETTER None.

MAKER'S MARK of Johan Dragman (b. c. 1670), who became a master at Arboga in 1701 and worked there until 1746 (*Sven. Silv.*, pp. 212–13, no. 2506).

DIMENSIONS H. (max.) 20 cm. Diam. (max. excluding feet) 17·5 cm.

CONDITION Some of the coins are partly worn: in some cases this was already so before mounting: others have become worn since mounting. The feet had been moved and reset: in this process the coins above them were damaged. They were replaced in their original position in 1936 and the gaps patched. Gilding renewed.

864–1882

PROVENANCE The Jones Bequest (Victoria and Albert Museum, *Catalogue of the Jones Collection*, pt ii, 1924, p. 75, no. 298).

A letter from Messrs Nixon & Rhodes of 390 Oxford Street, dated 13 February 1860, says that the tankard was purchased by them 'at the sale of effects of the late Sir Arthur de Cape Broke (sic) Bt of Oakley Hall—Nr Kettering Northamptonshire'. Sir Arthur de Capell Brooke

(1791–1858) for whom see the *Dictionary of National Biography*, s.v., travelled in Scandinavia in 1820. Neither his *Travels through Sweden, Norway and Finmark to the North Pole in the Summer of 1820*, 1823, nor his *Winter in Lapland and Sweden*, 1827, contains any reference to the tankard.

On a piece of paper forwarded with this letter as belonging to the tankard is written in an early nineteenth century Scandinavian hand:

Af
Drattnings
Louisa Ulrica
S. Kiän V it åt
Lars Thorbiörnsson
Da Warande Bondeståndels

———

From
Louisa Ulrica
given to
Lors Thorbionsen
at that time Speaker
of the Peasants House
of Assembly.

Lars Torbiörnsson (b. 26 March 1719; d. 3 March 1786), the son of Torbiörn Rasmusson and Katarina Ramberg, was born at Solberga. He was Speaker of the Peasants' House from 1755 until 1778 (*Svenska Män och Kvinnor: biografisk uppslagbok*, vol. viii, 1955, s.v.).

Queen Louisa Ulrica of Prussia (d. 1782) was the wife of King Adolphus Frederick (b. 1710, reigned 1751–71), whom she married in 1744. It is a reasonable assumption that, if the tradition of presentation is a true one, she gave Torbiörnsson the tankard at some date between 1755 and

his death in 1778. Bribery and corruption were endemic in Swedish politics of the day.

Obviously the tankard was not made for the queen, though it is an exceptionally heavy and splendid piece. The *terminus post quem* for its manufacture is 1727, the date of the coin of Frederick and Ulrica Eleonora set, significantly, in the centre of the lid. A *terminus ante quem* is provided by the inscription dated 1735 on the escutcheon on the handle. According to *Sven. Silv.* (p. 210) a year letter system was introduced in Arboga on 3 July 1733; the absence of a year letter on the tankard should mean that it was made before that date. On acquisition it was dated c. 1770: this was subsequently changed to a date c. 1720. The design is of standard Swedish Late Baroque type. Published by R. W. Lightbown, 'A Victorian's Taste in Silver' in *Apollo*, March 1972, pp. 49–50).

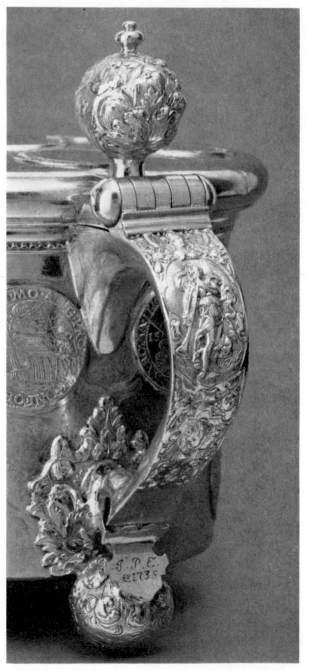

84b

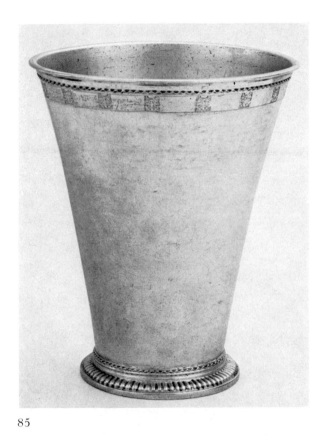

85

85 BEAKER

Stockholm, 1735. Parcel-gilt. The trumpet-shaped body has a moulded rim terminating in a band of zig-zag ornament in relief. Beneath this runs a band of gilding stamped at intervals with a pendent floral motif on a matted ground. The moulded base also has a band of zig zag in relief: the foot is radially ribbed. Both base and foot are gilt, as is the inside.

MARKS On the base.

TOWN MARK: the St Erik's head of Stockholm in left profile (*Sven. Silv.*, p. 34).

MAKER'S MARK of Johan Collin, working 1735–c. 1759 (*Sven. Silv.*, pp. 108–9, no. 716).

YEAR MARK: Y for 1735.

DIMENSIONS H. 15·2 cm. W. (max.) 11·9 cm.

CONDITION Dented and scratched; a deep crack in the rim.

M.496–1911

PROVENANCE Purchased (£12 14s 11d) from Herr G. A. Sandell, Kuusa Eisenbahnstation, Finland.

This must have been one of Collin's first works, since he was only received on 30 November 1734.

86 BEAKER

Västervik, c. 1736. Parcel-gilt. The trumpet-shaped body has a moulded rim decorated with a band of zig-zag in relief above a band of ribbing. Under the rim is engraved a broad gilt band of debased Bérainesque ornament on a lightly matted ground. Beneath this, on the front of the beaker, are engraved the initials F:J:W:C:E:M. The moulded base has on its upper section a band of zig-zag like that on the rim: the upper surface of the ring is decorated with radial ribbing. Rim, base and inside are gilt.

MARKS On the base.

TOWN MARK: the ship of Västervik (*Sven. Silv.*, p. 607, no. 8187).

MAKER'S MARK of Lars Pihl, working at Västervik from c. 1730 until 1755 (his widow Anna Pihl used his mark until 1760). See *Sven. Silv.*, p. 608, no. 8203.

YEAR MARK: H, belonging to a sequence whose chronology has not been worked out (see *Sven. Silv.*, p. 607).

DIMENSIONS H. 18 cm. W. (max.) 14·5 cm.

CONDITION The band of gilding on the upper part of the body originally extended further, and has been crudely scraped away beneath the present band.

M.48–1912

PROVENANCE Purchased (£9 18s 4d) from Herr C. Hirsch, Norrlandsgatan 16, Stockholm, on the recommendation of the Director.

On acquisition the year mark was identified, incorrectly, as that of 1766. Pihl (see *Sven. Silv.*, p. 608) made a chalice in

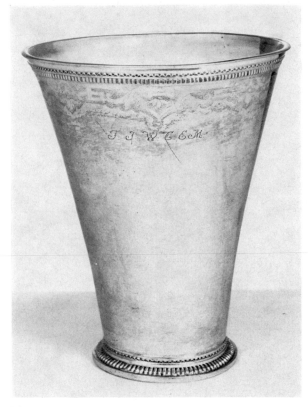

86

the church of Västervik which is dated 1730 and carries the year letter B. A date of 1736 for the beaker is obtained by assuming that the date and year-letter on the chalice correspond and that the H on the beaker belongs to this sequence. This date or one near it is also plausible on grounds of style and decoration, and is supported by the dates of Pihl's working career.

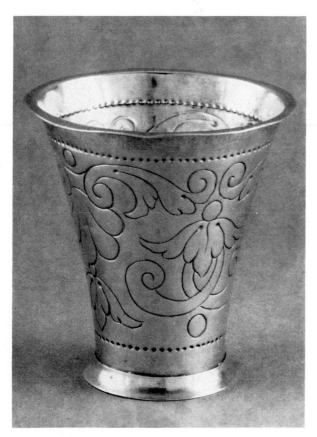

87

87 BEAKER

Karlstad, 1744. Trumpet-shaped body, with flanged rim, and applied concave base. The body is chased with a broad band of leaves, with pendant leaf and scrollwork motifs. The borders are outlined with punched dots. On the front are engraved the initials A.M.D. On the base are stamped the date 1744 and the number 10/9 (for the month?).

MARKS On the base.
TOWN MARK: the crowned C of Karlstad.
MAKER'S MARK of Niclas Warneck (Warncke) working 1727–80 (*Sven. Silv.*, pp. 367–68, no. 4852).
DIMENSIONS H. 8·5 cm. W. 8 cm.
CONDITION Dented.

296–1902

PROVENANCE Purchased (£1 10s) from G. Jorck.

On acquisition the town-mark (for which see *Sven. Silv.*, p. 365) was wrongly identified as that of Kristianstad. The system of dating is one used by Warneck on his work before the introduction of warden's marks in 1759 (see *Sven. Silv.*, p. 368).

88 BEAKER

Visby, dated 1746. Parcel-gilt. The trumpet-shaped body has a moulded rim, terminating in a band of zig-zag ornament in relief. A band of gilding runs beneath: on one side of the beaker, and evidently marking its front, is engraved a gilt cartouche of sexfoil form with hatched leaves protruding from the junction of the curves, enclosing the letters IGST in monogram. The moulded base, also gilt, begins with a band of ornament like that on the rim, and its ring has a radially ribbed upper surface. The ring is separately made from the upper mouldings. The base is pounced with the inscription: *W 32½ lo/1746*. The inside is gilt.

MARKS On the base.

TOWN MARK: the W of Visby (*Sven. Silv.*, p. 592, no. 8014).

MAKER'S MARK of Berndt Falkengren (1708–85), master in Visby from 3 June 1737, in business until c. 1774 (*Sven. Silv.*, p. 596, no. 8045).

DIMENSIONS H. 19 cm. W. (max.) 13·1 cm.

CONDITION Good. One or two dents only. Gilding renewed.

759–1904

PROVENANCE Purchased (£10 2s 9d) from G. Jorck, 35 Hatton Gardens, EC, acting as agent for Josef Nachemsohn of 31 Østergade, Copenhagen.

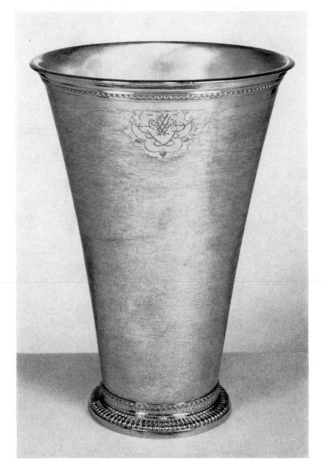

88

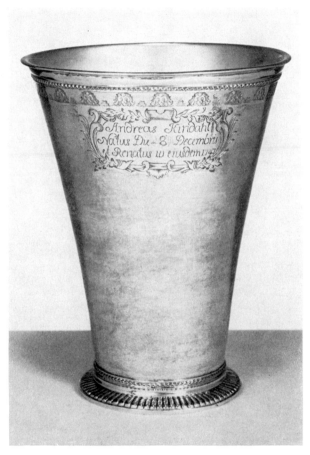

89

89 BEAKER

Norrköping, 1748. Parcel-gilt. The trumpet-shaped body has a moulded rim, terminating in a band of zig-zag ornament in relief. Beneath runs a gilt band stamped with Bérainesque plant ornament on a matted ground. Under this, on the front, is engraved a Baroque cartouche, whose frame is composed of palm branches, scroll-work and a leafy stem, lightly hatched. Inside this is engraved the inscription: *Andreas Kindahl/Natus Die 8* [over another figure, scratched out] *Decembris/et Renatus 10 eiusdem 1747*. On the other side is engraved a second gilt cartouche, in Bérainesque scroll-work, with the inscription: *Petrus/ Kindahl/1750*. The moulded base is decorated with a band of zig-zag ornament like that on the rim: the upper surface of the ring is radially ribbed. Both base and inside are gilt.

MARKS On the base.

TOWN MARK: St Olaf, sceptre and orb, the mark of Norrköping (*Sven. Silv.*, p. 467, no. 6254) introduced on 9 August 1755.

YEAR MARK: N for 1748 (*see Sven. Silv.*, p. 468).

MAKER'S MARK of Nils Orstedt (1710–1769), who became a master at Norrköping on 24 April 1745 (*Sven. Silv.*, p. 475, no. 6357).

DIMENSIONS H. 13·5 cm. W. (max.) 10·5 cm.

CONDITION Base dented: otherwise in good condition, except for the usual regilding.

1886–1898

PROVENANCE Given by Col. F. R. Waldo-Sibthorp.

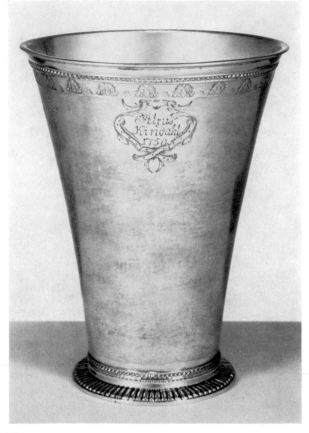

89a

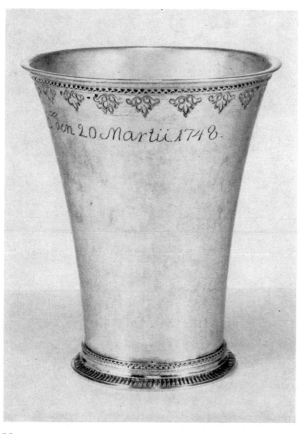

90

90 BEAKER

Stockholm, 1749. Parcel-gilt. The trumpet-shaped body has a gilt moulded rim, terminating in a band of zig-zag ornament in relief. Beneath this runs a gilt band of stamped leaf motifs. Engraved beneath this are the letters: *J.O.B.H.L.J.J.B. den 20 Martii 1748.* The gilt moulded base-ring is decorated with a border of zig-zag in relief: the upper surface of the foot is ribbed. The inside is gilt.

MARKS On the base.
TOWN MARK: the crowned head of St Erik of Stockholm (*Sven. Silv.*, p. 34).
MAKER'S MARK of Lorens Stabeus (*Sven. Silv.*, p. 113, no. 802), working in Stockholm from 1745 until his death in 1778.
YEAR MARK: a Gothic N for 1749.
DIMENSIONS H. 11 cm. W. (max.) 9 cm.
CONDITION Some small dents.

M.495–1911

PROVENANCE Purchased (£9 3s 2d) from Herr G. A. Sandell, Kuusa Eisenbahn-Station, Finland.

The inscription may give the year 1748 old style, but it is more likely that it is retrospective.

91 BEAKER

Piteå, 1756–59. Parcel-gilt. The trumpet-shaped body has a gilt moulded rim decorated with a band of zig-zag in relief. A narrow band of gilding runs beneath: under this is a broad band of engraved decoration consisting of a band of twisted cord, from which depend a series of ornaments composed of *rocaille*, scroll-work and foliage, all on a matted ground. The gilt foot consists of a moulded base decorated with a zig-zag moulding and a spirally fluted foot decorated with panels of Bérainesque ornament. The inside is gilt. On the front the initials J.C.T. in Gothic script for a nineteenth century owner.

MARKS On the base.

TOWN MARK: the reindeer head of Piteå (*Sven. Silv.*, p. 492).

MAKER'S MARK of Martin Simonis, working in Piteå from 1756–1759 (*Sven. Silv.*, pp. 492–93, no. 6683).

CONTROL MARK The three crown mark in force from 1754.

MEASUREMENTS H. 17·2 cm. Diam. 14·3 cm.

CONDITION On acquisition described as 'bent and dented and foot crushed'. These defects have since been restored. A small part of the edge replaced.

284–1902

PROVENANCE Purchased (£9) from G. Jorck, probably acting as agent for Josef Nachemsohn of 31 Østergade, Copenhagen.

Only one or two pieces by this maker are known.

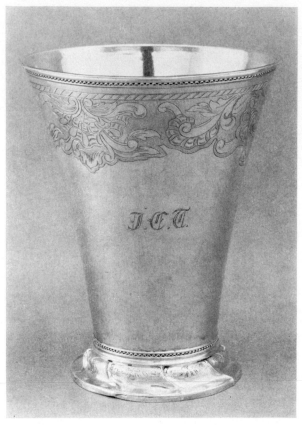

91

92 TWO-HANDLED BOWL

Hudiksvall, 1761 or 1765. The bowl has an everted rim and is engraved in wrigglework with two waving foliated stems, joining two cartouches, from each of which hang two leaves. In one are engraved the initials O:O:W:, in the other the initials S:F:D:. The scrolled handles terminate in stylized monster heads: they are cast. The trumpet-shaped foot is simply moulded.

MARKS On the base.

TOWN MARK: the buck's head of Hudiksvall (*Sven. Silv.*, p. 304).

YEAR MARK Either C or G for 1761 or 1765.

MAKER'S MARK of Nils Grubb (1728–85), working as a master at Hudiksvall from 1758 (*Sven. Silv.*, p. 306, no. 3818).

CONTROL MARK The three crowns mark in force from 1754.

DIMENSIONS H. 8·2 cm. W. (max.) 21 cm.

CONDITION Some dents.

1105–1904

PROVENANCE Purchased (£13 6s 0d) from G. Jorck.

Acquired as from Lapland, and as dating from the seventeenth century. This date was no doubt assigned to it on account of the resemblance between the bowl and generally similar bowls made in Holland and England in the seventeenth century. This piece, with the ornament omitted, was drawn by C. R. Ashbee (*Modern English Silverwork*, his own copy, with drawings from his hand bound in, now in the Library of the Victoria and Albert Museum). Two examples of the type from Helsingland were reproduced in the Special Autumn Number of *The Studio*, 1910, entitled *Peasant Art in Sweden, Lapland and Iceland*, ed. C. Holme.

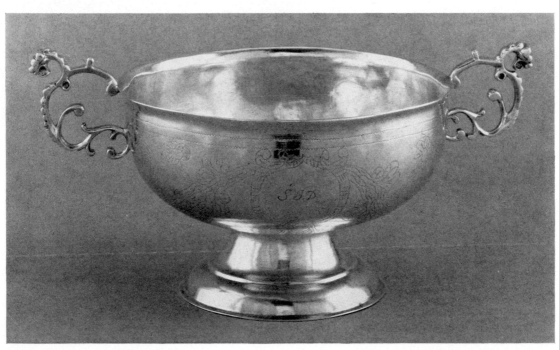

93 BEAKER

Piteå, 1762. Parcel-gilt. The trumpet-shaped body is encircled by two gilt moulded bands. To the upper band are applied three hoops, from which hang three pendants in the shape of the letters A M in monogram (for *Ave Maria*). The area between the two bands is engraved in wrigglework with three panels, each containing an upright plant or flower shown growing from the ground (two) or resting on a stylized foliated motif. Below the lower band the body is decorated with a wrigglework leaf-pattern above a border with zig-zag edging. The upper side of the flanged rim and a band round the edge of the inside are gilt. The beaker rests on three cast feet in the shape of classical masks on claws. The outside of these is gilt, and they are applied to the base, which has moulded sides. A weight mark is scratched on the base.

MARKS On the base.
TOWN MARK: the reindeer head of Piteå
 (*Sven. Silv.*, p. 492).
MAKER'S MARK of Johan Gadd, working
 1760–70 (*Sven. Silv.*, p. 493, no. 6685).
YEAR LETTER: D for 1762.
CONTROL MARK The three crowns mark
 in force from 1754.
DIMENSIONS H. 10·7 cm. W. 6·5 cm.
CONDITION Rim slightly dented: slight
 scratches.
 1881–1898
PROVENANCE Given by Col. F. R. Waldo-
 Sibthorp.

A Lapp beaker: reproduced by Fjellström (*Lapskt Silver*, cat., p. 40, no. 369, pl. 11: 9); Oman (*Scandinavian Silver*, pl. 23).

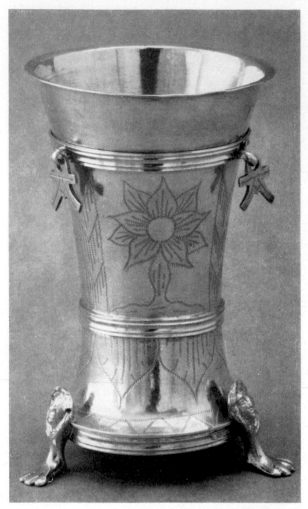

93

94 BEAKER

Södertälje, 1763. Parcel-gilt. The trumpet-shaped body has a gilt moulded rim decorated with a band of zig-zag in relief. Beneath this is a gilt band stamped with

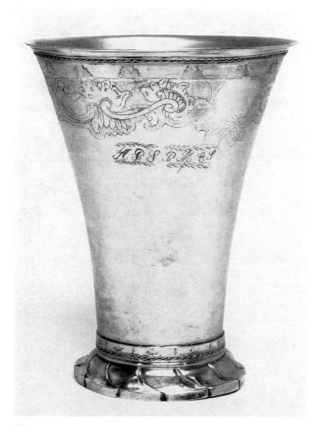

94

a foliated ornament on a matted ground. Below is a band of engraved ornament consisting of Rococo plant, flower and foliage motifs on a matted ground, with two enwreathed blank cartouches (see condition). Above the gilt foot are a moulded band decorated with stamped foliated ornament and a band of zig-zag in relief. The foot itself is spirally fluted. On one side are inscribed the initials ABS BM ES with two sprays above and below, and on the other side are the initials (rather later in date) JOS & CAD. The inside is gilt.

MARKS On the base

TOWN MARK: the three reindeer heads of Umeå (*Sven. Silv.*, p. 557). Struck over the mark of Södertälje (*Sven. Silv.*, p. 538).

MAKER'S MARK of Johannes Gadd, working c. 1798–1802 in Umeå (*Sven. Silv.*, p. 559, no. 7556). Overstriking another maker's mark, probably that of Johan Hedman, working in Södertälje from 1750–86 (*Sven. Silv.*, pp. 538–39, no. 7262?).

YEAR MARK: E for 1763 (see below). s2 for 1800.

CONTROL MARK The three crowns mark in force from 1754.

MEASUREMENTS H. 17·5 cm. Diam. 14 cm.

CONDITION A little dented and bent. Earlier owner's initials erased from the two blank cartouches.

26–1902

PROVENANCE Purchased (£7 16s) from G. Jorck, probably acting as agent for Josef Nachemsohn of 31 Østergade, Copenhagen.

On acquisition it was recognized that in spite of the late date of the marks the beaker must date from some forty years earlier. The overstriking of the Södertälje mark and the earlier year mark nevertheless escaped observation. This is an interesting instance of later re-marking for sale.

95 BEAKER

Gothenburg, 1770. Parcel-gilt. The body is trumpet-shaped. The moulded rim terminates in a band of zig-zag ornament in relief. The body is decorated in wrigglework with a crown over the cipher G III, framed by two sprays of laurel. Above and below runs a border decorated with a wavy line. The moulded foot has a ribbed upper surface: it is also ornamented with three bands of the same type of zig-zag ornament as the rim. The rim, foot and a band of the body below the rim, the crown, cipher and laurel and the inside gilt.

MARKS On the base.

TOWN MARK of Gothenburg (Göteborg).

MAKER'S MARK of Johann Christoffer Jungmarker (*Sven. Silv.*, p. 283, no. 3481: it differs in that the surname begins with an I, not a J and has a colon at the end).

YEAR LETTER: M for 1770.

CONTROL MARK The three crown mark in force from 1754.

DIMENSIONS H. 20 cm. W. (max.) 15·5 cm.

CONDITION The gilding worn and rubbed: on the crown, cipher and laurels it is now hardly visible, except in the engraved lines. It has also mostly worn away from the inside. The surface is pitted from cleaning and use.

M.49–1912

PROVENANCE Purchased (£9 12s 10d) from Messrs Bukowski, Stockholm.

Jungmarker (1721–1810) became a master at Gothenburg in 1752 and was in business there until 1779, when he moved to Marstrand (*Sven. Silv.*, pp. 281–82, 463). Gustavus III became King of Sweden in February 1771: it is tempting to think that the decoration was added for a loyal subject in his coronation year.

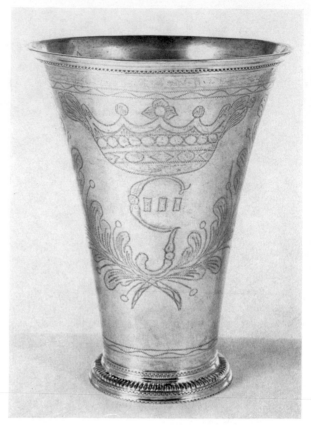

95

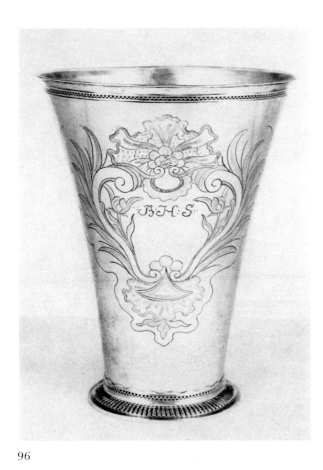

96

96 BEAKER

Landskrona, 1778. Parcel gilt. The trumpet-shaped body has a plainly moulded rim terminating in a band of zig-zag ornament in relief. The body is engraved in wrigglework with a Rococo cartouche, consisting of a scalloped outline border, open at the top, enclosing a cartouche composed of scroll-work, rocaille palm-branches, and plant and flower motifs, lightly hachured in wrigglework. The frame contains the initials. B:H:S. The base has a wavy edge and is decorated with a band of zig-zag in relief. The surface of the foot is radially ribbed.

MARKS On the base.

TOWN MARK of Landskrona (*Sven. Silv.*, p. 598).

MAKER'S MARK of Lorenz Wretman, born in Malmö c. 1740, master 1764–1791, died in 1809 (*Sven. Silv.*, p. 401, no. 5340).

YEAR LETTER: U for 1778.

CONTROL MARK The large three crown mark in force from 1765.

DIMENSIONS H. 18·5 cm. W. (max.) 15 cm.

CONDITION Good: one or two small chips and dents in the rim.

285–1902

PROVENANCE Purchased (£10) from G. Jorck, probably acting for Josef Nachemsohn of 31 Østergade, Copenhagen.

On acquisition, it was suggested, incorrectly, that in spite of the year mark, the beaker was 'probably made about 1740'.

97 BEAKER

Gothenburg, 1780. Parcel-gilt. The trumpet-shaped body has a moulded rim terminating in a band of zig-zag in relief. The body is engraved in wrigglework with a rudimentary frame, enclosing a cartouche in line-engraving formed of scrolls, rocaille, the stem of a plant (*left*) and a palm-branch (*right*) surmounted by the crown of a gentleman and bearing the initials A K B above A C K B. The moulded foot has a band of ornament like that under the rim; its upper edge is ribbed. The rim, cartouche, foot and inside are gilt.

MARKS On the base.

TOWN MARK of Gothenburg (Göteborg) (*Sven. Silv.*, p. 271).

MAKER'S MARK of Andreas Reutz (working 1767–1810) of Gothenburg (*Sven. Silv.*, p. 282, no. 3485).

YEAR LETTER: X for 1780.

CONTROL MARK The small three-crown mark in force from 1754.

DIMENSIONS H. 21 cm. W. (max.) 15·5 cm.

CONDITION Good, except for one or two dents in the rim.

PROVENANCE Purchased (£16) from G. Jorck, probably acting on behalf of Josef Nachemsohn of 31 Østergade, Copenhagen.

283–1902

On acquisition this fine and heavy beaker was said to bear the Kristianstad hallmark for 1780 and described as 'probably made about 1730–40'. The crown above the initials is one to which all bearers of coats of arms are entitled in Sweden; it indicates no special rank above that of gentleman.

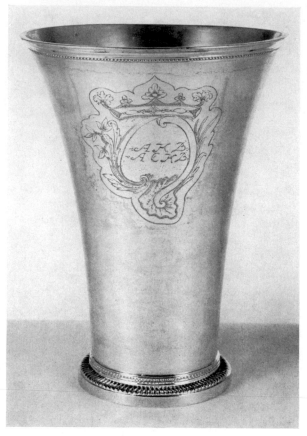

97

98 BEAKER

Swedish, c. 1780. Silver, parcel-gilt. The trumpet-shaped body has a gilt moulded rim with a band of gilding over a second band of wrigglework ornament. The body is engraved with two conjoined sprays of laurel (see below) on one side, and with a Swedish gentleman's crown (on a gilt ground) surmounting the initials and date J.A.S. A.C.D./1839. The base is moulded and decorated with a band of zig-zag ornament in relief. Beneath is a slightly domed band of ribbing: the side of the edge is decorated with two engraved outlines. The upper rim and upper surface of the base are gilt, as is the inside.

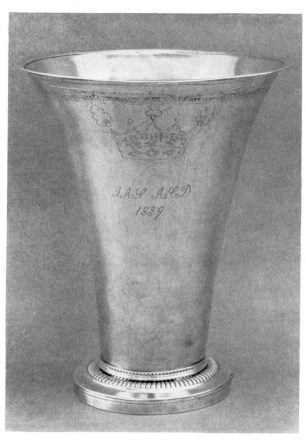

98

other maker's marks, which appear to be the same mark struck twice. The letters in this mark number five, and since they include an S as the first letter, an M as the last, and what appear to be R and O as the penultimate letters, it is possible that the mark is that of the Stockholm goldsmith Fredrik Petersson Ström (working 1765–1806: see *Sven. Silv.*, p. 132).

YEAR MARK: L3 for 1817.

CONTROL MARK: the large three crown mark in force from 1765.

DIMENSIONS H. 19·1 cm. Diam. 15·9 cm.

CONDITION Rubbed, worn and dented: surface roughened by an abrasive. Rim and foot replaced. See below.

Circ.406–1910

PROVENANCE Purchased (£8 12s 6d) from G. Jorck.

This beaker was evidently re-sold at least twice and, since the mark of the original maker is not certainly that of Ström, its place and date of origin cannot be fixed from the marks. On stylistic grounds a dating c. 1780 is plausible. The crown and initials are evidently an addition of 1839, probably made by Nordström of Marstrand, and it seems likely that it was he who added the foot and rim. There are what appear to be traces of an earlier band of decoration running round the rim (a zig-zag band in relief?).

MARKS On the base.

TOWN MARKS
1. The crowned GB of Gothenburg (Göteborg).
2. Partly superimposed, the town mark of Marstrand (three fish surrounding a star, see *Sven. Silv.*, p. 462).

MAKER'S MARKS
1. M FAUST for Melchior Faust of Gothenburg, working 1767–1819 (see *Sven. Silv.*, p. 283).
2. SNS for Sven Nordström of Marstrand, working 1822–48 (see *Sven Silv.*, p. 464, no. 6219).

Also struck on the base are two

99 SUGAR BASIN

Karlstad, 1787. Gilt. Urn-shaped in general form. The lower part of the bowl is formed as an embossed calyx of laurel leaves. Round its upper edge runs an applied band of acanthus on a background of cross hatching, surmounted by a row of beading. The rim of the mouth is also decorated with a row of beading, the beads being more widely spaced. The angular handles are fluted to resemble triglyphs. The foot is decorated with beading and fluting and has a moulded base. Beading and fluting are repeated on the lid, which is surmounted by an artichoke knob, cast and applied. There is a notch in the lid for a spoon *en suite* (missing). The inside is also gilt.

MARKS On the base.

TOWN MARK: a crowned C for Karlstad (*Sven. Silv.*, p. 365).

MAKER'S MARK of Wilhelm Smedberg (1749–1810), whose mark is found from 1777 (*Sven. Silv.*, p. 368, no. 4872).

YEAR LETTER: E2 for 1787.

CONTROL MARK The large three-crown mark in force from 1765, which also appears on the rim of the lid.

DIMENSIONS H. 19·5 cm. W. (max.) 14·5 cm.

CONDITION Good. The gilding appears to be original.

M.19–1940

PROVENANCE Given by Miss Tomes.

This is a handsome and well-finished piece. It was customary for these sugar-basins to be made in pairs and set on the table for use in sweetening dessert.

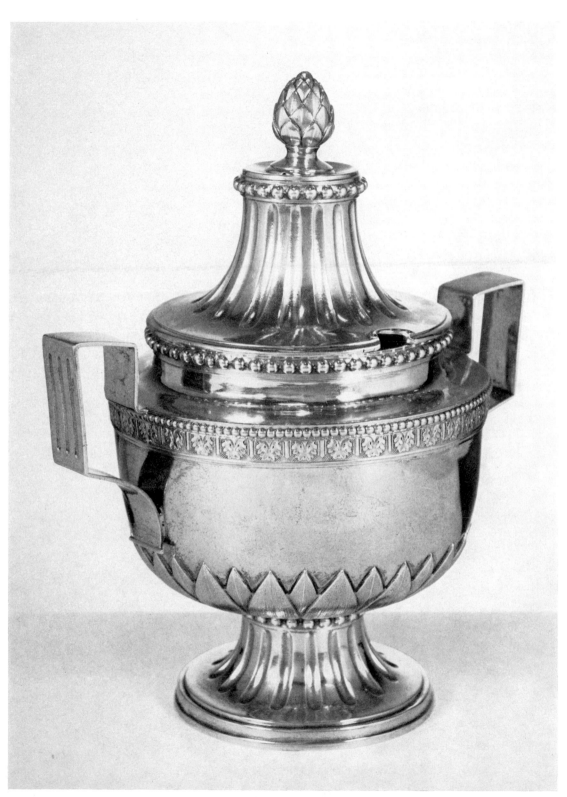

100 BEAKER

Ulricehamn, 1797. Parcel gilt. The trumpet-shaped body has a moulded rim terminating in a band of zig-zag ornament in relief. The body is engraved in wrigglework with a band enclosing a wavy branching stem. Beneath this is a gentleman's crown, surmounting the initials H:A:S:./C:J:D: above two crossed branches of laurel. A third branch of laurel curves horizontally over the surface to connect the two: a waving line beneath encloses the entire motif. A second engraved band of ornament like that at the top runs round the lowest part of the body. The base is moulded and decorated with a band of zig-zag in relief: the domed foot is chased and engraved with rocaille motifs. The inside is gilt.

MARKS On the base.

TOWN MARK: the crowned U of Ulricehamn (closest to *Sven. Silv.*, p. 554, no. 7480).

MAKER'S MARK of Johannes Lyberg (1756–1851), who became a burgher and master in Ulricehamn c. 1788 and was working there until 1823 (*Sven. Silv.*, p. 555, no. 7505).

YEAR MARK: P2 for 1797.

CONTROL MARK The large three-crown mark in force from 1765.

DIMENSIONS H. 18·5 cm. W. (max.) 14·5 cm.

CONDITION One or two slight dents and a small crack in the rim. The foot has been crudely re-soldered in comparatively modern times, but appears to be original.

24–1902

PROVENANCE Purchased (£8 10s 6d) from G. Jorck, probably acting on behalf of Josef Nachemsohn, of 31 Østergade, Copenhagen.

For the crown see the note to No. 97.

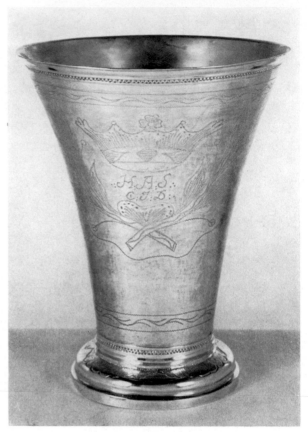

100

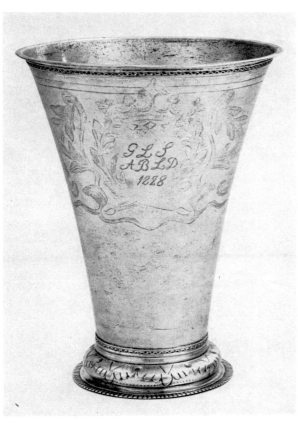

101

101 BEAKER

Karlskrona, 1799. Parcel-gilt. The trumpet-shaped body has a moulded rim decorated with a band of zig-zag in relief. On its upper part it is decorated with interlacing foliated sprays in wriggle-work. Two of the sprays form a cartouche (formerly gilt) enclosing the initials and date: GLS/ABLD/1828, surmounted by a Swedish gentleman's crown. The moulded base has a band of zig-zag in relief: the domed foot is decorated with foliage ornament enclosing stamped circles alternating with engraved triangles and has a ribbed flange. The inside is gilt (see below).

MARKS On the base.

TOWN MARK of Karlskrona (*Sven. Silv.*, p. 351, no. 4505).

MAKER'S MARK of Johan Fagerberg, working 1775–1822 (*Sven. Silv.*, p. 358, no. 4652, except that the mark on the present beaker has a point, not a colon, after the I).

WARDEN'S MARK: a crescent (*Sven. Silv.*, p. 351, no. 4529) used by Friedrich Silber from 12 January 1795 to 1813.

YEAR MARK: R2 for 1799.

CONTROL MARK The large three-crown mark in force from 1765.

DIMENSIONS H. 19·6 cm. Diam. 15·1 cm.

CONDITION The gilding of the exterior has been almost completely worn away: traces of it remain only on the upper part of the base. Engraving also worn. Foot and lip dented. See also below.

M.486–1910

PROVENANCE Purchased (no separate price) from M. Hammer, Stradgaden 57, Bergen.

As so often, the initials and date replace earlier ones.

102 BEAKER

Luleå, 1801. Parcel-gilt. The trumpet-shaped body has a narrow gilt moulded rim terminating in a band of zig-zag ornament in relief. The upper part of the body is engraved with a design in wriggle-work of rosettes alternating with foliated motifs to which the rosettes are joined by stems. The moulded base has a sloping ring, whose upper surface is radially ribbed. Base and inside are gilt.

MARKS On the base.

TOWN MARK of Luleå (*Sven. Silv.*, p. 421, no. 5638).

MAKER'S MARK of Johan Bergman (*Sven. Silv.*, p. 422, no. 5674), working in Luleå from 1788 until his death in 1808.

YEAR MARK: T2 for 1801.

CONTROL MARK The small three crown mark in force from 1754.

DIMENSIONS H. 8 cm. W. (max.) 6·5 cm.

CONDITION Good. Some denting.

293–1902

PROVENANCE Purchased (£1 12s 6d) from G. Jorck, probably acting as agent for Josef Nachemsohn of 31 Østergade, Copenhagen.

In all probability made for the Lapp market. Compare Fjellström, *Lapskt Silver*, pl. 11, figs. 14a–b (made in Torneå, 1764), and other examples of related design (pl. 11, figs. 15–17b). Bergman is known to have worked for Lapp clients (Fjellström, *op. cit.*, cat., p. 61).

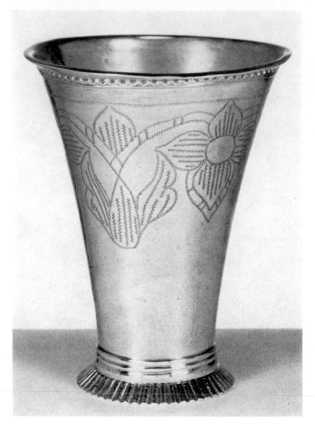

102

103 TWO-HANDLED DRINK-ING-BOWL (*kåsa*)

Luleå, 1806. The oval body is engraved in wrigglework with a band of ornament from which debased Neo-classical swags are suspended. The concave foot is decorated with a band of stamped floral motifs on a hatched ground. One handle is in the form of a cherub's head, the other is of acanthus shape and pierced to hold two corded rings. Both handles are cast.

MARKS On the base.

TOWN MARK of Luleå (*Sven. Silv.*, p. 421, no. 5639).

MAKER'S MARK of Olof Löfvander the Younger (1774–1823) working in Luleå from 1795 (*Sven. Silv.*, p. 423, no. 5679).

YEAR LETTER: z2 for 1806.

CONTROL MARK The three crown mark in force from 1754.

DIMENSIONS H. 4 cm. W. (max.) 14 cm. W. of bowl crosswise 7 cm.

CONDITION Cracked, a large dent repaired in early times by a large shield applied to the front, the cherub's head re-soldered.

1934–1898

PROVENANCE Given by Col. F. R. Waldo-Sibthorp.

An example of a *kåsa* or ceremonial drinking vessel made for a Lapp client by this goldsmith, who, like his father, is known to have worked for the Lapp market (see Fjellström, *Lapskt Silver*, cat., p. 61). For comparable examples of the motifs see her pl. 13, figs. 28a–b (also made in Luleå), figs. 32a–b (made in Bergen). For a bowl of 1809 made by Löfvander in which the acanthus handle appears to be from the same mould see her pl. 13, figs. 27a–b cat., p. 47, no. 439.

The admiration felt for this sort of piece in Edwardian England can be seen from the Special Autumn Number of *The Studio*, 1910, entitled *Peasant Art in Sweden, Lapland and Iceland*, ed. C. Holme, where different types from Dalarne (Dalecarlia) are reproduced.

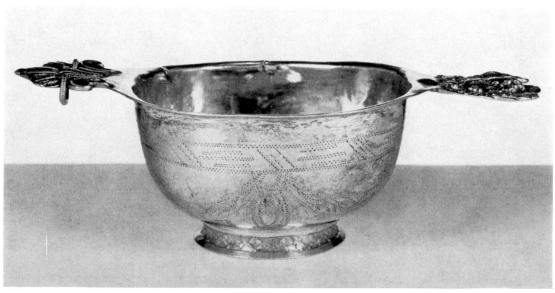

104 CUP (*supkopp*)

Luleå, c. 1806–10. Parcel-gilt. The gilt moulded rim terminates in a band of zig-zag ornament in relief. Beneath this runs a band of gilding. The scroll handle is ribbed. The inside of the cup is gilt. Concave foot.

MARKS On the base.

TOWN MARK of Luleå (*Sven. Silv.*, p. 421, no. 5639).

MAKER'S MARK of Olof Löfvander the Younger (1774–1823), working in Luleå from 1795 (*Sven. Silv.*, p. 423, no. 5679).

CONTROL MARK The small three crown mark in force from 1754.

DIMENSIONS H. 5 cm. W. (max.) 8 cm.

CONDITION The body is badly dented.

299–1902

PROVENANCE Purchased (19s 6d) from G. Jorck, probably acting as agent for Josef Nachemsohn of 31 Østergade, Copenhagen. Said to come from Haparanda.

Made for the Lapp market. Cups of this kind were used for drinking *brännvin* (potato spirit). Compare Fjellström, *Lapskt Silver*, text, figs 129–30; pl. 12, figs. 1–8a–b). One of her examples (figs 12:4) is of the same design and was made by the same goldsmith in 1800. It has a provenance from Finnish Lapland. Another (fig. 12:5) made by the same goldsmith in 1811 is of a different design. When acquired the cup was dated to the second half of the eighteenth century. On a piece made in 1804 Löfvander's mark has a different form. On 1934–1898 (No. 103), which was made in 1806, and on a piece made in 1811 it has the same form as the present piece (see *Sven. Silv.*, p. 423, no. 5679). The examples of this design illustrated by Dr Fjellström all date from the first decade of the nineteenth century.

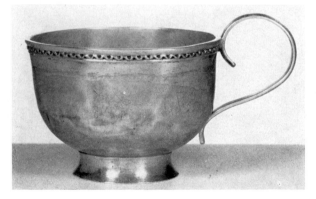

104

105 SUGAR BASIN

Luleå, between c. 1806 and 1823. The rim of the boat-shaped bowl is ribbed: the body is lightly engraved in wrigglework with a band of stylized foliated scrollwork. The loop handles are ribbed. The bowl rests on four feet, whose upper sections are fish-tail shaped, and lightly hatched in wrigglework and pouncing. The ends are trifid shaped, and also lightly hatched. On the front of the body, above the band of ornament, are engraved the initials B.C.B.S:

MARKS On the base.

TOWN MARK of Luleå (*Sven. Silv.*, p. 421, no. 5639).

MAKER'S MARK of Olof Löfvander the Younger (1774–1823), working in Luleå from 1795 (*Sven. Silv.*, p. 423, no. 5679).

DIMENSIONS H. (max.) 10 cm. W. (max.) 13 cm.

CONDITION Some small dents.

297–1902

PROVENANCE Purchased (£1 17s 6d) from G. Jorck, probably acting for Josef Nachemsohn, of 31 Østergade, Copenhagen.

This pretty basin is of superior quality to the other pieces in the collection from the same master's shop. The type is uncommon in silver from this region. For the dating see the note to 299–1902 (No. 104).

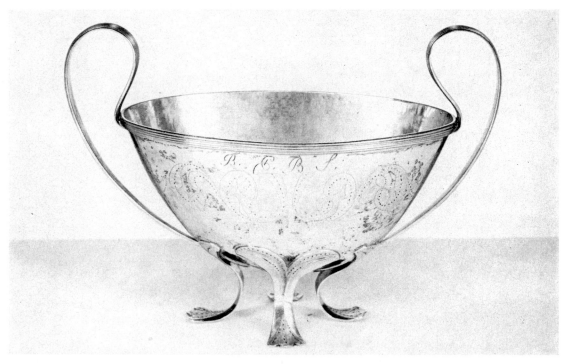

106 TUMBLER CUP (*tumlare*)

Luleå, early 19th century. Parcel-gilt.
Hollowed base. The moulded rim is gilt
and terminates in a band of zig-zag in
relief. Beneath this runs a band of gild-
ing. The inside is gilt. Initials roughly
scratched on side.

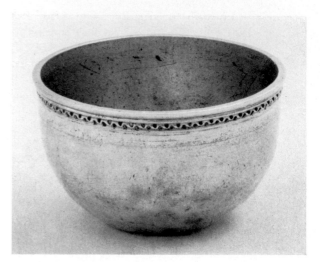

106

MARKS On the base.

TOWN MARK of Luleå (*Sven. Silv.*, p.
421).

MAKER'S MARK of Olof Löfvander the
Younger (1774–1823), working in
Luleå from 1795 (*Sven. Silv.*, p. 423,
no. 5679).

CONTROL MARK The small three-crown
mark in force from 1754.

DIMENSIONS H. 3·9 cm. Diam. 6·5 cm.

CONDITION Much dented and scratched.
298–1902

PROVENANCE Purchased (£1 6s 6d) from
G. Jorck.

Probably for the Lapp market (compare
Fjellström, *Lapskt Silver*, p. 165, figs.
126a–b).

Swedish Spoons

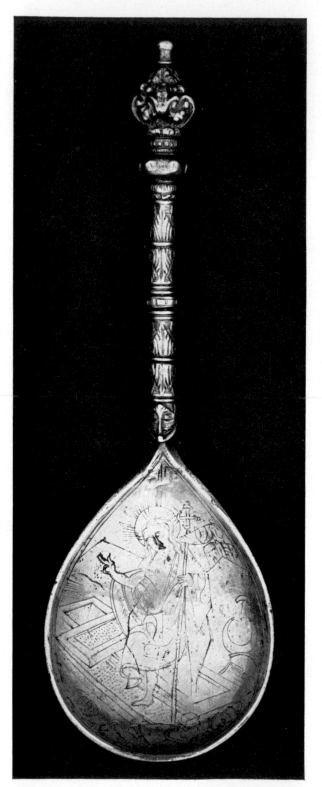

107 SPOON

Swedish?, c. 1600. Gilt. The inside of the deep pear-shaped bowl is engraved with the Resurrection. Christ rises with his banner from the sarcophagus, which is set transverse to the front plane. Behind are the houses of Jerusalem: a crescent and another object in front of them seem to be intended for shields, a third object behind for a lance. A sleeping soldier lies in the foreground. A double line borders the scene. The underside is engraved with the Virgin and Child; the Virgin is seated in a low chair. Around, in the border, runs the inscription: L: VIRGO GLORIOSA CAELI IVBAR MVNDI ROSA CAELIBATVS LILIVM: C.N. The lower part of the stem is shaped above as a dragon head, and below as a laurel leaf: above this are two bunches of acanthus leaves, with a band round the middle, giving them a baluster form. Above is a flat bulging member decorated with bosses, supporting a knop of fruit and foliage enclosed in volutes and topped by a plain finial.

MARKS None.
DIMENSIONS L. 15·9 cm. W. 5·1 cm.
 Bowl length 7 cm.

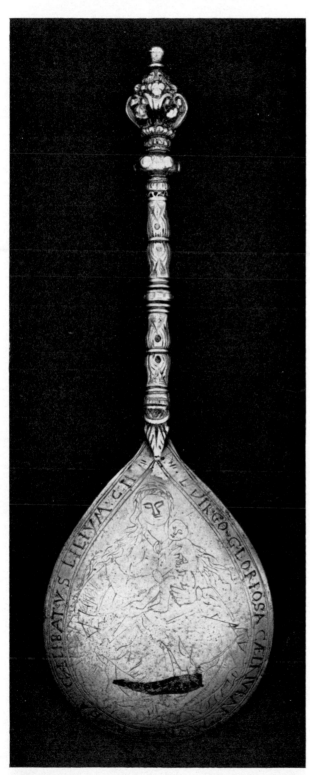

107a

CONDITION Re-gilded. Worn on the underside of the bowl. The face of the Virgin and Child crudely touched up about the eyes, nose and mouth, that of Jesus similarly touched up about the nose, mouth and right hand. The bowl has been broken off at the top, re-soldered and re-engraved.

2266–1855

PROVENANCE Purchased (£10 5s 0d) from the Bernal sale (23 April 1855, lot 3429).

Acquired as Flemish, c. 1540. The attribution to Sweden was made at a later date. Two or three spoons of closely comparable form are illustrated in Källström and Hernmarck (*Svenskt Silversmide 1520–1850*, vol. i, Stockholm, 1941, figs. 393, 394, 396, 397, 406 especially the last), and dated by them c. 1600. For another example of a Swedish spoon decorated with the Resurrection see their fig. 411. Scandinavian spoons of this type are notoriously difficult to place: Dr Holmquist accepts that a Swedish origin is possible.

108 SPOON

Stockholm, early seventeenth century. Gilt. The inside of the pear-shaped bowl is engraved with scrolling, foliated strapwork, hung with a swag from which depends a tassel, the whole within a border of hit-and-miss work. The lower end of the stem is shaped above and at the sides as a bunch of leaves: the rest of the stem is octagonal and encircled round the middle with a moulded band. The knob is shaped as two addorsed cherub heads surmounted by an Ionic capital topped by a shaped finial. The underside of the stem is flat; the underside of the bowl is engraved with a bunch of flowers, fruit and foliage in a border of hit-and-miss. An earlier owner's inscription has been obliterated at the upper end of the underside of the bowl and the initials J.M.S have been engraved above.

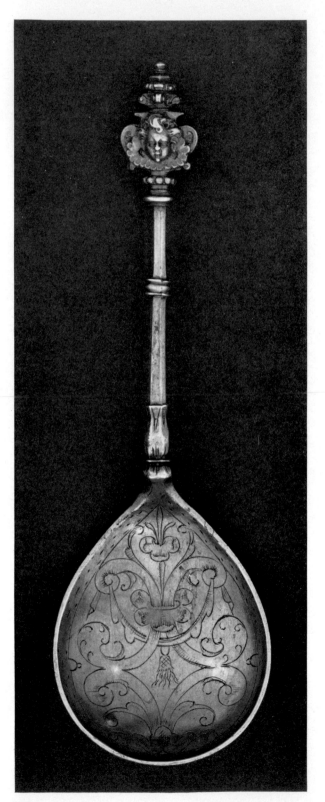

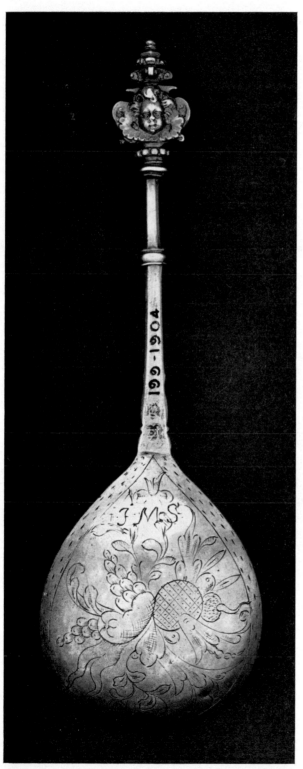

108a

MARKS On the underside of the stem at the base.

TOWN MARK The crown of Stockholm in a shaped shield (*Sven. Silv.*, p. 33, no. 3).

MAKER'S MARK P in monogram with other letters: the mark reproduced in *Sven. Silv.*, p. 51, no. 117, as that of an unidentified master recorded between c. 1596 and c. 1630.

DIMENSIONS L. 16·8 cm. W. 5·2 cm. Bowl length 6·9 cm.

CONDITION Knop regilt: other gilding worn. See below.

199–1904

PROVENANCE Purchased (£6 10s 0d) from G. Jorck, acting as agent for Josef Nachemsohn, of 31 Østergade, Copenhagen.

The cherub knop of this spoon is of very handsome execution: it is an early example of a common Swedish type.

109 SPOON

Swedish?, c. 1630–40. Gilt. The pear-shaped bowl is engraved with a grotesque in the form of a female mask above a swag. Above her head is a foliated spray, on either side is a scrolling foliated stem, beneath are leaves and two large roses. The whole is enclosed in a ribbon border. The underside is engraved with a large foliated spray of two apples, with scrolling, foliated stems on which grow blossoms: again the motif is enclosed in a ribbon border. The bowl rises to join the stem, which is composed of balusters alternating with bound bunches of leaves, each member being separated from the rest by a band of three mouldings. The knop is composed of a bunch of fruit and flowers framed by volutes and surmounted by a finial.

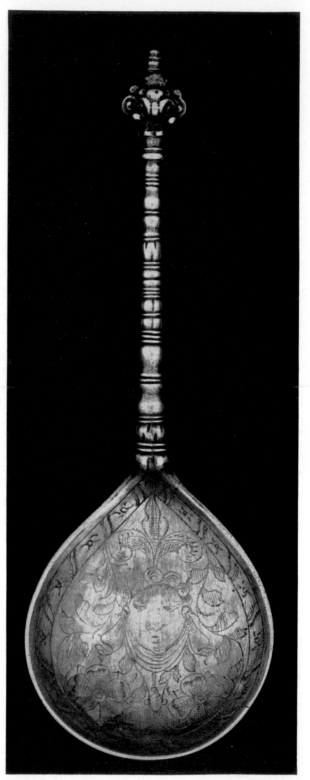

109

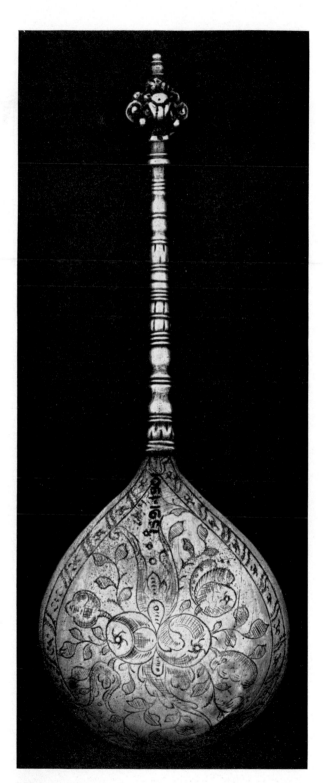

MARKS None.

DIMENSIONS L. 16·8 cm. W. 5·9 cm. Bowl length 7·2 cm.

CONDITION Gilding rubbed and worn: engraving worn in centre of bowl, both above and below.

1591–1901

PROVENANCE Purchased (£4 15s) from G. Jorck.

This notably heavy spoon was acquired as Swedish, seventeenth century. For a parallel compare the spoon illustrated in Källström and Hernmarck, *Svenskt Silversmide*, vol. i, Stockholm, 1941, fig. 406. The incipient stylization of the stem suggests a dating in the second quarter of the seventeenth century, as do the two roses, which do not belong to the vocabulary of grotesque ornament.

110 SPOON

Swedish, first half of the seventeenth century. Silver, parcel-gilt. The upper part of the inside of the pear-shaped bowl is engraved with scroll-work and foliage. The upper side of the lower part of the stem is shaped as a leaf, banded twice: the rest of the stem is flat, except for a moulded band encircling the middle. The knop is shaped as a bunch of grapes emerging from leaves.

MARK On the underside of the base. N in an octagonal shield (see below).

DIMENSIONS L. 15·5 cm. W. 5·4 cm. Bowl length 6·8 cm.

CONDITION Gilding renewed. See also below.

1592–1901

PROVENANCE Purchased (£2 16s 0d) from G. Jorck.

Acquired as Swedish. The mark has not been identified. The collar suggests an attribution to Sweden, but the type is not unknown elsewhere in Scandinavia. The engraving of the bowl may not necessarily be original.

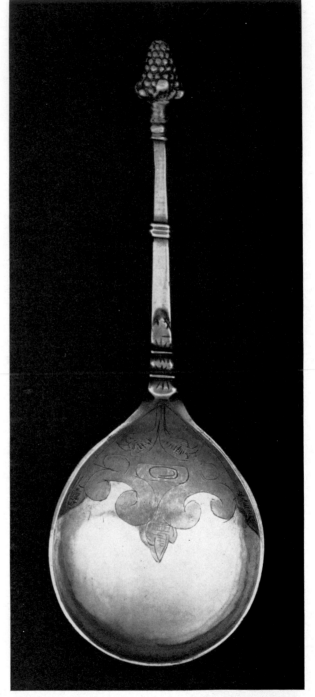

110a 110

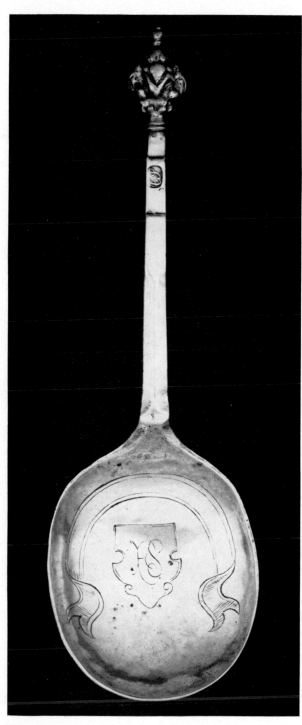

111

111 SPOON

Stockholm, between 1656 and 1682. Oval bowl. The inside is engraved with a band terminating in split scrolled ends. This frames a shaped shield with the initials HCS in monogram. The upper side of the stem is shaped in the lower part as a bevelled ridge, which at the base becomes a flat fig-shaped swelling and at the top a plain panel in relief. The end of the stem is also raised in flat relief. The knop is formed as a bunch of scrolled leaves topped by a finial. The underside is inscribed with the initials E.P.S.C.M.J.D.

MARKS On the underside of the stem, at the base.

TOWN MARK The crown of Stockholm (probably *Sven. Silv.*, p. 33, no. 14 or 15).

MAKER'S MARK In a shaped shield. Indistinct, but in all probability that of Lorenz Westman, working 1656 to 1682 (*Sven. Silv.*, p. 68, no. 191).

OTHER MARK On the upper side of the stem is struck a goldsmith's mark, Italic CS conjoined, of late eighteenth or early nineteenth century date.

DIMENSIONS L. 16·8 cm. W. 5·3 cm. Bowl length 7 cm.

CONDITION Bowl dented (see below).

Circ.293–1912

PROVENANCE Purchased (15s) from G. Jorck.

The later mark is unrecorded. This spoon has been much altered, probably by the later goldsmith whose mark is stamped on the stem. The knop is an addition: the stem has been shortened, and the bowl rehammered.

112 SPOON

Stockholm, between 1656 and 1682. Parcel-gilt. The bowl curves upwards to join the four-sided stem, which terminates in a knop shaped as a stylized bunch of grapes with a small knob on top. On either side of the underside of the bowl are engraved the names: (*left*) HANS BEHRENDS; (*right*) V.F.TELSCHE: in the centre are engraved the initials M.C. On the edge is pounced the name *P. Ar Dedless.*

MARK On the back of the bowl.

MAKER'S MARK: LW in monogram for Lorenz Westman, working in Stockholm 1656–82 ((*Sven. Silv.*, p. 68, no. 194).

DIMENSIONS L. 19·4 cm. W. 5·6 cm. Bowl length 7·1 cm.

CONDITION Some scratching and denting. Gilding of knop almost worn away.

1595–1901

PROVENANCE Purchased (£2 10s 0d) from G. Jorck.

Acquired as Danish, a designation retained until the preparation of this catalogue.

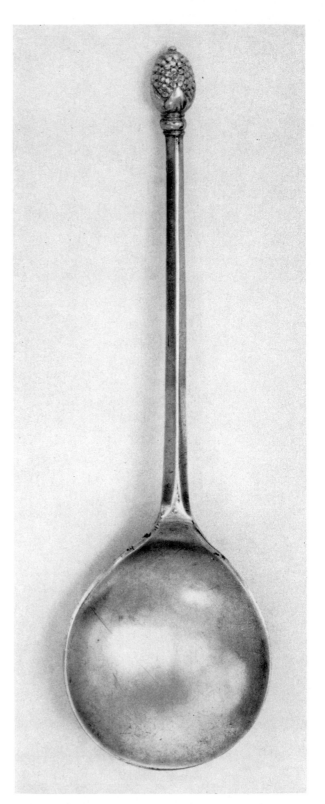

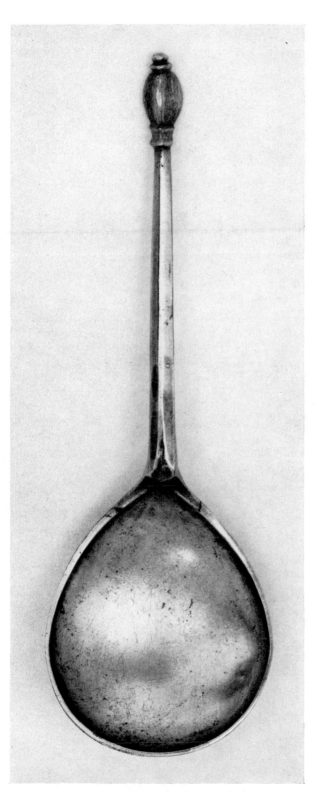

113 SPOON

Växjö, between 1656 and 1693. The bowl curves upwards to join the octagonal stem: at their junction the sides are bevelled and there is a rudimentary furrow. The knop is formed as a beechnut surmounted by a small finial. Engraved on the upper part of the underside of the bowl are the initials S.E.I.F.

MARK On the underside of the stem at the base.
MAKER'S MARK: AT/W with a star above in a shaped shield for Anders Thorsson (working 1656–93) of Växjö (*Sven. Silv.*, p. 622, no. 8412).
DIMENSIONS L. 15·1 cm. W. 4·8 cm. Bowl length 6·2 cm.
CONDITION Good; some scratching.
1104–1904
PROVENANCE Purchased (£2 19s 9d) from G. Jorck.

Acquired as Danish, a designation maintained until the preparation of this catalogue. A date c. 1660 is plausible for this spoon, given its design. The motif of the knop is exceptional in Swedish spoons but there is no doubt of its authenticity.

114 SPOON

Malmö, between c. 1678 and 1707. The pear-shaped bowl is engraved in the Floral Baroque style with a flower between two half-leaves. The flat handle tapers towards the knop, and is decorated with bands of mouldings at its lower end and encircled with a moulded band towards its upper. The knop is shaped as two addorsed cherub masks surmounted by a finial.

MARKS On underside of bowl.
TOWN MARK: the crowned griffin-head of Malmö (*Sven. Silv.*, p. 435).
MAKER'S MARK: HB in monogram for Hans Hannson Brun, working as a master in Malmö by 1678. He died in 1707 (see *Sven. Silv.*, p. 444, no. 5927).
DIMENSIONS L. 16 cm. W. 5·6 cm. Bowl length 7·3 cm.
CONDITION Dented and scratched.

2005–1898

PROVENANCE Given by Col. F. R. Waldo-Sibthorp.

On acquisition the town mark was misread as that of Stockholm. A tentative attribution to Norrköping was later substituted, and the maker's mark identified as possibly that of Hans Reiners.

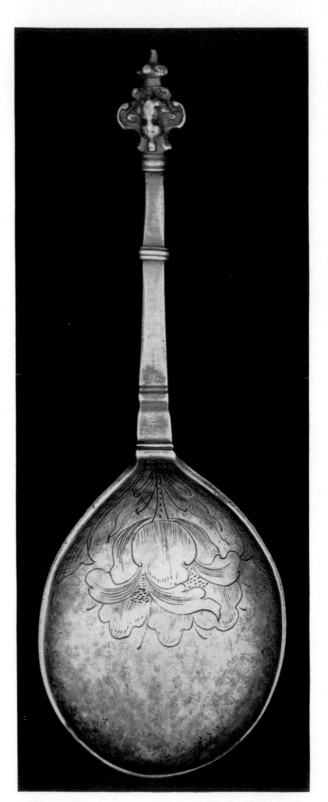

114

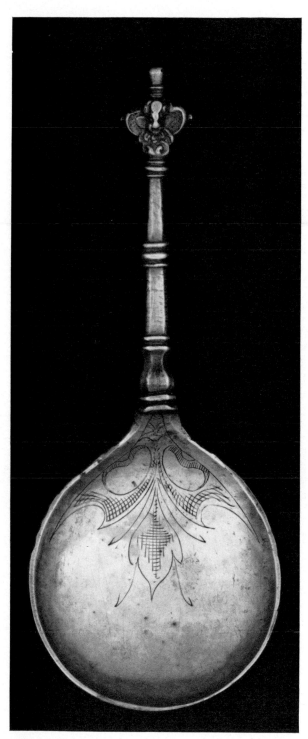

115

115 SPOON

Swedish, late seventeenth century. The bowl, of rounded pear-shape form, is engraved with a plant motif. The stem is of crude baluster shape at the lower end: it then becomes of tapering hexagonal form and is banded by mouldings at either end and encircled by a moulded girdle round the middle. The knop is shaped as two addorsed cherub heads surmounted by a finial.

MARK There is a plant-shaped device on the back of the stem, at the base.

DIMENSIONS L. 14·4 cm. W. 5·6 cm. Bowl length 6·8 cm.

CONDITION Bowl much dented: it has in addition been rejoined to the stem and re-engraved over the repair.

<div align="right">2008–1898</div>

PROVENANCE Given by Col. F. R. Waldo-Sibthorp. (Possibly a spoon listed in *A Collection of Silver and Silver-gilt Plate ...formed by Colonel F. R. Waldo-Sibthorp*, Brighton, privately printed, n.d., p. 32, no. 199, but this was silver-gilt.)

Acquired as Swedish, seventeenth century. Compare the Malmö spoon (2005–1898, No. 114) of the last quarter of the seventeenth century. A Norwegian origin, however, is also possible.

115a

116 SPOON

Kalmar, between 1754 and 1761. Parcel-gilt. The round bowl has a gilt border enclosing a gilt cross with a roundel at the crossing. The base of the stem consists of a moulded band, three bevelled panels separated by a moulding and an upper section with bevelled edges. The knop is shaped as a hatched inverted cone topped by four strawberry leaves. To the intervals between the leaves are attached four hoops from which are suspended rings. Inside the cone is set an octagonal plate with a central boss surmounted by a hoop holding a ring and surrounded by a circle of small bosses.

MARKS On the underside of the stem at the back.

MAKER'S MARK: HW in monogram for Hans Wiggman of Kalmar (working 1712–61: see *Sven. Silv.*, p. 339, no. 4282).

CONTROL MARK The three crown mark in force from 1754.

DIMENSIONS L. 14·6 cm. W. 6·4 cm. Bowl length 7·1 cm.

CONDITION Dented.

2265–1855

PROVENANCE Purchased (£3 10s 0d) at the sale of the Bernal Collection (23 April 1855, lot 3428).

Acquired as German or Scandinavian, 'about 1600'.

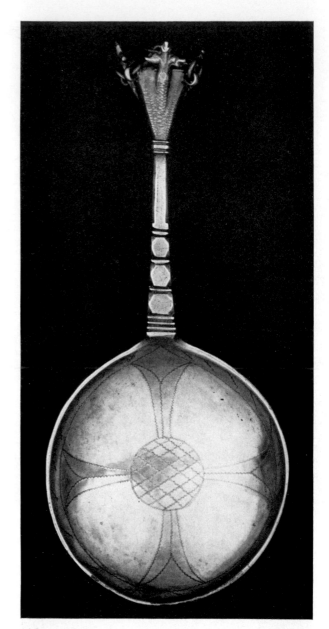

116

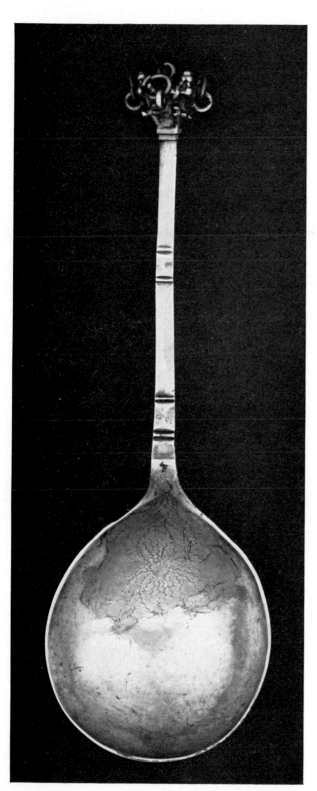

117 SPOON

Hudiksvall, 1762. Parcel-gilt. The pear-shaped bowl is decorated with floral engraving in wrigglework (largely worn away). The upper side is divided into two bevelled panels by small moulded and bevelled bands. The knop is shaped as four Gothic leaves surrounding a concave boss: to the intervals between the leaves and the top of the swelling are attached hoops from which depend corded rings.

MARKS On the underside of the stem at the base.

TOWN MARK: the buck's head of Hudiksvall.

MAKER'S MARK: CB/M for Cristoffer Bauman, working 1758–97(8) (*Sven. Silv.*, p. 305, no. 3813).

CONTROL MARK The three crown mark in force from 1754.

DIMENSIONS L. 17·7 cm. W. 5·8 cm. Bowl length 7·0 cm.

CONDITION Gilding much worn: dented, some scratching. See also above.

767–1904

PROVENANCE Purchased (£2 9s 10d) from G. Jorck.

On acquisition, this spoon was identified as Swedish, and as probably seventeenth century in date, in spite of the hallmarks. There seems no reason to think that it is older than the marks: its rather old-fashioned form is probably one which appealed to a rural market. According to *Sven. Silv.*, (*loc. cit.*) spoons by this maker are common.

118 SPOON

Ystad, 1770. Parcel-gilt. The bowl is round, and rises to join the stem which is decorated on its upper side with an incised zig-zag pattern in double lines. The knop is formed as an inverted cone, to which are applied four cast acanthus leaves. Its central plate has a boss surrounded by a circle of small punched bosses: to the intervals between the acanthus leaves are attached four hoops: from these, and from a fifth hoop, which rises as a finial from the central boss, hang corded rings.

MARKS On the underside of the stem at the base.

TOWN MARK: the griffin passant of Ystad.

MAKER'S MARK: IAL for Jonas Aspelin the Elder, working 1761–1802 (*Sven. Silv.*, p. 635, no. 8614).

YEAR MARK: M for 1770.

CONTROL MARK The three crown mark in force from 1754.

DIMENSIONS L. 15·2 cm. W. 6·2 cm. Bowl length 6·3 cm.

CONDITION Bowl dented.

2263–1855

PROVENANCE Purchased (£1 10s 0d) at the Bernal sale (23 April 1855, lot 3426).

Acquired as German or Scandinavian, about 1600.

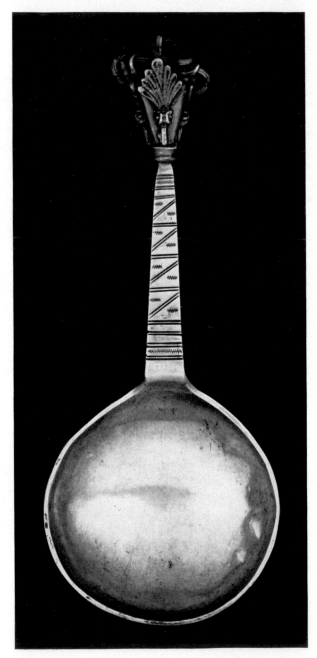

119 PUNCH-LADLE

Swedish, second half of the eighteenth century. Parcel-gilt. The bowl is round except for a small spout with a gilt moulded rim. The letters of the original inscription on the coin from which it has been beaten still show round the upper edge of the rim. In the bottom is set a riksdaler of King Frederick I of Sweden (d. 1751). On the obverse is a bust of Frederick with the inscription: FRIDERICVS D.G. REX SVECIAE. The reverse shows the royal arms enclosed in the insignia of the Serafinerorden with the motto *Gud Mitt Hopp* in Gothic letters above, the date 1748 on either side, and the inscription: D. 17 APR. Beneath are the initials H.M. Attached to the bowl is a socket for the handle; this is two-pronged where it joins the bowl, and has a sunk neck in the middle. The inside of the bowl is entirely gilt.

MARKS None.

DIMENSIONS Diam. of bowl. 5·7 cm. L. of handle 8·7 cm.

CONDITION Some light scratching. Handle wanting.

1202–1902

PROVENANCE Given by J. H. Fitzhenry, Esq.

The Serafinerorden was instituted on 17 April 1748. The initials on the coin are those of the mint-master Hans Malmberg (information communicated by Mr G. K. Jenkins, Department of Coins and Medals, British Museum, citing B. Tingström, *Svensk numismatisk upplagsbok*, 1963.)

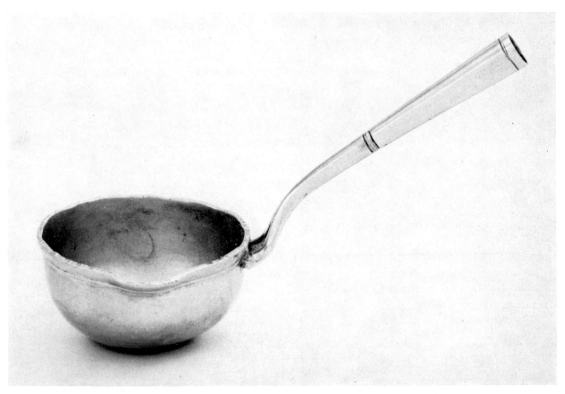

120 SPOON

Luleå, between c. 1805 and 1847. Parcel-gilt. The oval bowl is engraved with an oval panel of criss-cross straps super-imposed on a second oval containing a double triangle. These motifs are linked by three straps at the base to the outer border, which consists of a plain band decorated with zig-zag on either side (those on the outer side in double out-line). The border of the two central mo-tifs consists of a band with a single out-line zig-zag: here and on the outer border a stroke down the centre of each of the triangular forms of the zig-zag suggests that the ornament is really a stylized and debased leaf form. All these engraved motifs were originally gilt. The stem, which is joined by a rat-tail to the under-side of the bowl, is ornamented with two sections of ribbing separated by a zig-zag ornament. It forks at the top and is then joined by a transverse bar. To the stem are attached eight hoops, from which hang rings: a ninth, corded ring, ter-minating in a faceted cube, hangs from the transverse bar.

MARKS On the back of the bowl.
TOWN MARK: the crossed keys of Luleå.
MAKER'S MARK: O:F for Olof Forsberg, working in Luleå from 1805 to 1847 (*Sven. Silv.*, p. 423, no. 5685).
OTHER MARK A sign shaped like a 3 which is recorded on silver made by Forsberg (cf. *Sven. Silv.*, no. 5686). Not a date letter.
CONTROL MARK: the three crown mark in force from 1754.
DIMENSIONS L. 12·5 cm. W. 5·7 cm. Bowl length 7·1 cm.
CONDITION Gilding worn: owner's marks scratched on the underside of the stem.
M.631–1910
PROVENANCE Salting Bequest.

For illustrations see p. 221.

Made for the Lapp market, for which

Forsberg is known to have worked. For a spoon closely comparable in design and ornament by Forsberg dating from 1828 see P. Fjellström (*Lapskt Silver*, pl. 15: 56a, cat., p. 56, no. 546). E. Klein ('Lapsk Hornslöjd och Nordiskt Silver-smide' in Nordiska Museet, *Fataburen*, 1922, pp. 65–88) says this design was typical of Luleå spoons for the Lapp mar-ket from the early nineteenth century.

121 SPOON

Piteå, second quarter of the nineteenth century. Gilt (much worn). The oval bowl is decorated with a wriggle border containing a stylized spray and with a circular rosette containing stylized orna-ment. From the centre of the rosette runs a corded rib (cast and applied) which ex-tends well up the leaf-shaped stem and is surrounded by engraved wrigglework vein motifs. From the holes pierced in the lobes of the leaf hang seven corded rings. The underside of the stem is outlined in wrigglework and the underside of the bowl with a semi-circle containing a spray of leaves.

MARKS Struck inside the bowl.
TOWN MARK: P for Piteå (*Sven. Silv.*, p. 492, no. 6673).
MAKER'S MARK: N.O. for Nils Öhstedt (1829–81) of Piteå (*Sven. Silv.*, p. 494, no. 6716: P. Fjellström, *Lapskt Silver*, cat., p. 52, nos. 491–92).
CONTROL MARK The three crown mark in force from 1754.
OTHER MARKS A symbol of Lapp type (double struck).
DIMENSIONS L. 14·2 cm. W. 5·5 cm.

CONDITION Some light scratches in the bowl. As noted in the description, the gilding almost entirely worn away.

2002–1898

PROVENANCE Given by Col. F. R. Waldo-Sibthorp.

For illustrations see p. 221.

For spoons of comparable design see P. Fjellström, *Lapskt Silver*, pl. 15: 12a, b (from Piteå), pl. 15: 13 (from Piteå), pl. 15: 65a (from Piteå). These three spoons all bear Öhstedt's mark, and this would suggest that the spoon was made by him. But the undecipherable symbol, though unrecorded, also appears to be a maker's mark. According to E. Klein ('Lapsk Hornslöjd och Nordiskt Silversmide' in Nordiska Museet, *Fataburen*, 1922, pp. 79–80) for most of the nineteenth century Öhstedt was the favourite silversmith of the Lapps.

Lapland

122 TWO-HANDLED CUP (*käsa*)
Lapland, second half of the eighteenth century. The oval bowl is chased with a band of ornament consisting of six circular panels outlined in punched dots. The panels are separated by an engraved and punched motif of three leaves tied into a bunch. Along the upper edge the interstices of the ornament contain scrollwork. One handle is flat and engraved with a stylized plant motif and scrollwork: the other is pointed and engraved with chevron-work, and terminates in a round knob engraved with leaves. Underneath is a loop from which hangs a corded ring. The bowl stands on a separately made circular domed foot.

MARKS Under the flat handles.
MAKER'S MARK: Italic s? or L? in monogram with another letter (not recorded in Fjellström, *Lapskt Silver*, cat., pp. 61–3).
DIMENSIONS H. 6·7 cm. W. (max.) 16 cm.
CONDITION Crack in edge by pointed handle and by flat handle.

65–1905

PROVENANCE Purchased (£6 5s) from G. Jorck.

The maker's mark, typically Lapp, is imperfectly struck. A number of ceremonial kåsa of this type are illustrated by Dr Fjellström (*Lapskt Silver*, 1962, text, p. 175, fig. 140; pl. 13, figs. 4a–b, 7, 42) but she shows no example of this exact design. For other silver certainly or possibly made for Lapp clients see 1934–1898, 2002–1898, 2004–1898, 2006–1898, 293–1902, 298–1902, 299–1902, M.45–1909, M.631–1910.

The piece was drawn by C. R. Ashbee in *Modern English Silverwork* (his own copy, with drawings from his hand bound in, now in the Library of The Victoria and Albert Museum).

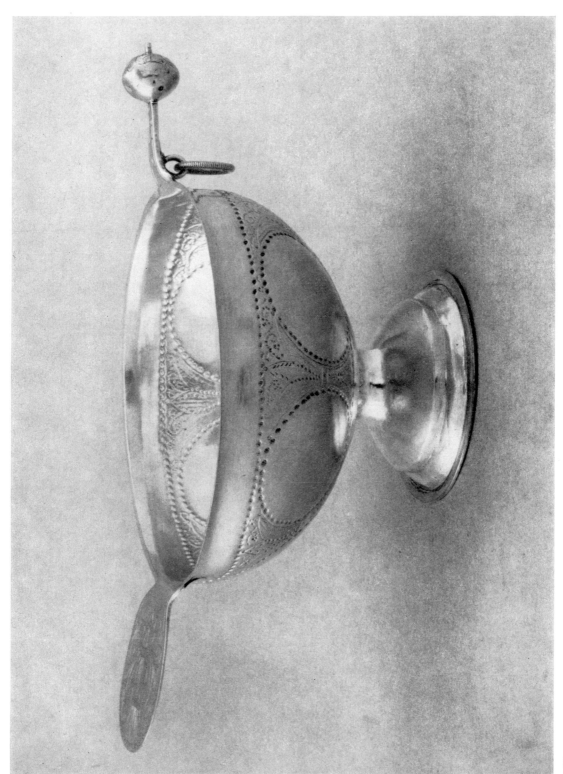

123 TWO-HANDLED CUP (*käsa*)
Lapland, late eighteenth or early nine-
teenth century. Parcel-gilt. Plain bowl
with a gilt band beneath the everted rim,
on plain trumpet-shaped foot. The leaf-
shaped handles are engraved with
stylized Baroque cartouches of foliated
scroll-work: each of them is hung with a
gilt ring. The inside is gilt.

MARKS On the underside of the handles.
MAKER'S MARK: KM struck twice (not
 recorded in Fjellström, *Lapskt Silver*,
 cat., pp. 61–3).
DIMENSIONS H. 6·5 cm. W. (max.)
 15·1 cm.
CONDITION Cracked to one side of both
 handles. Foot dented.
 760–1904
PROVENANCE Purchased (£2 9s) from G.
 Jorck, acting as the agent of Josef
 Nachemsohn, of 31 Østergade, Copen-
 hagen.

Acquired as a 'Lapkose' or wedding cup
from which a bride and bridegroom
drink from opposite sides. Recommended
for purchase as 'a good and simple piece'.
Ceremonial drinking vessels of this type
are characteristic of Lapp silver, and a
large number are illustrated by Dr Fjell-
ström (*Lapskt Silver*, 1962, text, figs.
133–41, cat., pl. 13, figs. 1–44). She does
not reproduce an example of this exact
design, which appears to show neo-classi-
cal influence in its proportions and sim-
plicity. The piece is a very handsome
example of Lapp silver.

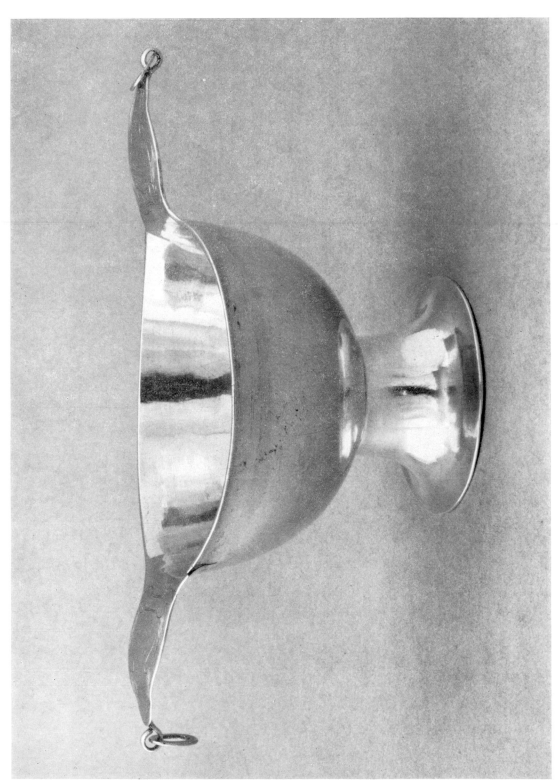

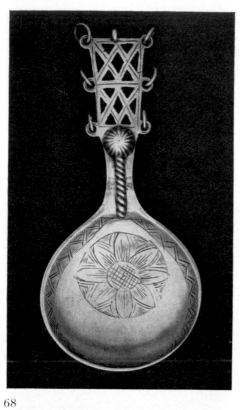

68

68a

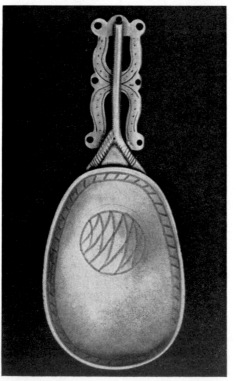

71

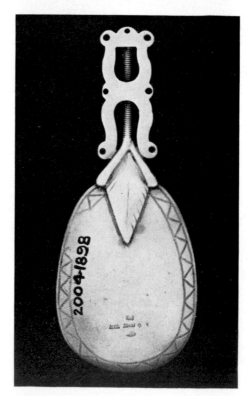

71a

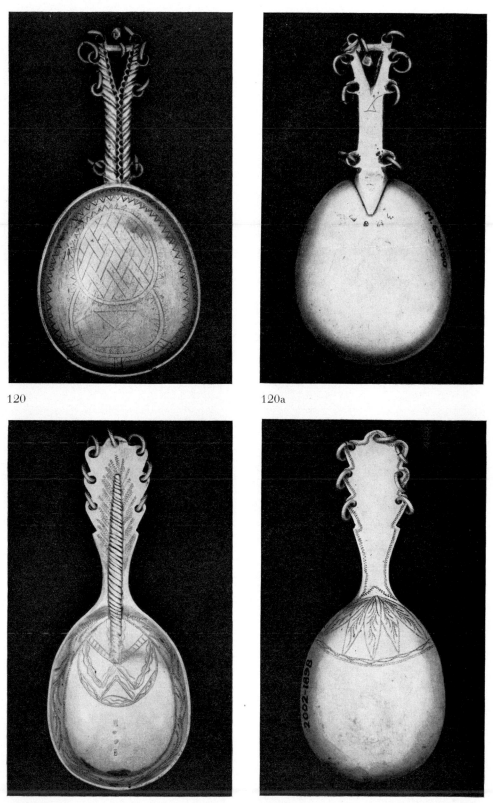

120

120a

121

121a

Finland

124 BEAKER

Finnish, c. 1720–30. Silver, parcel-gilt.
The trumpet-shaped body has a moulded
rim, beneath which is a plain gilt band.
On an oval gilt patch in front is en-
graved the monogram RHSM sur-
mounted by a gentleman's crown and
framed by two palm-branches fastened
together at the base by a bow. The rim
(separately made and attached) of the
foot is gilt and moulded: the inside of the
beaker is also gilt. On the opposite side of
the body from the monogram are en-
graved the initials J:G:

MARKS On the base.

TOWN MARK: W for Wiborg.

MAKER'S MARK: HQ in an oblong for
Henrik Quarnberg (1777–1847), who
moved to Wiborg from Fredrikshamn
in 1819 and worked there until his
death (see T. Borg, *Guld-och Silver-
smeder i Finland*, Helsingfors, 1935,
p. 465).

CONTROL MARK A single crown in a
shaped shield (Finnish control mark,
see Borg, *op. cit.*, p. 25).

DIMENSIONS H. 12·7 cm. Diam. 10–8
cm.

CONDITION Good, but some trifling
scratches. Gilding renewed (in the
early nineteenth century?). See also
below.

M.520–1910

PROVENANCE Purchased (£14 10s 9d,
with nos. M. 521, 522–1910) from
Herr G. A. Sandell, Kuusa Eisenbahn-
station, Finland.

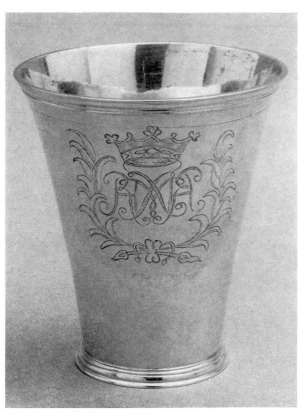

124

On acquisition this fine beaker was classed as Swedish, c. 1700, the crown mark having been interpreted as that of Stockholm. Subsequently, when the marks were deciphered, it was reclassed as by Quarnberg of Wiborg 'though made in the manner of the late 17th century'. In style the piece is characteristic of the first half of the eighteenth century and the initials J.G. for a subsequent owner engraved on the back (see above) date from the late eighteenth or early nineteenth century. Finnish silver follows the usual evolution of decorative styles, however provincially and belatedly, and it is intrinsically improbable that a piece of this type and quality was made in the nineteenth century. A much more plausible explanation is that originally it was unmarked or differently marked and was marked or remarked on passing through Quarnberg's shop. In fact the present base seems to be a replacement covering an earlier base.

125 BEAKER

Wiborg, second quarter of the eighteenth century. Parcel-gilt. The trumpet-shaped body has a moulded rim, beneath which runs a plain gilt band. It is set with coins and medals, eleven German and one Dutch, and decorated with engraved scrolling foliage and oval medallions relieved on a hatched ground. The medallions each contain a little male figure naked except for a drape, mostly performing an act associated with drinking or its consequences – holding a bunch of grapes, pouring liquid from a measure into a vat, drinking from a beaker (two) dancing after drinking from a beaker (two), skipping or dancing or holding the drape with outstretched hands (four). The four medallions on the bottom row show the same little man looking at, gathering or plucking at what seem to be ears of corn. The moulded foot which is separately cast, is ribbed and gilded. The inside is gilt.

The front face of the beaker is indicated by a patch of gilding. The coins and medals are arranged in three rows and graded according to size, the largest at the top, the smallest at the bottom. As usual, they are set with the obverse on the outside and the reverse on the inside.

Top Row (reading from the gilt patch to the left)

1. A coin of the Elector Johann Georg II of Saxony, (d. 1680). Inscribed on the obverse, which shows Johann Georg in half-length profile, wearing an electoral mantle and with an electoral crown on a table beside him: IOHAN . GEORG . II . D . G . DUX . SAX . IUL . CLIV . ET . MONT. The reverse, which bears the ducal coat of arms, is dated 1659 and has the inscription: SAC . ROM . IMP . AR/CHIM . ET . ELECT.

2. A coin of the Emperor Ferdinand II (Emp. 1619–37). The obverse, which bears a laurelled profile head of the Emperor, is inscribed: FERDINANDVS . II . D:GR . I . S . AVG . GER . HVNG . BOH . REX. The reverse, which bears the imperial coat of arms, is dated 1632, and inscribed: ARCHIDVX . AVS . DVX . BVRG:COMES . TYR:

3. A coin of the Saxon Dukes Johann Philip Friedrich, Johann Wilhelm and Friedrich Wilhelm (Ernestine Line). The obverse, which is dated 1625, is inscribed: D:G:IOH: PHIL : FRID: IOH : WIL . ET :FRI : WIL:FRAT: and has a half-length portrait in profile of a ruler in armour, probably the father of the three dukes. The reverse bears three half-length portrait heads and

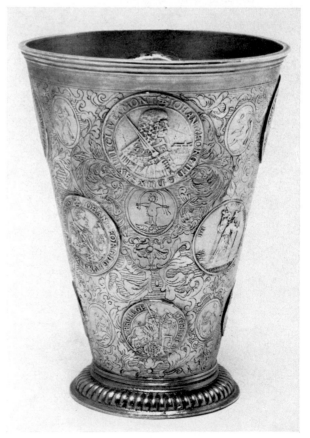

the inscription: DVC : SAXON : IVL : CLIVI . ET . MONT . LIN : ALDEN.

4. A coin of the Elector Johann Georg I of Saxony (b. 1585, Elector 1611– d. 1656). The obverse, which is dated 1613, bears a half-length portrait in profile of the Elector, wearing armour, with an upraised sword in his right hand and a plumed helm in his left. It is inscribed: IOHAN : GEORG : D : G : SA : RO : IMP : ARCHIM : EL. The reverse bears a profile head of the elector, with an inner band inscribed: E . AVGVST . FE . D . S . I : GEM, and an outer band bearing coats of arms.

Second Row

1. Medal. The obverse shows a tree growing by the junction of two

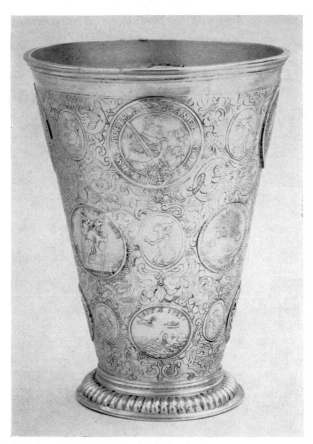

rivers, with a town in the left background. Beneath is the inscription: PS . 3 (*i.e. the verse*, 'And he shall be like a tree planted by the rivers of water, that bringeth forth his fruit in season; his leaf also shall not wither: and whatsoever he doeth shall prosper'). Round runs the German version of the first part of this verse: DER IST WIEN EIN BAUM GEPLANTZET AN DEN WASSERBACHEN. The reverse shows the tables of the law, inscribed: DV SOLT GOTT DEINEN HERREN LIEBEN VON GANZE HERZE/VND DEINEN NAECHS... (rest illegible, as is surrounding inscription). This is a shortened version of *Mark*, 12, 30: Thou shalt love the Lord Thy God with all thy heart and thy neighbour as thyself.

2. Medal. The obverse shows a female figure, resting on an anchor and holding up a caduceus, against a background of sea, ships and mountainous shore. Around runs the inscription: CONSULTE PERGENTES DEI FAVOREM SPERAMUS. Beneath is the inscription: UNITI CORDE MANUQUE and the signature of the medallist I M LAGEMAN (see entry below). On the reverse is a spray consisting of a palm and a palm and a laurel branch, surmounted by a hive of bees. Beneath is the inscription: ALS DEUGT EN YVER, WERT/BETRAGT/ZIET MEN ZYN HOOP, EN VEWE/ VOLBRAGT,/WANT DOOR HAAREN SHEMB?S/ZEEGEN/WERT WAT WENSEL YK . IS?/VERKREEGEN/?WAGT GYLLN GELU (rest illegible, including date, which may be 1798).

3. Another coin of the Elector Johann Georg I. The obverse bears a variant of the same design as above (top

row, no. 4) with the inscription: IOHAN : GEORG : D : G : DVX SAX: IVL:CLIV:ET MONT. The reverse bears his coat of arms, is dated 1630, and has the inscription: SACRI . RO-MANI.IMP.ARCHIM.ET.ELECT.

4. Medal. The obverse shows a Jew carrying a sack, with a devil seated on it, letting fall a stream of corn. Above is the inscription: DU KORN IUDE: beneath the inscription: THEUREZEIT (a time of scarcity) and the date 1694. On the reverse is inscribed: WER KORN INHELT DEM FLVCHEN DIE LEUTHE. ABER SEGEN KOMT ÜBER DEN SO ES UER KAUFT. Beneath is the reference: SPRICH . SALOM XI 26. This is the verse of *Proverbs*, II, 26: 'He that withholdeth corn, the people shall curse him: but blessings shall be upon the head of him that selleth it.

Bottom Row

1. Coin of Johann Georg I, Elector of Saxony. The obverse, dated 1619, has an equestrian portrait of the elector with the inscription: PRO LEGE ET GREGE. The reverse is inscribed: D . G . IOHANN . GEORG . DVX . SAX . IVL . CLIV ET MONT. SRI . ARCHIMAR . ELECT ATQ. POST EXCESSVM . D . IMP . MATTHIAE . AVG . SECVNDUM. VICAR...THVR . MARCH . MISNIAE ...(rest illegible from position).

2. Medal. *Obverse*. The dove returning to the ark with the inscription: BONAE SPEI. *Reverse*. In the upper part the city of Augsburg: below the inscription: UI OCCUPATA/ D.16: : DECEMB : 1703/MIRACULO LIBERATA/D. 16 . AUGUSTI . 1704.

3. Medal. Jewish. *Obverse*. A cup from which flames issue surrounded by a Hebrew inscription. *Reverse*. A branch of laurel surrounded by a Hebrew inscription.

4. Medal. *Obverse*. Army besieging a walled town. The reverse has a German inscription (mostly illegible but containing dates 14/4 July to 12/2 September).

MARKS On the base.

TOWN MARK: the crowned W of Wiborg.

MAKER'S MARK: LR for Lorenz Rosenius, working 1729–62. The punch has slipped, partly obliterating the horizontal stroke of the L.

DIMENSIONS H. 16·8 cm. Diam. 12 cm.

CONDITION One or two dents: some scratching. Some of the coins and medals partly worn by use and by mounting, as usual. See also below.

1901–1898

PROVENANCE Given by Col. F. R. Waldo-Sibthorp.

The weighty beaker was acquired as German, late eighteenth century. For mark and goldsmith see T. Borg, *Guld-och Silversmeder i Finland*, Helsingfors, 1935, pp. 453–54, who also reproduces (figs. 255–56) a small oval box and a canister by Rosenius in two Wiborg collections. The scroll-work on the oval box is very similar to that on the beaker. The coins and medals on the beaker are all German and all date from the seventeenth century with the possible exception of the Jewish medal and that of the Lageman (second row, no. 2). The latter is obviously a replacement and it is probable that the Jewish medal may be another. For Lageman, an Amsterdam medallist, see Forrer, *Biographical Dictionary of Medallists*, vol. iii, 1907, pp. 269–70. His recorded work runs from 1773 until 1815. The engraved decoration of the beaker is provincial in quality.

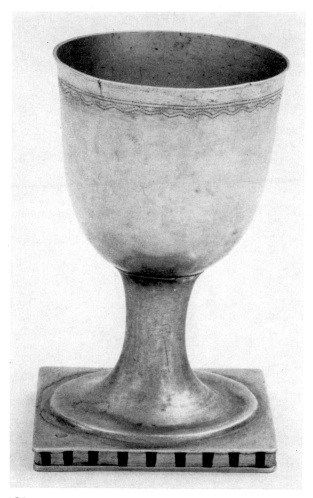

126

126 CUP

Raumo, early nineteenth century (before 1829). Silver, parcel-gilt. The urn-shaped bowl has an everted rim, beneath which runs a pounced border composed of a straight band and a wavy band. The spool-shaped stem rises from a square base whose sides are decorated with oblong piercings. Rim and inside are gilt.

MARKS On upper side of base.
MAKER'S MARK: SW for Samuel Fredrik Wesander, working in Raumo from 1793 to 1819 (T. Borg, *Guld-och Silversmeder i Finland*, Helsingfors, pp. 330–31, no. 1705).
CONTROL MARK The Finnish crown control mark, struck twice (see Borg, p. 25).
DIMENSIONS H. 8·8 cm. W. (max). 5·2 cm.
CONDITION Rim dented and in one place cracked: bowl dented.
<div align="right">M.497–1911</div>
PROVENANCE Purchased (£2 7s 11d) from Herr G. A. Sandell, Kuusa Eisenbahnstation, Finland.

Acquired as Finnish, late eighteenth century. Wesander's widow continued in business after his death until 1829. A comparable cup of 1824 by his son is reproduced by Borg (*op. cit.*, fig. 187a, on plate facing p. 328).

127 CUP

Kuopio, early nineteenth century (before 1833). The plain oval bowl has an everted rim. The spool-shaped stem is encircled by a ring-neck. The trumpet-shaped foot terminates in a plain circular base. On the front are engraved the initials s:b: in wrigglework.

MARKS On the rim of the foot.

MAKER'S MARK of Lars Östman (1768–1833) of Kuopio (see below).

CONTROL MARK Three crowns in a shaped shield.

DIMENSIONS H. 12·1 cm. W. (max.) 6 cm.

CONDITION Bowl scratched and dented. Repair in stem.

M.522–1910

PROVENANCE Purchased (£2 19s 0d) from Herr G. A. Sandell, Kuusa Eisenbahnstation, Finland.

According to Borg (*Guld-och Silversmeder i Finland*, Helsingfors, 1935, p. 271), Östman came from Upsala to Kuopio in 1800. He obtained burghership in 1801, and worked there until his death.

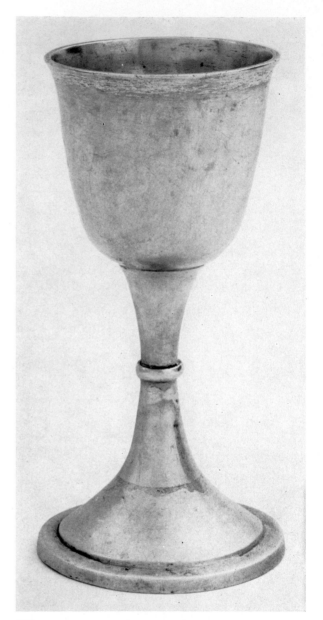

127

Baltic

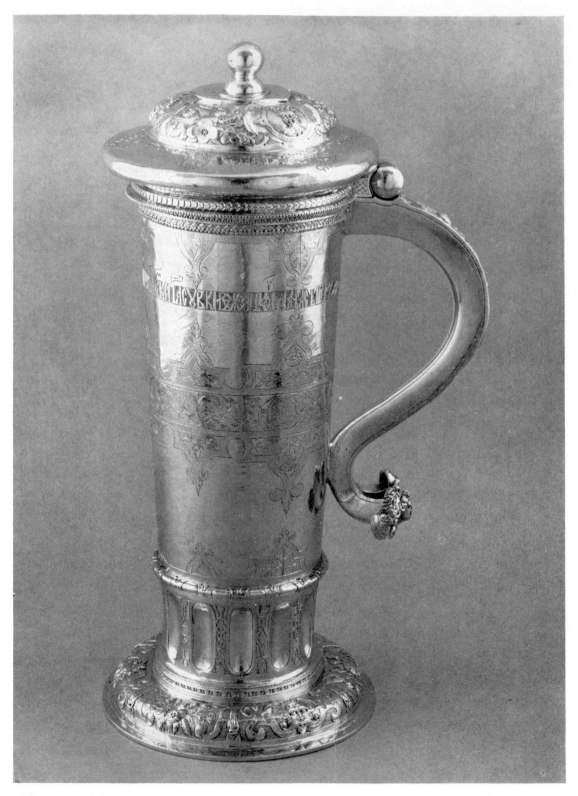

128 TANKARD

Riga, late sixteenth century. Silver, parcel-gilt. The tall cylindrical body tapers downwards. Its rim is richly decorated with mouldings, the upper and lower ornamented with zig-zag in relief, the central one with a diaper pattern in relief. These are gilt, as is the band of engraved strap-work ornament beneath, which forms six panels enclosing engraved foliated scrolls. A similar band of ornament is repeated round the protruding moulding at the base. Round the centre of the body runs a rich band of ornament consisting of a band of engraved scrollwork with the band of ornament of rim and base repeated above and below. This is gilt. The foot consists of a drum, edged at the top by a roll moulding decorated with strap-work cartouche, and ornamented with twelve vertical sunk gadroons in white silver relieved against the gilt and parcel-gilt surround which is decorated between them with ornament of bands and quatrefoils on a hatched ground. Beneath is a moulded rim, the upper band decorated with zig-zag and the central one with egg and dart. The gilt domed base is embossed with six strapwork cartouches containing alternately antique masks (a man, a lion and a putto) and swags of fruit on a matted background, and has a narrow flange. The lid is domed: round the foot of the dome, it is decorated with panels of gilt strapwork on a plain ground. The side of the dome itself is gilt and embossed with three strapwork cartouches containing antique heads alternating with bunches of fruit, all on a matted ground. The flat top is of plain silver, and is surmounted by a gilt-knop (see below). The lid is hinged to the scroll-handle, whose outside is gilt and embossed with a stem of fruit with a cartouche suspended from it, again on a matted ground. The handle terminates in three antique busts, evidently cast from patterns, one that of a philosopher, one of a youth and one of a warrior. Round the upper part of the body runs an engraved band with a Russian inscription: '(*Tankard given after* [*the death of*] Boyarin Ivan Andreevich Miloslavsky to the [Chapel] of Christ at the Monastery of Kirjatz).' The inside is gilt. The initials THBB engraved in monogram on the base.

MARKS On the base.

TOWN MARK The crossed keys surmounted by a cross in a shield with a pointed base, given by Neumann (*Verzeichnis baltischer Goldschmiede*, Riga, 1905, p. 7) as the mark of Riga in the sixteenth century.

MAKER'S MARK: HR in monogram for Hans Rolowes the Elder (working in Riga in the second half of the sixteenth century and the first decade of the seventeenth) or else for his son Hans the Younger (master 1580–1602). For these see Neumann (*op. cit.*, p. 68, nos. 413–14).

DIMENSIONS H. 30 cm. W. 16·5 cm.

CONDITION An oblong piece inserted in the rim of the lid above the hinge. The gilding of the inside renewed. The body appears to have been buffed. See also below.

M.31–1961

PROVENANCE Purchased (£750) from H. S. Wellby.

Tankards of this form are typical of the Baltic lands in the second half of the sixteenth century (see Introduction under style). From an illustration of two made in Riga by Lambert Goldenstedt, who was a master there in the second half of the sixteenth century and the first decade of the seventeenth (reproduced in A. Buchholtz, *Goldschmiedearbeiten in Livland, Estland und Kurland*, Lübeck, 1892, pl. 1, pp. 7–8, as in the collection of Baron Behr'schen Majorats Popen in Kurland) it is evident that the present tankard originally had a tall cast thumb-piece, probably of cartouche-form, whose loss has been disguised by the insertion of the oblong piece above the hinge. Evidently too the knop is a late substitution for a spool-shaped pedestal on which stood a small figure. Otherwise this magnificent tankard is an impressive example of its kind.

The inscription records its later presentation by the Russian government official and nobleman Ivan Andreevich Miloslavsky to the monastery of Kirzhack, which was founded at the end of the fourteenth century and closed in 1764. Ivan Andreevich Miloslavsky became boyarin in 1657–58. He was previously an official in the Petitions Department in 1648–49, in the Pharmaceutical Department from 1655, and from 1649–63 was also in the 'Yamsky' (coachman) Department. He was related to Ilia Danilovich, father-in-law of Tsar Alexei Mikhailovich. He died in 1663 (information supplied to Mr C. C. Oman by Madame Postnikova-Losseva, State Historical Museum, Moscow).

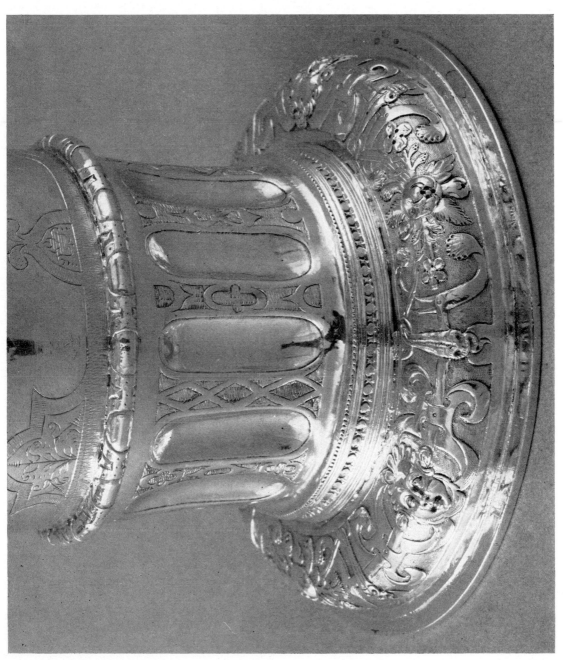

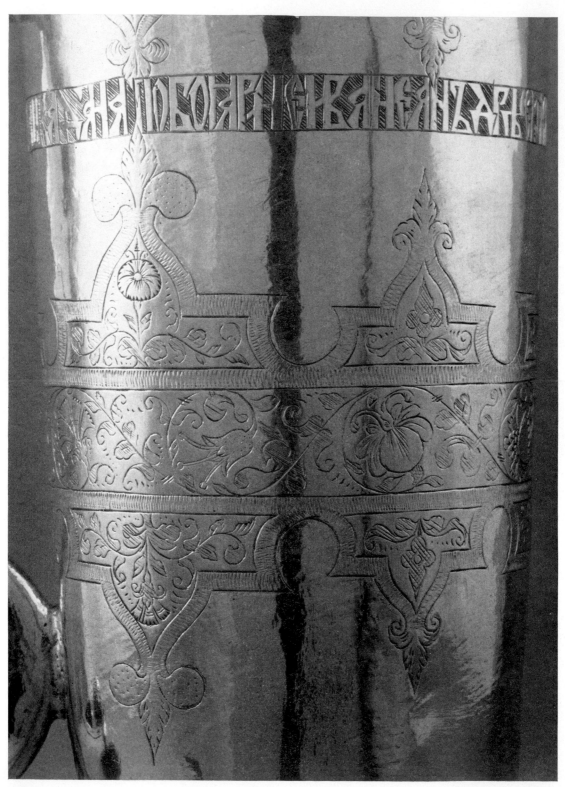

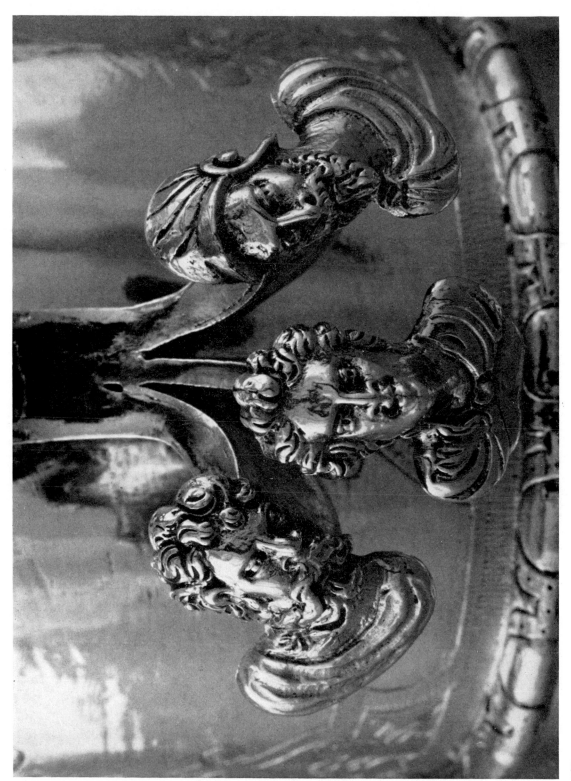

129 COVERED BEAKER

Riga, c. 1680. The body, which rests on three plain cast and applied ball feet, is chased and embossed with scrolling stems of foliage and flowers. The rim is everted, and a plain band runs beneath it, separated by a punched line of ornament from the decoration beneath. The lid is decorated with swirling acanthus foliage inside a plain border, matted and chased, in the Louis XIV Baroque style: the knob is shaped as a cast stylized acorn in a nest of oak-leaves.

MARKS On the base.

TOWN MARK The crossed keys surmounted by a cross of Riga.

MAKER'S MARK: IL on either side of a tree for Georg (Jürgon) Linden.

DIMENSIONS H. 14·8 cm. Diam. of bowl 10·5 cm. Diam. of lid 11·8 cm.

CONDITION The lid is dented and cracked: the junction of knob and lid damaged and repaired. Parts of leaves around knob missing. An erased inscription round the lip.

485–1911

PROVENANCE Purchased (£22) from G. Jorck.

Georg Linden (for whom see W. Neumann, *Verzeichnis baltischer Goldschmiede*, Riga, 1905, pp. 61–2, no. 387) became a master in Riga on 14 January 1674. He was still alive in 1680, but was dead in 1688. Beakers of this type usually lack the cover: since so few covered examples survive it is of unusual interest.

130 BASIN

Riga, dated 1694. Silver. The raised outer rim has a wavy edge and is heavily embossed and chased with leafy fruit and flower-bearing stems. The central depression is encircled by a laurel wreath; in the medallion so formed is the head of a Roman youth in right profile. On the rim is the inscription: *Hillardt Ihnken: A 1694 Christina Calder.*

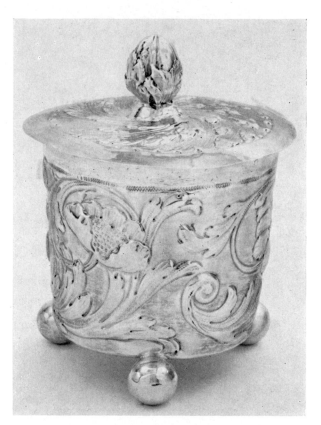

129

MARKS On the upper side of the rim.

TOWN MARK: the crossed keys sur-
mounted by a cross of Riga.

MAKER'S MARK: J or T with perhaps
another letter in an oval.

DIMENSIONS Diam. 28·7 cm.

CONDITION Two cracks in embossed bor-
der of fruit, flowers and foliage re-
paired.

M.40–1922

PROVENANCE Purchased (£10) from Miss
V. M. Hope, Crix, Hatfield Peverel,
Essex.

The mark is possibly that of Israel Caroli
(d. 1709), who became a citizen of Riga
and a master in the guild on 17 July 1691
(see W. Neumann, *Verzeichnis baltischer
Goldschmiede*, Riga, 1905, p. 45). The
thin silver, wavy edge, and ornamental
forms are characteristic of silver made
round the shores of the Baltic at this date.

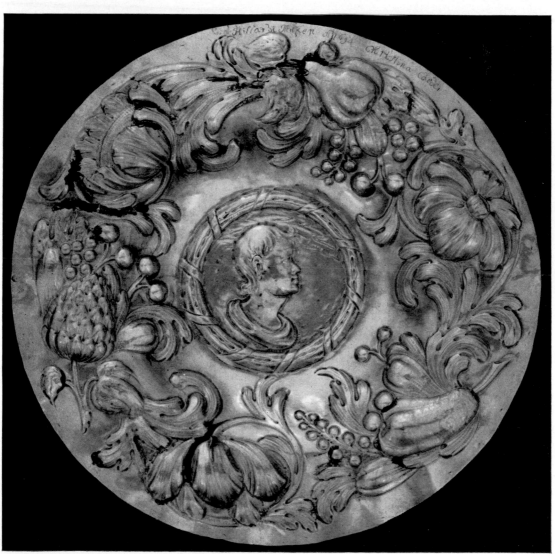

131 PLAQUE

Riga, 1705. Embossed and chased on the background with a military trophy consisting of swords, clubs, cannon, drums, Turkish bows, arrows, six banners (two Russian, two Turkish, and two Polish) pistols, pennons, lances, a mortar, battle-axes, trumpets, bombs, cannon-ladles, linstocks, cannon-balls, and a plumed classical helmet on a pole (centre top). Four battle-scenes are depicted in car-touche-shields of different form which are held up by flying angels draped in cloaks. A branch of laurel stretches across the body of the angel to the right and another branch of laurel appears from behind the right arm of that on the left. The scene on the left-hand shield, which is pelta-shaped and has a border composed partly of foliage and partly of scroll-work, depicts a pitched battle. The inscription round its edge reads: VICTORIA

131

AD SALATEN D XIX MART MDCCIII.
The scene in the shield on the right,
which is an elongated hexagon, shows a
cavalry engagement during a battle.
The inscription on the border reads:
VICTORIA AD IACOBSTADIVM DIE
XXVI IVLII MDCCIV. The oblong shield
with incurved sides shows mortars
launching bombs over a stockade on to
the roofs of a fort: the inscription on the
border reads: EXPUGNATIO ARCIS
BIRSAE DIE XIV SEPTEMB. MDCCIV. In
the oval shield above, which unlike the
other three is fully visible, is a battle
with a cavalry engagement taking place
on the slope in the foreground. This
shield is supported from below by an
angel while another flies over it and
points to the first letter of the inscription
in the border, which reads: VICTORIA
VILTZNICA PROPE GEMAURTHOF DIE
XVI IVLII. MDCCV. Round the edge runs
the inscription in italics:

Victoria nulla clarior, aut hominum
votis optatior unquam Contigit. In-
gentes geminant discrimina magna
Triumphos. Quam certa fuere Gaudia,
cum totas victoria panderet alas. Cunctis
inopina reluxit, Te Victore, Salus.

Within the border the ground is deli-
cately matted. On the cannon end which
protrudes at the left side is the date 1705
and the inscription: I.G.EBEN ME FEC/
RIGA.

MARK At the bottom, right of centre,
just within the matted ground is
struck a crowned V in a shield, the
Dutch standard mark current from
1813 until 1893 (Rosenberg, vol. iv,
p. 394, no. 7555; Voet, 1937, p. 29).

DIMENSIONS Diam. 21·9 cm.

CONDITION Cracks: a notable split along
the left buttock of the central angel.
Traces of the original pitch on the back.
3633–1855

PROVENANCE Purchased (£30, vendor
not recorded).

The battles represented on this plaque
are all victories won by the celebrated
Swedish general Count Adam Ludwig
Lewenhaupt (1659–1719) in the cam-
paigns of 1703–05 in Courland and Lith-
uania during the great war fought
against Czar Peter the Great and King
Augustus the Strong of Poland by King
Charles XII of Sweden. The first repre-
sents the battle of Salat (1703), which
took place after the Polish general Ogin-
ski had captured Birsen. Lewenhaupt
was detached to re-take Birsen, and was
then recalled. He was pursued in his re-
treat by the Russians and the Lithu-
anians, who caught up with him at Salat
on 18 March. Lewenhaupt encamped at
Salat: next day the Russians entrenched
themselves behind a river and were
attacked and defeated by Lewenhaupt.
The scene on the plaque may be in-
tended to represent the cavalry charge
which opened the action. The battle of
Jacobstad (1704) on the borders of Cour-
land was also fought against the Russians
and the Lithuanians. The third scene
shows the capture of Birsen, which
Lewenhaupt took from Oginski and the
Russians after a blockade of several
weeks. He took the town not by storm
but by composition. The last scene shows
the important battle of Gemauerthoff.
In 1705 Peter the Great took advantage
of the absence of Charles XII to attack
the Swedish forces in Courland. The
Russian general Bauer succeeded in en-
tering Mittau, the capital of Courland:
as soon as he heard the news Lewenhaupt
collected some cavalry and dragoons and
rode to Mittau by Gemauerthoff. On
learning that the Russians had with-
drawn from Mittau Lewenhaupt
marched on Gemauerthoff and on 16
July 1705 joined battle with the Rus-
sians there. In spite of his greatly
inferior forces Lewenhaupt inflicted a
serious defeat on the enemy. Although
the trophy was a conventional emblem of

military triumph, it is possible that some of the weapons represented on the plaque allude to the cannon and trophies Lewenhaupt is known to have sent to Riga after his victories, for example after the battle of Jacobstadt. (For these campaigns of Lewenhaupt the compiler has consulted Gustaf Adlerfeld, *Histoire militaire de Charles XII*, Amsterdam, 1740, vol. i, pp. 367–74, vol. ii, p. 230, pp. 425–35, and J. A. Nordberg, *Histoire de Charles XII*, vol. i, The Hague, 1748, pp. 480–481. He has not been able to consult H. Uddgren, *Karolinen Adam Ludwig Lewenhaupt Hans krigföring i Kurland och Litauen*, 1919–50).

Adam Ludwig Lewenhaupt, in whose praise this relief was executed, belonged to a distinguished Swedish noble family. He studied at the University of Lund, which he entered in 1671, and later at the universities of Upsala and Rostock, where he disputed in 1682. Only after leaving university did he turn to a military career, serving first with the Bavarians from 1685 to 1688, and from 1688 to 1698 with the Swedish and Dutch. He was made a colonel (*överste*) in the

131a

Swedish army in 1700, and after the opening of the war with Russia and Poland his promotion was rapid. In 1703 he was appointed a major-general of infantry, vice-governor and commander in Courland, Pilten and Semigallia, with the rank of Commander-in-chief in Courland. In 1705 he became a lieutenant-general, and in 1706 a full general, governor of Riga, and commander-in-chief of the armed forces in Courland, Lithuania and Latvia. He accompanied Charles XII on his disastrous march into Russia, and was taken prisoner in 1709 by the Russians at the great defeat of Pervolotjna, spending the rest of his life as a prisoner of war in Moscow, where he died on 12 February 1719. Lewenhaupt was a learned man nick-named 'den latinske oversten' by his fellow-soldiers. The design and the long inscription on the border show that the plaque was commissioned in thanksgiving for his final victory at Gemauerthoff: 'No brighter victory, or more desired in the prayers of men ever befell. The great perils double the huge triumphs. How sure were the rejoicings,

when victory unfolded her wings entire. Salvation shone unexpectedly to all by thy victory.'

For Johann Georg Eben, the maker of this plaque, see W. Neumann (*Verzeichnis baltischer Goldschmiede*, Riga, 1905, pp. 48–9). He first appears in 1698 as the designer and engraver of a suite of six plates of ornament (Guillemard, 1881, p. 410), and was still working as an engraver in 1709, when he signed the engraved title-page of a book printed in Riga. In 1700 he was an apprentice in the goldsmith's shop of Georg Dechant,

who put him up for admission to the guild in 1702: he registered his mark on 24 January 1703. Eben died in the second half of 1710. As can be seen from this plaque, he was a masterly silver chaser. Three other important embossed works from his hand are known, set on the lids of three tankards in the collection of the Compagnie der Schwarzen Häupter in Riga. The first, which has the maker's mark of Georg Dechant and an inscription dated 1701, is embossed with Charles XII's victorious entry into Narva in 1700. The second, on a tankard dated

131c

1704 which has Eben's own mark, represents the cavalry battle on the Spilwe near Riga, with flying putti holding a medallion portrait of Charles XII. The third, dated 1705, is decorated with the battle of Gemauerthoff, the principal battle shown on the present plaque, but in a different composition, and with a medallion portrait of Field Marshal Lewenhaupt. (For these see Neumann, *loc. cit.*, and A. L. Buchholtz, *Goldschmiedearbeiten in Livland, Estland, und Kurland*, Lubeck, 1892, Taf. XIII, nos. 36–8, pp. 15–16).

The arms of the trophy are partly classical and partly contemporary. The influence of French ornament is evident. The probability is that the design as well as the execution of this splendid plaque is by Eben. The idea of depicting Lewenhaupt's victories on shields was inspired by classical epic poetry and is probably of German origin. On the back are the remains of four plugs with which the relief was once mounted – presumably in an ebony frame.

151d

132 BEAKER

Riga, dated 1737. Parcel-gilt. The coni-
cal body has a plain moulded rim, which
is gilt. Beneath runs a band of gilding,
enclosed in an engraved double line
frame. On this is pounced the inscription:
Herman Humborg Wittibe 1737. The
cast base is decorated with a thin band of
zig-zag in relief: the curved ring (separ-
ately cast) is decorated with broad and
narrow ribs, set at an angle.

MARKS On the base.
TOWN MARK: the crossed keys in saltire,
 surmounted by a cross, of Riga.
MAKER'S MARK of Franz Hagen, who
 became a master in Riga in 1720 and
 died in 1741.
DIMENSIONS H. 16·5 cm. W. (max.)
 11·7 cm.
CONDITION Dents and scratches. On
 acquisition it was suggested that the
 inscription may supersede an earlier
 one: this is improbable.

25–1902

PROVENANCE Purchased (£7 4s 0d) from
 G. Jorck, probably acting as agent for
 Josef Nachemsohn, of 31 Østergade,
 Copenhagen.

On acquisition the beaker was identified
as Swedish. For Franz Hagen see W.
Neumann (*Verzeichnis baltischer Gold-
schmiede*, Riga, 1905, pp. 53–4, no. 354).

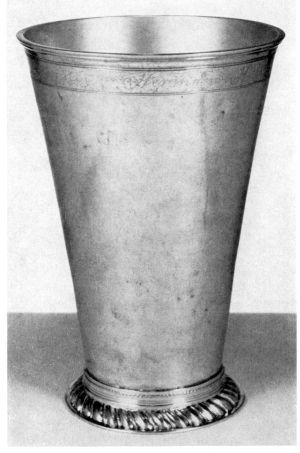

132

155 COVERED BEAKER

Riga, 1760–64. Parcel-gilt. The body of the beaker is shaped as an inverted cone, and has a broad moulded rim and a separately made domed foot, the latter decorated with radiating ribbing and gadrooning and surmounted by a moulded ring. The rim and a broad band beneath, the ring and the foot are gilt. The main part of the body is ungilt, and is chased in relief with three oval strapwork cartouches, between which are set vases of flowers. Above the vases and above and below the cartouches are motifs composed of Bérainesque ornament, intertwining with or curling over the cartouches. Those above the cartouches enclose a bunch of pomegranates. All these ornaments are on a matted ground. The three cartouches contain scenes of Cupids. One shows two Cupids seated on the ground holding bows and arrows: the Cupid on the left brandishes an arrow. That to the right shows two dancing Cupids, one holding up a burning torch, the other holding a thyrsus and a cup. They disport themselves in a grassy valley, with a mountainous background. In the third scene one Cupid is seated with his back against a tree, overpowered by fatigue and holding a flute in his right hand. Another Cupid holding a cup stands beside him, one arm round his neck. A jug stands on the ground to the left: the background is more or less the same as in the previous scene.

The inside is gilt, and the base is set with a thaler of Frederick Augustus, Elector of Saxony and King of Poland. The obverse shows the king dressed in laced coat and breeches, crowned and with a fluttering classical cloak, riding a rearing horse and holding a military baton. Beneath is a cartouche enclosing a shield bearing the arms of Saxony and Poland. The obverse shows two Baroque stools; on that to the left are placed a royal mantle, sceptre, orb and crown, on that to the right a sleeved electoral mantle, lined with ermine, a sword and an electoral crown. Above is the inscription: FRID: AUG:/REX ELECTOR. Beneath is a third stool supporting a mantle. On the mantle two sprays of laurel enclose the inscription: ET/VICARIUS/ POST MORT:/IOSEPHI IMPERAT: On either side is the date MDC/CXI. Beneath on the left are the initials of the medallist I.L.H. (see below).

The lid is shaped as a low two-tiered dome. The rim is gilt: the first tier is ungilt except for a narrow gilt acanthus border in relief running round its upper edge. Above this is a gilt sunk border; the lower part of the second tier is ungilt, while the upper part is richly

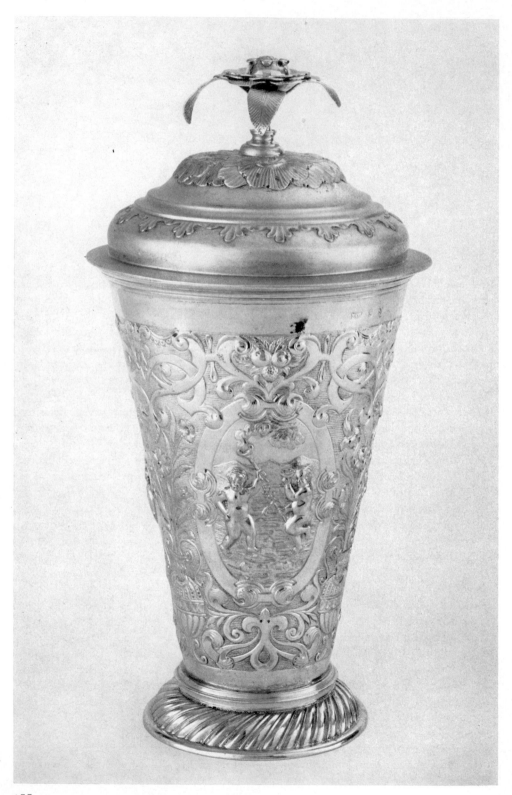

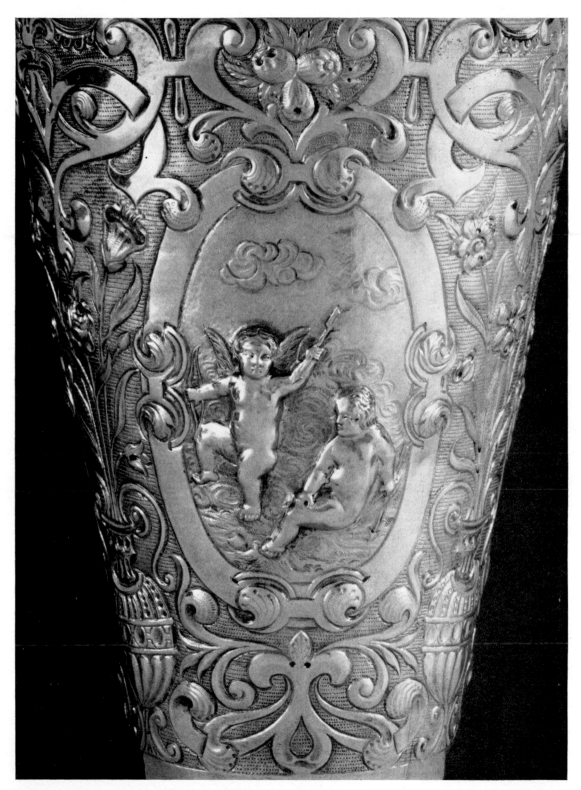

133a

decorated with four scrolling motifs on a rich ground of three layers of *rocaille* leaves. From a gilt moulded base rises a finial of ungilt silver, shaped as a double rose resting on a three-leaved stem.

The plain band below the rim is pounced with the initials F.G.H. Some weight marks scratched inside the base.

MARKS On the rim of the beaker.

TOWN MARK: the crossed keys surmounted by a cross of Riga.

MAKER'S MARK of Michael Krezner III (working in Riga from 1754: last recorded work 1786). Also struck on rim of lid.

WARDEN'S MARK: C for Johann Dietrich Rehwald, warden 1760–64 (Neumann, *Verzeichnis baltischer Goldschmiede*, Riga, 1905, p. 6).

DIMENSIONS H. (max.) 29·5 cm. Diam. (max.) 14·8 cm.

CONDITION Good. The arms on the coin a little blurred in the bottom right. Gilding renewed.

M.34–1949

PROVENANCE Bequeathed by Mr F. J. Varley.

Other beakers by the same maker similar to this fine and massive display-piece are recorded by Neumann (*op. cit.*, Riga, 1905, pp. 57–58, no. 376). The decoration introduces late Baroque and Rococo motifs into a type of ornamental composition which first appears in late sixteenth century German goldsmith's work. The Bérainesque ornament may show Scandinavian influence. The thaler was designed by Johann Lorenz Holland, mintmaster at Dresden from 1698 to 1716. It is known as the Vicariats Thaler, and was issued to commemorate the appointment of King Frederick Augustus (better known as Augustus the Strong) as Imperial Vicar after the death of the Emperor Joseph I on 17 April 1711. Forrer (*Biographical Dictionary of Medallists*, vol. ii, London, 1904, pp. 533–34) reproduces the obverse and reverse of an example of the thaler.

INDEX OF PLACES OF ORIGIN

INDEX OF MAKERS AND ARTISTS

NUMERICAL CONCORDANCE

MUSEUM NO.	catalogue no.		catalogue no.
2162–1855	29	1592–1901	110
2263–1855	118	1593–1901	112
2264–1855	15	1595–1901	21
2265–1855	116	24–1902	100
2266–1855	107	25–1902	132
2267–1855	48	26–1902	94
3633–1855	131	283–1902	97
48–1864	59	284–1902	91
485–1865	14	285–1902	96
283–1878	80	286–1902	6
864–1882	84	293–1902	102
651–1890	30	296–1902	87
652–1890	58	297–1902	105
653–1890	53	298–1902	106
654–1890	18	299–1902	104
1265–1893	73	917–1902	72
1266–1893	74	1202–1902	119
1273–1893	75	559–1903	16
470–1897	9	1566–1903	7
933–1898	76	199–1904	108
1879–1898	40	759–1904	88
1880–1898	43	760–1904	123
1881–1898	93	765–1904	81
1886–1898	89	767–1904	117
1901–1898	125	769–1904	65
1902, 1902A–1898	41	768–1904	51
1907–1898	8	771–1904	20
1913–1898	36	1104–1904	113
1934–1898	103	1105–1904	92
2000–1898	17	65–1905	122
2001–1898	66	1007–1905	70
2002–1898	121	595–1907	3
2003–1898	19	M.45–1909	44
2004–1898	71	M.70, 70a–1909	38
2005–1898	114	Circ.332–1910	67
2006–1898	68	Circ.333–1910	63
2008–1898	115	Circ.334–1910	64
1612–1900	10	Circ.406–1910	98
1613–1900	11	M.479–1910	4
1614–1900	12	M.483–1910	62
1615–1900	13	M.485–1910	79
1591–1901	109	M.486–1910	101

	catalogue no.		catalogue no.
M.487–1910	83	M.225–1912	23
M.488–1910	35	Circ.292–1912	25
M.491–1910	60	Circ.293–1912	111
M.492–1910	50	Circ.295–1912	61
M.493–1910	52	Circ.411–1912	82
M.494–1910	46	Circ.162–1913	33
M.520–1910	124	M.54–1914	27
M.522–1910	127	M.54a–1914	28
Circ.548–1910	54	M.311–1919	45
Circ.553–1910	56	M.40–1922	130
M.629–1910	57	M.229–1924	47
M.630–1910	55	M.236–1924	1
M.631–1910	120	M.41–1925	39
M.632–1910	49	Circ.322–1927	2
M.485–1911	129	M.38–1929	31
M.495–1911	90	M.19–1940	99
M.496–1911	85	M.522–1940	69
M.497–1911	126	M.1789–1944	22
M.570–1911	42	M.30–1948	32
M.572–1911	37	M.54–1949	133
M.48–1912	86	M.42–1949	34
M.49–1912	95	M.51–1953	77
M.50–1912	78	M.51–1961	128
M.223–1912	24	M.49–1965	5
M.224–1912	26		